SPORTS
PEOPLE

SPORTS

Surfer. Honopu
Beach, Kauai,
Hawaii, 1976

PEOPLE

PHOTOGRAPHS
BY
WALTER IOOSS, JR.
TEXT BY
FRANK DEFORD

HARRY N. ABRAMS, INC., PUBLISHERS, NEW YOR

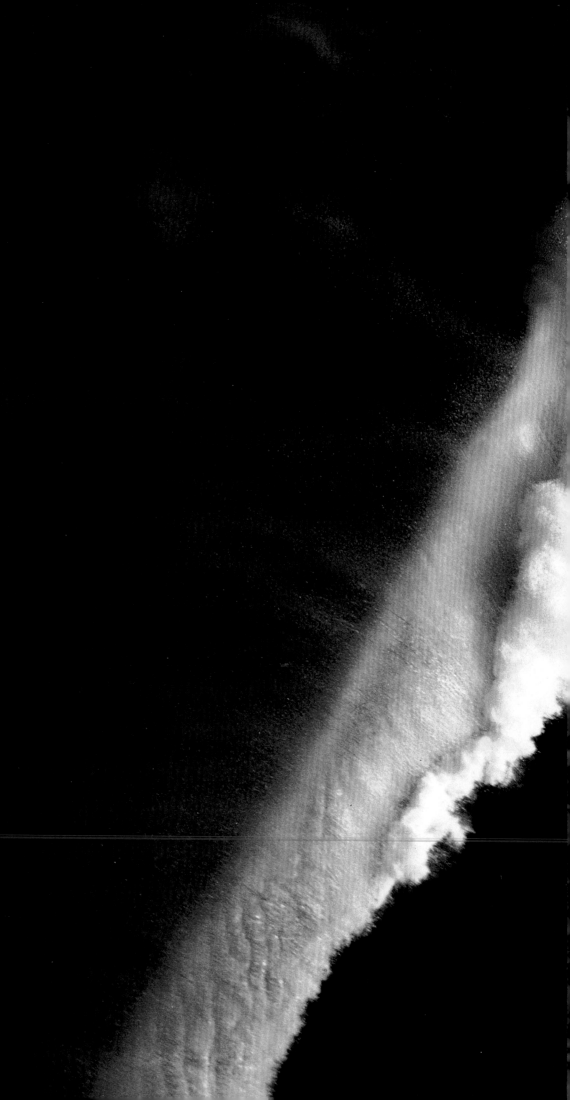

To
Eva, Christian,
& Bjorn

Project Director:
Robert Morton
Editor:
Harriet Whelchel
Designer:
Will Hopkins,
Will Hopkins Group

Library of Congress
Cataloging-in-Publica-
tion Data

Iooss, Walter.
Sports people / pho-
tographed by Walter
Iooss, Jr.; [text by]
Frank Deford.
p. cm.
ISBN 0–8109–1520–0
1. Photography of
sports. 2. Athletes—
Portraits. I. Deford,
Frank. II. Title.
TR821.I66 1988
779' .9796—dc19
88–5883

Photographs on pages
48–51, 56–63, 66–70,
72–73 courtesy Fuji
Photo Film U.S.A.,
Inc.

The publisher grate-
fully acknowledges
the cooperation of
Sports Illustrated in
making many of these
photographs
available.

Published in 1988 by
Harry N. Abrams, In-
corporated, New York

A Times Mirror
Company
Printed and bound in
Japan

**Surfer. Hanalei
Bay, Kauai, 1976**

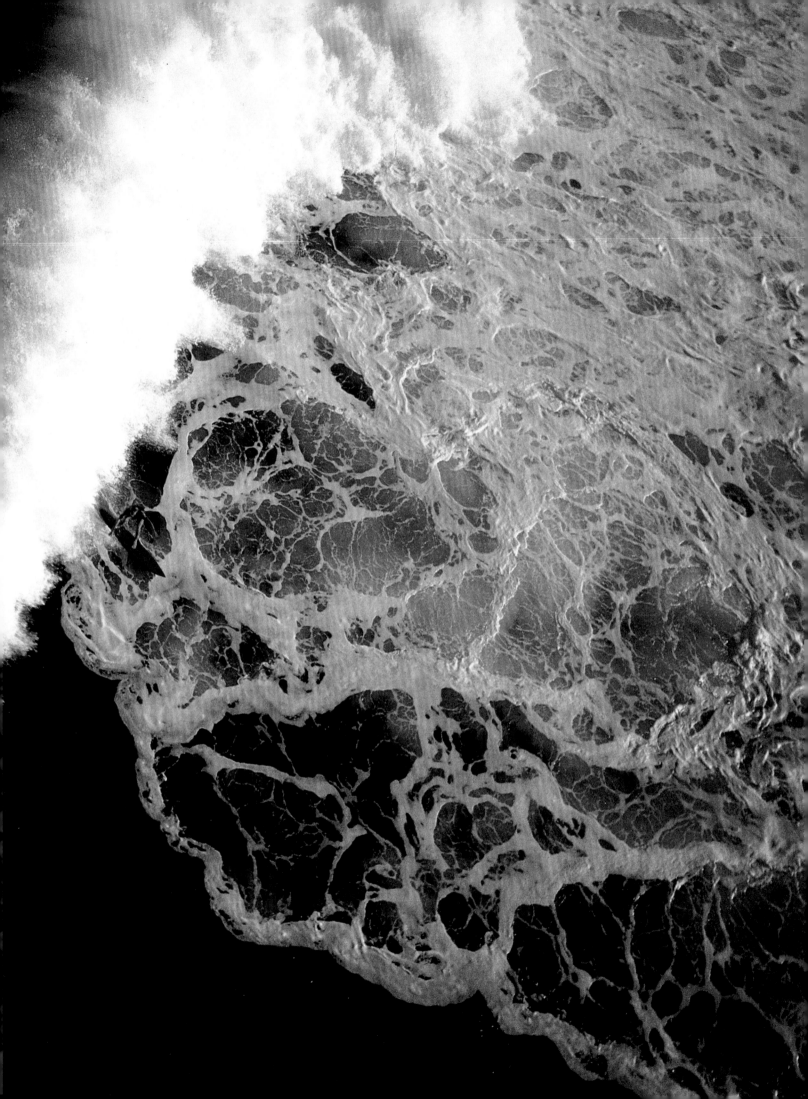

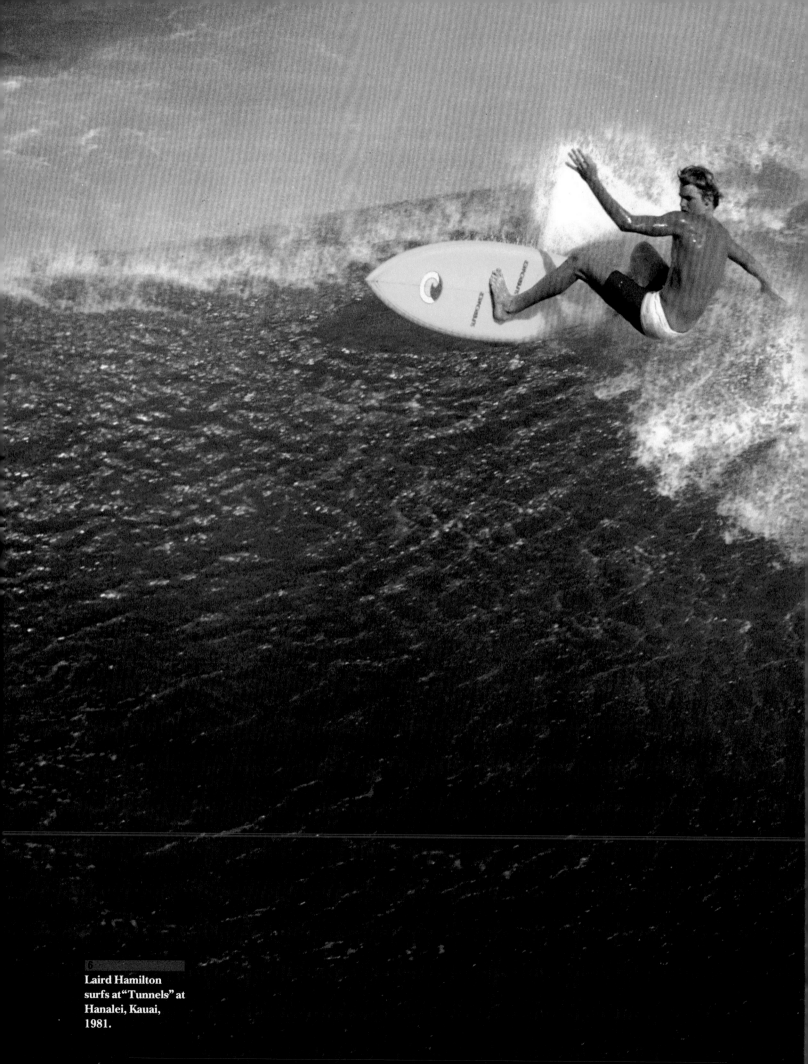

**Laird Hamilton
surfs at "Tunnels" at
Hanalei, Kauai,
1981.**

Skateboarder
Christian Hosoi.
Venice, California,
January 1988

SPIRIT
OF SPORT...
THE
INDIVIDUAL
& THE
TEAM

From one point of view, the sports photograph is an anachronism. Who needs a guy with a Japanese camera to duplicate what we just saw ourselves, live and in color, on the network?

But, if anything, television does not satiate us in this regard, it only whets our appetite. When television first loomed, all promoters in sports were panicky that it must be controlled, that no one in his right mind would go out and pay to see a game that he could stay at home and watch for free. And this wasn't the conventional wisdom. It was the only wisdom.

In fact, though, quite the reverse happened. It turned out that television opened the door a crack and made people more curious to see for themselves, in person, truly live—alive—what they had glimpsed over the air, once removed.

The same principle applies to still photography in sports. It is true enough that we not only watch the game on TV, but now we can see the game slowed down, blown up, isolated, dissected, and ... frozen—just like a photograph.

It is also true that television cameras have transmitted to us some wonderful moments: the coach hoisted upon his team's shoulders, the cheerleader crying, the fallen warrior. Still, those moments are fleeting,

and it is largely dumb luck that brings them to us. In sports, the television camera is inevitably an instrument of journalism, a device. The mandate is to report. Miller Lite and Midas Muffler aren't paying $300,000 a commercial minute for aesthetics and humanity. They're paying that for touchdowns and home runs.

Moreover, television is such an aggregate enterprise. The cameraman may take the shot, but his location was selected in advance by somebody with a computer and a chart, he has been advised via his earphones where to point the camera, and a gaggle of producers and directors decides which buttons to push that might put the shot on the air.

It is altogether different for a sports photographer like Walter Iooss, Jr. He is one person, two eyes, one camera, one vision. Professionals such as Walter are trained as journalists, but I don't think it is overstating the case to say that the best of them are, foremost, artists. In fact, someone like Iooss will go back and forth between being a reporter and an artist in the course of the same game. Iooss is a wonderful mixture of mobility and instinct. Sometimes he takes what we call shots. Sometimes he takes pictures.

In the word usually employed, the photographs in this book *capture* sports—in a way that neither television nor your own eye could. You see, television reports, Iooss captures. He hasn't intruded or leered. Only in a few instances has he taken his camera where your eye couldn't go (so long as you bought a ticket at the box office). But his camera has done what we can't do. He has captured; and more, he has brought it back alive. Shots are part of the game. Pictures are part of our life.

Now, look at the expressions in these pictures Walter gives us. When we think of kids playing, we automatically visualize fun (and games), laughter and joy. Certainly, here, some of these emotions are apparent, but I think that the intensity and the dedication on the faces shine through even more.

In most cases, too, Walter Iooss has just found a bunch of kids playing some game together. There are no adults around to coach and referee and make everybody shake hands afterward, even though they don't want to, because *that teaches sportsmanship,* even though of course it doesn't. I suspect, in fact, that children have always worked much harder at sports than we would like to imagine. When parents come around it's to give orders and instructions and make everything very organized, but that doesn't necessarily mean the kids take the games more seriously. I suspect that kids are even less serious when grown-ups are around because they don't want grown-ups to know how important play really is to them.

The photographs here literally come from all over. The fellows playing

cricket on the beach were in the West Indies, the surfers were in Hawaii, the young baseball player in Jersey, and the hockey and basketball players in Manhattan and Brooklyn. Iooss had to shoot the black kid who is dribbling through the fence because Walter had ridden his bike into a black section, and the kids' suspicion was beginning to verge on hostility. They thought Walter was a narc or something.

Getting the picture of the surfer with the red board was one of the most difficult photographic challenges Iooss ever faced. The location was the island of Kauai, at a site known as Honopu Beach, which is inaccessible by foot. The only way to get there was by helicopter, but the red surfboard could not be fitted inside the copter. The ends of the board stuck out of the doors, which, in effect, gave the copter an additional wing, changing the aerodynamics of the flying machine.

The pilot was, wisely, scared, but he took the board up first by himself, and was satisfied enough to come back down and pick up Iooss, his assistant, and the surfer. They took off for the beach and, despite a rather harrowing flight, made it. On *terra firma,* Iooss got this picture, exactly what he wanted.

Then they all flew back the same way, risking their lives to return with the surfboard, which, for safety's sake, they should have left behind. But the surfer was very fond of this particular red board.

Still, my favorite picture in this section is of kids playing cricket on the beach. The subtext to it is that their beach and cricket are no different to them from the Brooklyn street where other kids are playing hockey. They don't have the foggiest idea that the beach they happen to play on is beautiful and picturesque. Walter chanced on this scene on the tiny island of Bequia, which is south of Saint Vincent, in the Grenadines.

Iooss was more or less a born photographer. He was shooting for *Sports Illustrated* at the age of sixteen, with braces still on his teeth. There are so many natural athletes that he shoots, and he is a natural photographer. Neil Leifer, his contemporary, another teenage phenomenon, who has been Iooss's friend and rival for a quarter of a century, says unashamedly: "Walter is the most extraordinarily intuitive photographer I've ever seen. I've met very few geniuses in my life. Walter may be the only person I know who I'm *sure* is a genius."

I first met Walter in 1963, shortly after I had joined *Sports Illustrated.* I was twenty-four years old, fresh out of college, and I was assigned to cover several teams in spring training. The job requirement was to go down to Florida and wire back breathless stuff like: "The Phillies can contend for the first division if the wily Mauch can find a southpaw fireman and a

seasoned utility infielder." But, hey, it was the big leagues, and I was very proud of myself indeed.

And then Walter showed up, assigned to shoot the potential left-handers and glovemen to support my prose.

It burned me up, although I certainly didn't tell him. Here I was, a veritable boy wonder of sports journalism, and they sent me a photographer *five years younger* than I was. Walter Iooss was the first person, I think, ever to make me feel old.

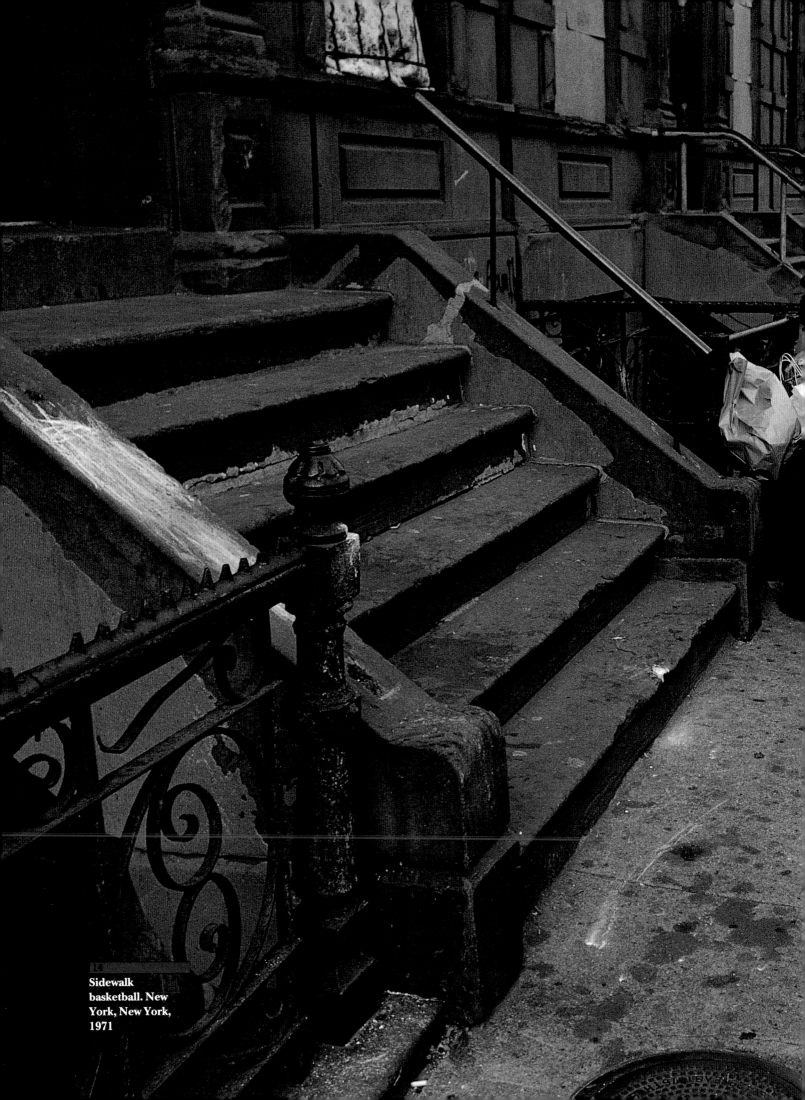

Sidewalk
basketball. New
York, New York,
1971

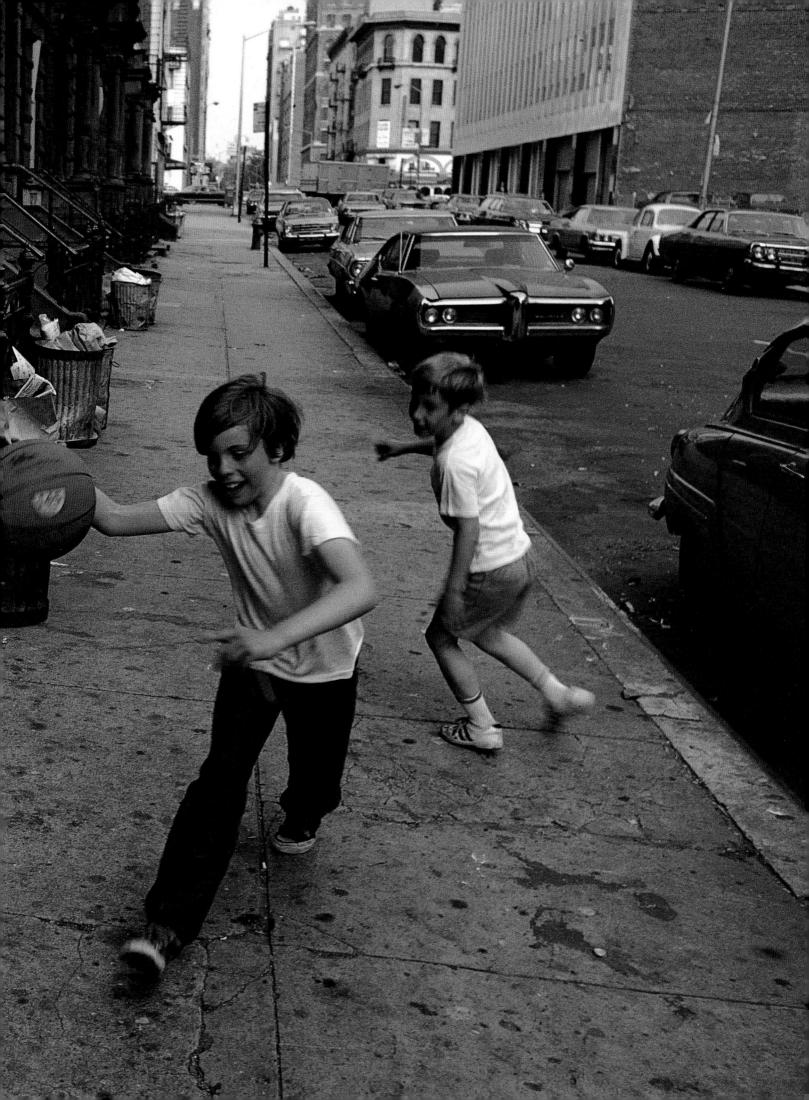

**Street hockey
player. New York,
December 1973**

**Street hockey.
Brooklyn,
New York, 1978**

**Young basketball
player. Power
Memorial Academy,
New York, 1971**

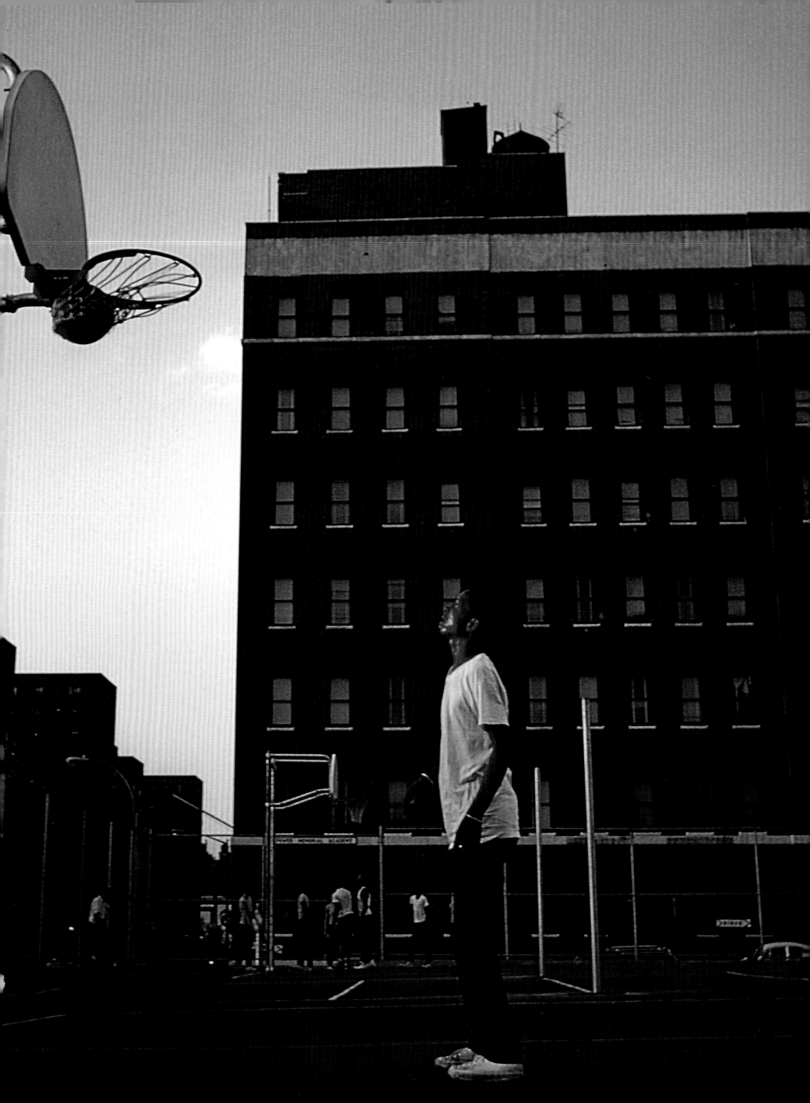

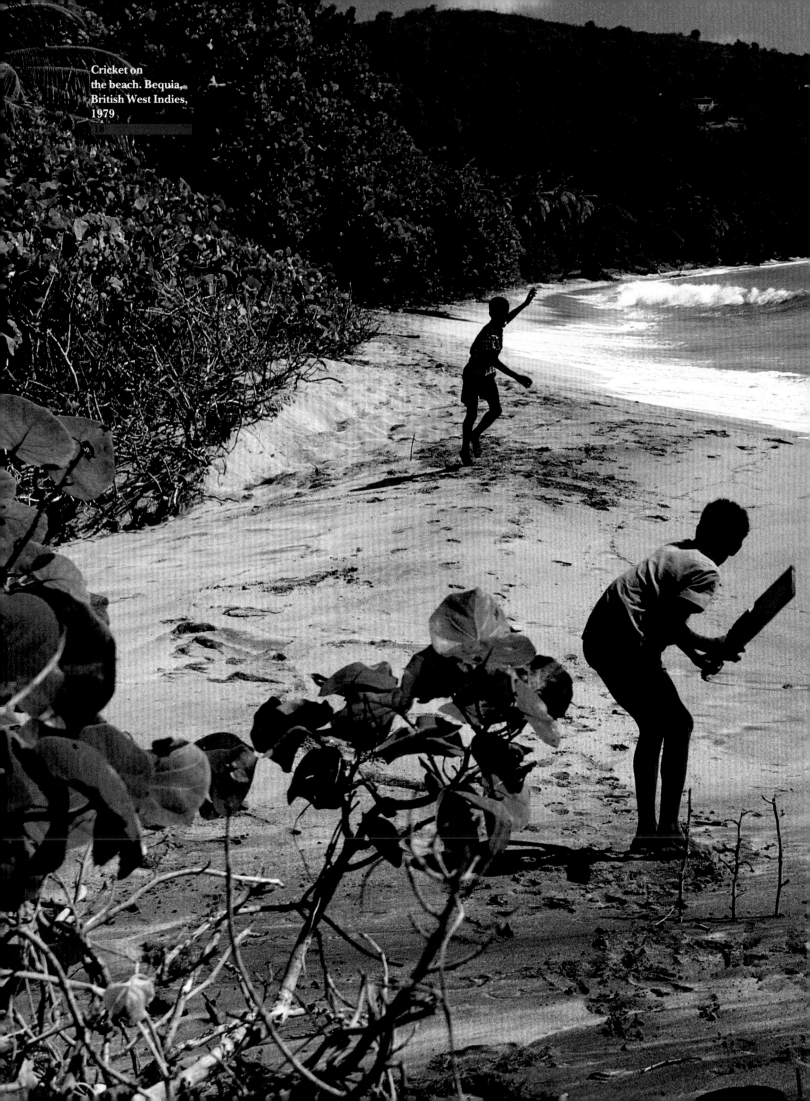

Cricket on
the beach. Bequia,
British West Indies,
1979

18

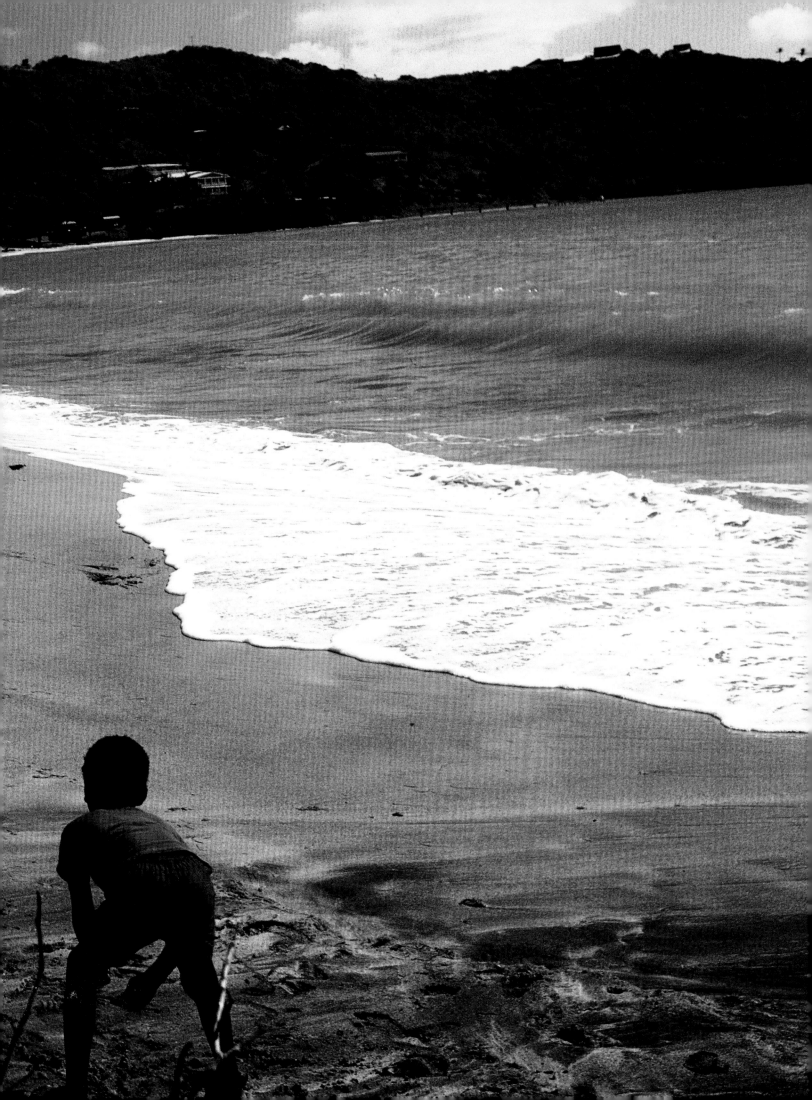

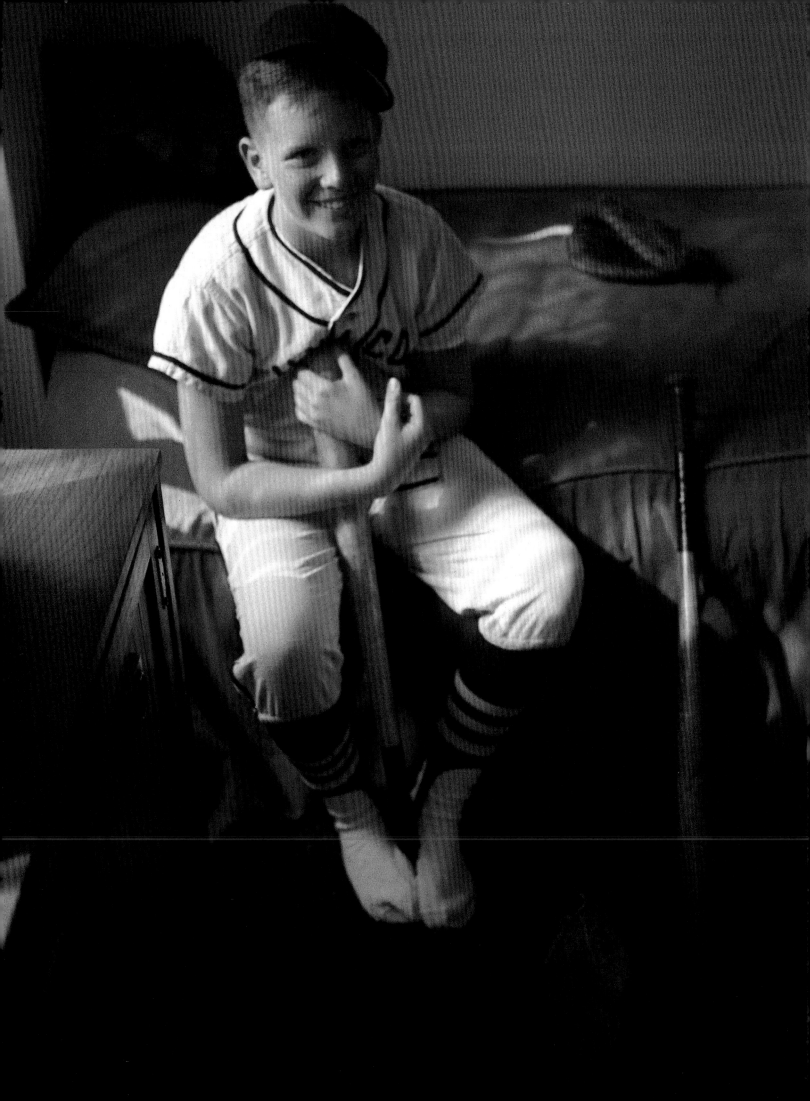

20
Little League
baseball player.
East Orange, New
Jersey, June 1968

21
Young basketball
player. New York,
1971

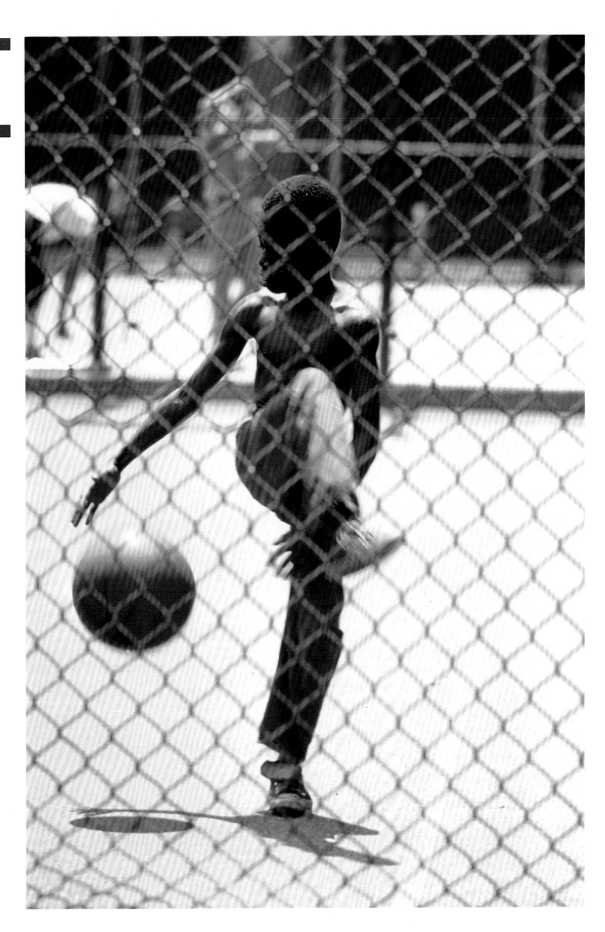

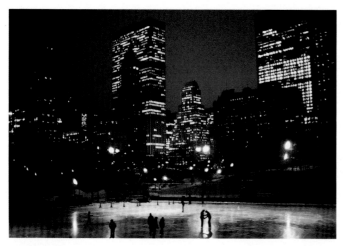

**Wollman Rink,
Central Park.
New York, 1974**

**Central Park.
New York, 1978**

"Every time it snows
in New York," Iooss
says, "I get dressed
up and walk outside
to take pictures.
Sometimes I stay
out for hours." This
is not just a matter
of aesthetics, ei-
ther. He is also
looking for next
year's Christmas
card. This shot of a
jogger in Central
Park came when
Iooss had been
tramping around in
a blizzard for more
than four hours.
Freezing, he was

about to head back
to his apartment
when the lone run-
ner suddenly mate-
rialized and then
ran under the
streetlights. "Too
often that's the way
it goes," Walter
says. "You work for-
ever, and then, all
of a sudden, it
comes together
once. Just for that
moment. And if you
miss it, it's never
there again."

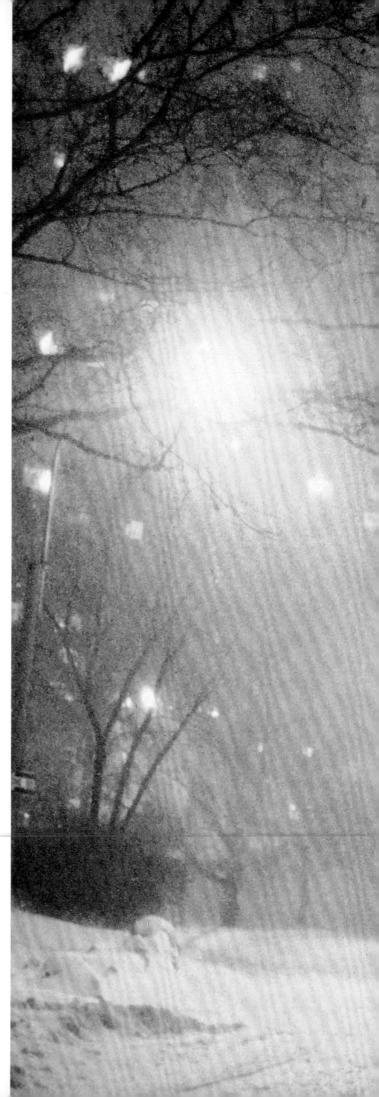

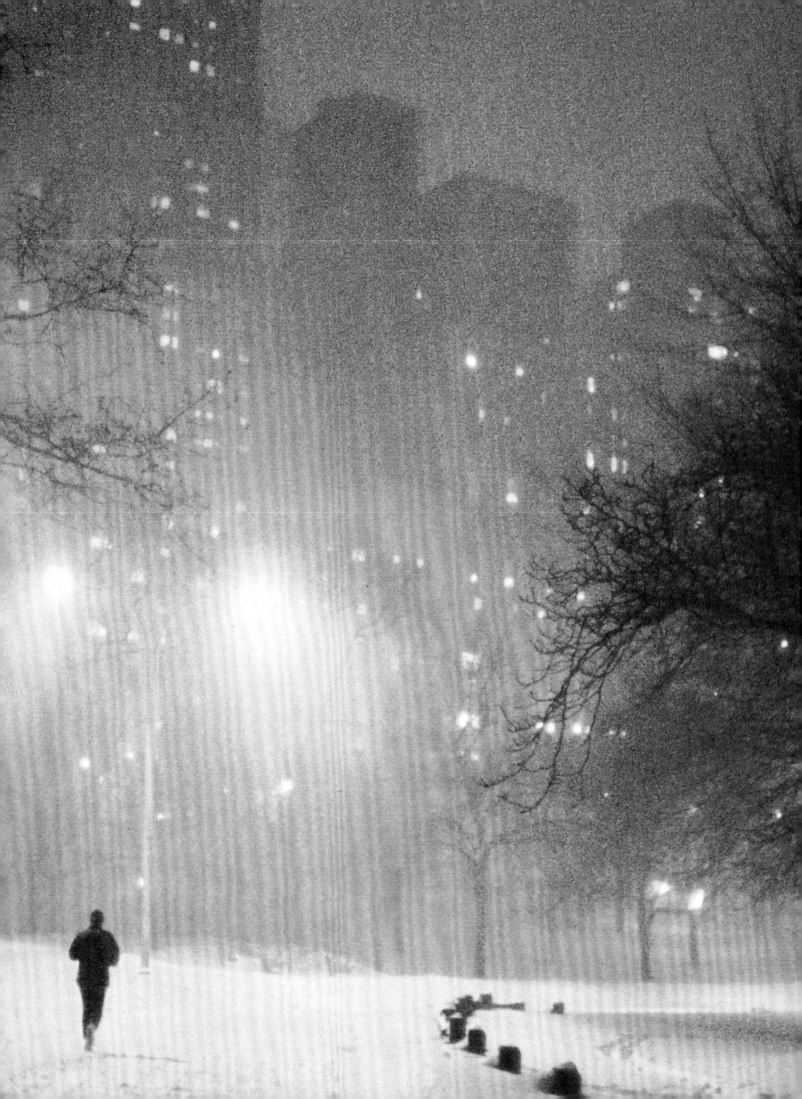

THREE
GREAT
RIVALRIES

There probably have been only five truly great sports rivalries of our times, and one of them—Affirmed versus Alydar—wasn't between people. The ones that were, were: Wilt versus Russell, Nicklaus and Palmer, Ali versus Frazier, and Chrissie and Martina. Iooss missed the horses and the boxers, but he photographed the other three.

The most momentous rivalries are not, either, merely a matter of competition. Beyond that there must be some distinct imagery, usually a perceived villain and hero, or a David and Goliath, or a young lion versus an old warrior. People speak nowadays of, say, Larry Bird and Magic Johnson being rivals, but although they possess many of the obvious characteristics—the country white versus the urban black, playing on the two most recognized teams in their sport—Bird and Johnson don't square off directly against one another. It's difficult under any circumstance to have an individual rivalry in the midst of a team sport. Fans loved to compare the two great contemporary center fielders Mickey Mantle and Willie Mays, but there was no sense of confrontation between them; neither was there with Hank Aaron and Mays despite the dozens of times they were in the lineups on the same field. Newspapers tried to make something of Sam Huff and Jimmy Brown, the tackler and the runner, but in the hurly-burly of the football scrimmage, too many uniforms and other factors obscure the private issue. Wilt and Russell were almost surely the purest rivals any team sport has ever known.

They were invariably called that way, the one by his first name and the other more conventionally. Martina and Chris, like most female tennis players, are both strictly first name; even *Ms.* magazine, although gagging on it, had to admit that it would be disingenuous to call Ms. Evert and Ms. Navratilova anything but Chris and Martina, because everybody else did, and so *Ms.* did too, throughout the article. But Wilt was always Wilt and Russell, Russell. That spoke volumes of how people saw them, just by itself.

Chamberlain's Christian name is, in fact, Wilton, and very early on, almost predictably, he became Wilt The Stilt. Even now, when he's in his fifties and retired from basketball for fifteen years, people see him and say, "There's The Stilt," and then call out to Wilt. And while other athletes may

be taller or heavier, Chamberlain remains the generic giant of our times, of the twentieth century.

He was already that when he arrived in the National Basketball Association in 1959, seven feet something, almost three hundred pounds of sculptured muscle. Because of his presence, from the first, Wilt *a)* was expected to win but *b)* nobody wanted him to, so *c)* when he didn't, he was dismissed as a congenital loser. He was so prepossessing that, as Iooss points out, "they kept changing the rules on Wilt."

When Chamberlain arrived in the NBA, Russell had already been there for two years. His first name was Bill, although his friends all called him Russ (just as Wilt, to his buddies, was never Wilt, but was Dippy or Dipper, from The Big Dipper). Although both men were black, at a time when blacks were relatively rare in basketball, and both men were true athletes at a time when most tall players were fairly dismissed as "goons," Russell's peculiar magnitude was not just in his physical size and his agility, but in the dynamics of height. He was six feet ten inches tall, about the size of men like Bird and Johnson, who today (incredibly) serve as playmakers, away from the basket. But Russell had invented defense—or, anyway, defined it anew—while Chamberlain had only followed along in the natural progression of other giants—notably Bob Kurland and George Mikan—who had been renowned for their offense. Chamberlain was bigger and stronger and more athletic than anyone else had ever been, but, altogether, he was still only state of the art. Russell was unique, original.

As a schoolboy in Oakland, skinny and a late bloomer, nobody knew Russell existed. Wilt was receiving national publicity by the time he was fifteen; he was everywhere recruited, finally choosing to leave Philadelphia and matriculate at the University of Kansas. Russell took the only offer he had, going across the bay to the University of San Francisco, a neighborhood Jesuit streetcar college with a modest basketball team that had to practice at the local high school for want of its own gymnasium. But by inventing defense, Russell took the Dons to two national championships, and then, inventing defense in the pros, he carried Boston to its first title, as soon as he returned, in mid-season, from victory in the Melbourne Olympics.

Russell's forte was the blocked shot. That was how he changed the game. Yet he had a genius for doing it rather quietly. Even when Chamberlain began to ape Russell and concentrate more on defense, he never could separate the art from the intimidation. Russell would tip a shot away, turning it into, effectively, the first pass on a fast break. Wilt would smash

the ball violently away. Russell, in fact, didn't even have to block many shots. It was enough for the opposing players to know that the deterrent was there, ever present, and they came to freeze or change the natural arc of their shots—in mere anticipation that Russell *might* loom up. Chamberlain was an army in full battle dress, while Russell was the secret police.

Notwithstanding that Russell had won two national college titles and Olympic and NBA championships, while Chamberlain had no titles, it was casually assumed that, as soon as he arrived in the NBA, Wilt would destroy Russell, the league, and basketball as we know it. In fact, he was soon averaging fifty points a game, but he could not beat Russell.

Or, as Wilt will have it to this day, his teams could not beat Russell's more superior teams.

It was seven years before Wilt and/or Wilt's team (the Philadelphia 76ers, in this instance) finally beat Russell and/or Russell's team for the championship. Of the decade that the two men squared off against each other, the Celtics won nine times. "But it wasn't just that Russell's team always beat Wilt's," says Tom Meschery, a sensitive Chamberlain teammate (with the San Francisco Warriors) who is now a high school English teacher. "More than that, it was that somewhere along the way, Russell became the intellectual, the sensitive man, more human, more humane. And Wilt wasn't supposed to be any of those things. Well, it was a bad rap. Wilt was every bit as good a person as Bill, and you could tell how much he was hurt by the way he was perceived."

Or, as Wilt's favorite coach, Alex Hannum, said it so softly at the time: "Nobody loves Goliath."

Russell was indisputably bright, and, as the civil-rights movement washed over the land, he became the darling of liberal sportswriters. Russell grew a beard—a first in twentieth-century American professional sport. He wore Nehru suits, chains, and capes, and he possessed the most engaging laugh, a cackle that balanced his dark countenance and his forceful intellect. By contrast, Wilt had a deep voice that all but resonated "fee-fi-fo-fum," and a little boy's stutter that in anybody else would have seemed charming; in him, it merely affirmed his critics' belief that he must be a blockhead. When Wilt grew a beard he was a copycat, yet when he became the rare black man this side of Sammy Davis, Jr., to come out for Richard Nixon, he was not celebrated for his independence but castigated as a sellout.

Russell won much acclaim for operating a restaurant that sought to attract a racially mixed clientele, and he invested in a rubber farm in Africa. Unfortunately, both ventures struggled, while Chamberlain became wealthy

from conventional investments in real estate and the stock market. He also became quite a sophisticated world traveler in the off-season. But this particular side of Chamberlain was dismissed.

Russell cast his own role perfectly. After all, he was six feet ten, but playing himself off against Wilt, he became the little guy. The Celtics won every year, but Russell regularly convinced the world that they were the underdogs. He also befriended Wilt, soothing the monster—then distressing Chamberlain with brutal public criticism when Russell retired in 1969. "Friends had told me that Bill had been conning me," Chamberlain says now, "and I didn't want to believe them. You want to believe that somebody likes you for yourself. But now, I'm afraid that they were more right than I was."

Unlike most controversial figures, Chamberlain's image was never really modified. He changed teams, but was always more of a road attraction, because then fans could come out to root against him. The more he scored, the more he appeared to be a bully, so he concentrated on rebounds instead—and then on assists—but whatever he accomplished he never became a love object. Wilt was a dreadful free-throw shooter (although he had been more than adequate at that as a younger man) and I always assumed that this was some part of him crying out to the fans that he too was flawed. But that failure was never seen as some Achilles' heel that made him human, too, just like the rest of us. No, it was only more proof that he was a blustering brute who could do nothing requiring the more subtle, sensitive skills.

Russell, by comparison, only seemed to be tolerated more with age. He looked old to start with and grew into his face. Those who had once considered him radical and extreme came to accept him more as a man wise before his time. He left the game as a respected senior citizen, the first black coach in major-league sport.

To the day he quit basketball, Wilt maintained that the happiest he had been was the one year he left Kansas and traveled with the Harlem Globetrotters. Then he could just joke around. In college and the NBA, it wasn't any fun because he was always supposed to win, and if he didn't he was a loser, and if he did, so what?

It was only when Chamberlain got out of basketball that he began to have more happy years. He remains a loner, never able to marry, "to commit to one soul," but he travels the world, plays games, chases women, and makes lots of money, still, from advertising agencies that employ him because they want to make some statement about size. Wilt climbs in and out of Volkswagens and stuff like that.

By contrast, even at the height of Russell's powers, when he trumped Chamberlain on the court every year, even then Russell would be hailed as "Wilt" and asked for his autograph. I think that sort of thing hurt him, even offended his strong sense of justice. Russell was a very orderly person, an ideal team man. One time we spent a few days together working on a story, and, near the end, when our car stopped at a red light, he turned to me and said: "I think we could be very good friends, I'd really like to be your friend, but I don't think either one of us has the time to do it properly." I was very touched, but, also, I was impressed by all the thought that went into his evaluation of our situation.

Wilt was not a little man trapped in a large body, nothing like that. No, he was an individual athlete trapped in a team game. What Chamberlain enjoyed most about athletics was track and field—and, especially, putting the shot, an ugly, lonely exercise. If he hadn't grown so tall, that would have been his destiny, but instead, he became The Stilt, and with it, a basketball player.

Russell, on the other hand, was a team player who just happened to be a tall person. Probably he leaned naturally toward defense because he developed late and he never was taught that he was supposed to dominate, score. But Wilt. Even when he excelled in teamlike things, rebounds and assists, he continued to think of these achievements in individual terms, in statistics, and that ultimately tilted the count toward Russell.

"Wilt was totally misunderstood," says Iooss, who studied him for so long from up close, under the basket—and I too have come to agree with that assessment since Chamberlain left the game and found his peace. But still, no one ever appreciated the tangled relationship of the player-within-the-team so well as Russell. Wilt would have won everything—even if it was a free-throw shooting contest—if it was just one-on-one. But the game wasn't played that way. He wasn't a loser, though. He was just a great athlete who happened to be seven feet something tall, and, because of that, he was lost in the wrong game.

The fear fans had with Chamberlain was that he was so big and strong he would "destroy" the game. Thus, while Russell was not intrinsically a popular figure, he became one as the protector of the game. In his sport, Jack Nicklaus presented a different concern than had Chamberlain. There was nothing about Nicklaus to dislike or be suspicious of. No; in fact, he was a fairly bright, white, middle-class pharmacist's son from Ohio—exactly the sort of Buckeye-American who used to grow up and (so prototypical were they) be selected in a smoke-filled room to become president of the

United States of America. All the more, unlike Chamberlain, who was physically startling, Nicklaus was blond and chubby, red faced, precisely the fellow another Columbus native and good old Ohio State alumnus, James Thurber, would have invented if he hadn't already conjured up Walter Mitty.

And everybody loved Walter Mitty.

And everybody hated Jack Nicklaus.

Unfortunately for Fat Jack, although he was no threat to obliterate golf, he assaulted much more hallowed territory, for at once he challenged the sainted Bobby Jones as the greatest player ever and the popular Arnold Palmer as the reigning champion (and people's choice). And here comes this blubberous blond kid with rumpled clothes and a squeaky voice to outdo them both. Jones's own gracious remark, "Jack Nicklaus plays a game with which I am not familiar," only served to make the newcomer even more menacing.

Palmer was very special to golf. Before he came on the scene, the game was losing favor, generally being dismissed as an exercise for old, country-club people. While President Eisenhower's devotion to the sport traded on his popularity, it is also a fact that he was also an old, country-club person. And then Palmer burst into view, and he was not at all like what golfers were supposed to be. He gave the game a romantic new dashing image. Palmer took chances, and when the risks caught up with him it didn't matter that much because it had been fun for everybody, win or lose. What is referred to by the very polite, almost archaic, term *gallery* became, for him, "Arnie's Army" (as in Walter's picture at the 1967 U.S. Open, which was, of course, won by Nicklaus).

As a consequence, for most people, Palmer and golf became synonymous, and when Nicklaus appeared, beating Arnie seemed very much like beating the game itself. There is a further irony in this, too, because Nicklaus has proved, with time, to be more consonant with the sport. What made Palmer so bloody attractive was that he thrived on the accoutrements, on the crowds and the drama, the moment. In a real sense, he was so popular because he made golf like something else—football or Las Vegas or whatever. Palmer may have been identified with Eisenhower as a golfer, but he was more truly a Kennedyesque figure.

Nicklaus neither had nor desired any flourishes. "Golf is as clean a sport as there is," he told me once—and although I think many would agree with that assessment, I doubt if the thought ever crossed Palmer's mind. Nicklaus was mortified when Walter took a photograph of him with wild sunglasses, a cigarette dangling from his lips, in Florida in 1967, when

he let down his guard for a moment at a formal portrait session. It was part of Palmer to draw on a cigarette, then flip it away insouciantly before putting, to retrieve it for another drag as soon as he holed out. For years, Nicklaus would go through periods when he was a chain smoker, but on the course, he was able to control himself, and he would never light up where it was clean.

A quarter century after his last major title, Palmer is still called upon to take part in major advertising campaigns, doing commercials for everyday products that have nothing to do with golf. He is still the performer. Nicklaus, after having conquered all the courses, began to design them. Walter's portraits here of the two men are correct: Palmer, in the midst of a crowd; Nicklaus, alone in a clubhouse.

Just after Jack's forty-sixth birthday, I talked to him on a putting green in Florida. It was the winter of 1986. I was interviewing him about other matters, but, deferentially, I inquired about how his game was holding up. He was struggling in this particular tournament, and he told me that this and that were off and needed a little work, but if he could find some time to get away from his various ventures to concentrate, then he certainly could be competitive with anybody in a big tournament. I came back and told people that poor old Nicklaus was so deluded he actually thought he could win another major title. What a hoot.

The next major, a few weeks later, was the Masters. He won it.

It was, of course, an extremely popular victory. With enough years, as a sport like golf does give a contender, Nicklaus's sheer excellence, coupled with his gentlemanly behavior and his handsome new svelte body, eventually won the fans over. What mattered as much, though, was that Palmer got old and faded away and became a grand old man, so that it no longer appeared as if Nicklaus was squaring off against Palmer . . . against golf.

As Nicklaus discovered so early on, the hardest thing to be appreciated for in sport is sheer unadulterated excellence. It is all the worse if you display that at a young age. That's why Nicklaus and Chris Evert share so much in common.

Nicklaus was a prodigy. He was twenty-two when he won his first major professional title, the U.S. Open; in some sports that is dotage, but in golf it's infancy. Since that time, 1962, there has been a succession of younger and younger champions in most individual sports. Consider just a few of them: Muhammad Ali and Mike Tyson; Steve Cauthen; virtually all of the swimmers and most of the skaters; gymnasts Olga Korbut, Nadia Comaneci,

and Mary Lou Retton; Chris Evert, Tracy Austin, and Steffi Graf; Boris Becker. Although not quite so pronounced, the trend toward precocity in team sports has also been evident. As child labor has gone out of everything else, it has expanded in sport.

As fans, we have not adapted well to this reality. We might still have a soft spot for little girls, like the gymnasts, but mostly that's only because they're competing against other little girls. Generally, though, we are put off by the kids, wet behind the ears, who beat the established champions. We call them robots or automatons and merely assume that their coaches (or their fathers or their father-coaches) are either Machiavellian or are living vicariously through their children. Teenagers who succeed in a sport may be geniuses, no less than Mozart, but we are more inclined to believe that they are blasphemers, mocking their sport, for if a game is so easy that a teenager can master it, then the sport mustn't amount to much, must it?

As much as anyone, Christine Marie Evert Mill first scraped this nerve. When she burst on the scene at the U.S. Open in 1971 she was a sweet sixteen; she was a novelty and the public smiled down on the little darling. But quickly they frowned on her. Her grooved-in baseline game, which demanded discipline and consistency, was dismissed as boring and vacuous. Chrissie was labeled The Ice Lolly by the British, and variations of that moved into other idioms. Against either Billie Jean King, her older rival, who played an aggressive, Arnold Palmer–style game, or her exotic and unpredictable contemporary Evonne Goolagong, Chrissie was thin soup.

No matter how intense rivalries may be in sport, they belong strictly to the fans. Indeed, when we cite great rivalries between teams—be it Auburn–Alabama, Harvard–Yale, Steelers–Browns, Lakers–Celtics—the only thing that matters, that is constant, is the audience. The uniforms are merely filled for the amusement of the spectators by different players. Similarly, with individual sports, the two competitors must play distinct roles. A competition may be close, but a rivalry must be dramatic. Thus, when Goolagong started having babies and fading into the background and Billie Jean was tarred by a scandalous lawsuit, and when Martina Navratilova began to loom as a new challenger, then Chrissie emerged in an entirely different light. She switched over and became the heroine, while Martina took Chris's place as the heavy.

Navratilova was a different sort of villain, to be sure. Fans had to see Chrissie to decide they didn't like her. They could reach that judgment about Martina merely by reading the resumé: she came from a Communist country; she was chubby and powerful (like the young Nicklaus, only more

so, because her fleshiness meant she was unfeminine too); she admitted to bisexuality, and her female lovers were well known. Most fans decided, subconsciously, that Martina was an Amazon, Chrissie a little porcelain doll. In fact, Martina stands about five feet seven-and-a-half inches, perhaps an inch or so taller and only one dress size larger than Chris. Also, the two young women grew very fond of each other.

But the Commie–lesbian–foreign invader was threatening America's little princess, and, overnight, Chrissie's image changed. What had been boring was now reliable; what had been juvenile was now Miss America. Incredibly, although Martina was supposed to be the mannish one, Chrissie took a page from the book of male athletes and her popularity soared with it. As Walter's picture of Mr. and Mrs. John Lloyd shows, Chrissie had, like most all-American guys, married a real beauty. When her marriage began to crumble, she was caught in a gallivanting affair with a rock promoter, but this only served to make her more popular because it proved somehow that she really had grown up and was more attractive as a *real* woman.

Laughing, Chrissie told me this story on herself once, that when she was working out in a gymnasium in Los Angeles a couple of years ago, she ran into John McEnroe. He shook his head at her and said: "I don't see how you do it."

"Do what?" Chrissie asked.

"You play around and everything and they still don't get mad at you. They get mad at me just for saying things."

Even allowing for McEnroe's comic hyperbole, the point was well made. As the white hat in a rivalry, Chrissie's place was fixed.

The Navratilova–Evert rivalry has been so special, though, that eventually it began to lift up both players. The whole was so large that both its parts were bound to increase. They have played more than seventy-five tournament matches now, extending over fourteen years—and for most of the last years almost all of the confrontations were finals. The process has formed a symbiotic unity, symbolized by the fact that when Martina finally tied Chris (at thirty matches apiece), she graciously observed that it would only be right for them to stop playing at that moment so that neither of them would ever end up with an edge. In fact, the younger Martina has moved out in front by several matches now, and Chrissie can almost surely never make up the extra losses. More important, though, somehow she has bequeathed her positive image to Martina, for now that Chrissie has slipped from championship status, the capricious fans have, at last, begun to cheer for Martina as she sallies forth against the young challenger Steffi Graf.

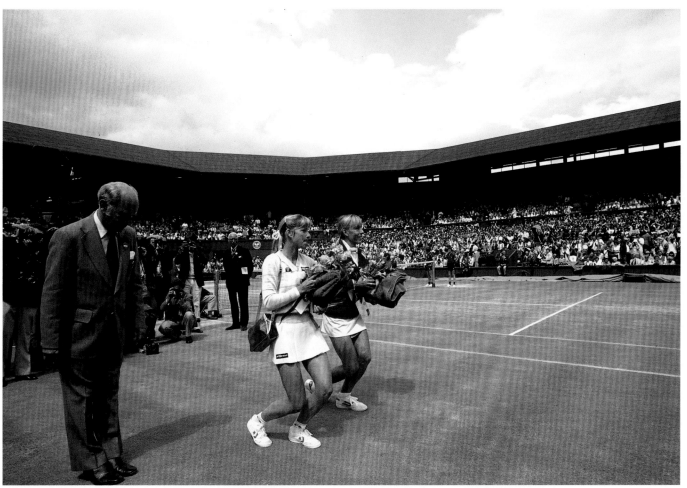

Chris Evert (left)
and Martina
Navratilova after
the women's singles
final, won by

Navratilova, at The
Championships,
more commonly
referred to as Wim-
bledon. The All

England Lawn
Tennis & Croquet
Club, Wimbledon,
England, July 1982

**Mr. and Mrs.
John Lloyd. Amelia
Island, Florida,
April 1981**

**Martina Navratilova
after defeating
Chris Evert to win
the women's singles
final at Wimbledon.
July 7, 1978**

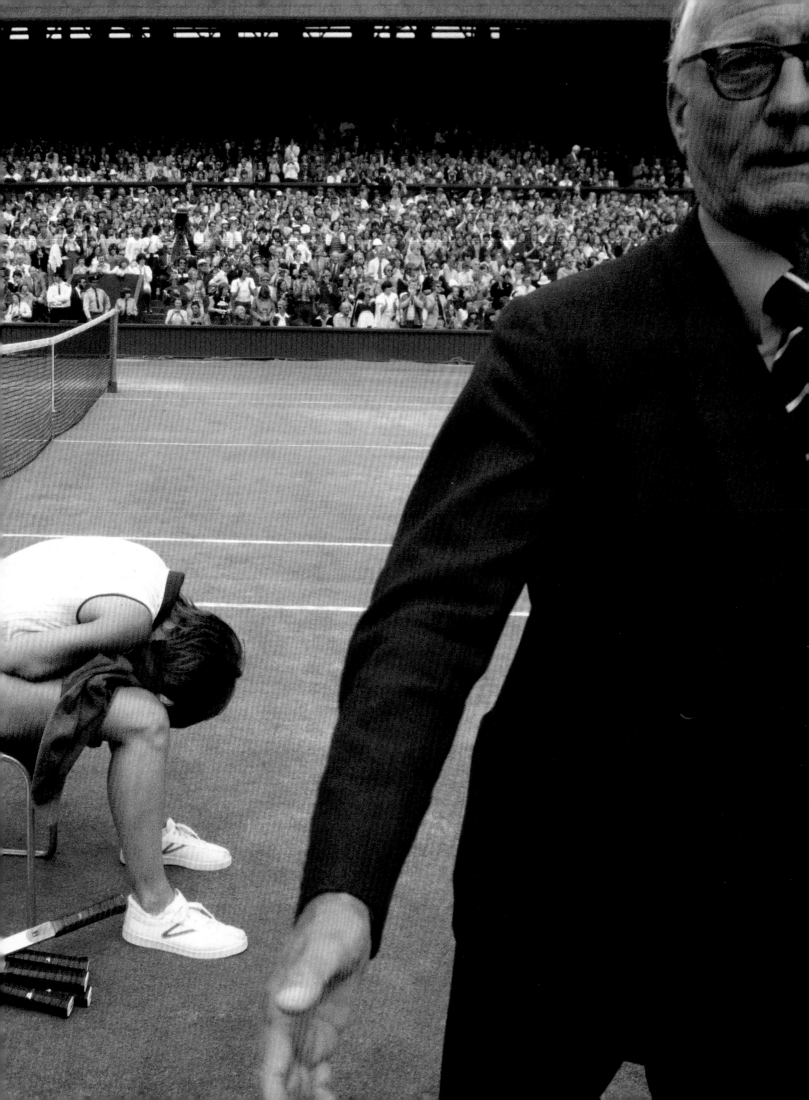

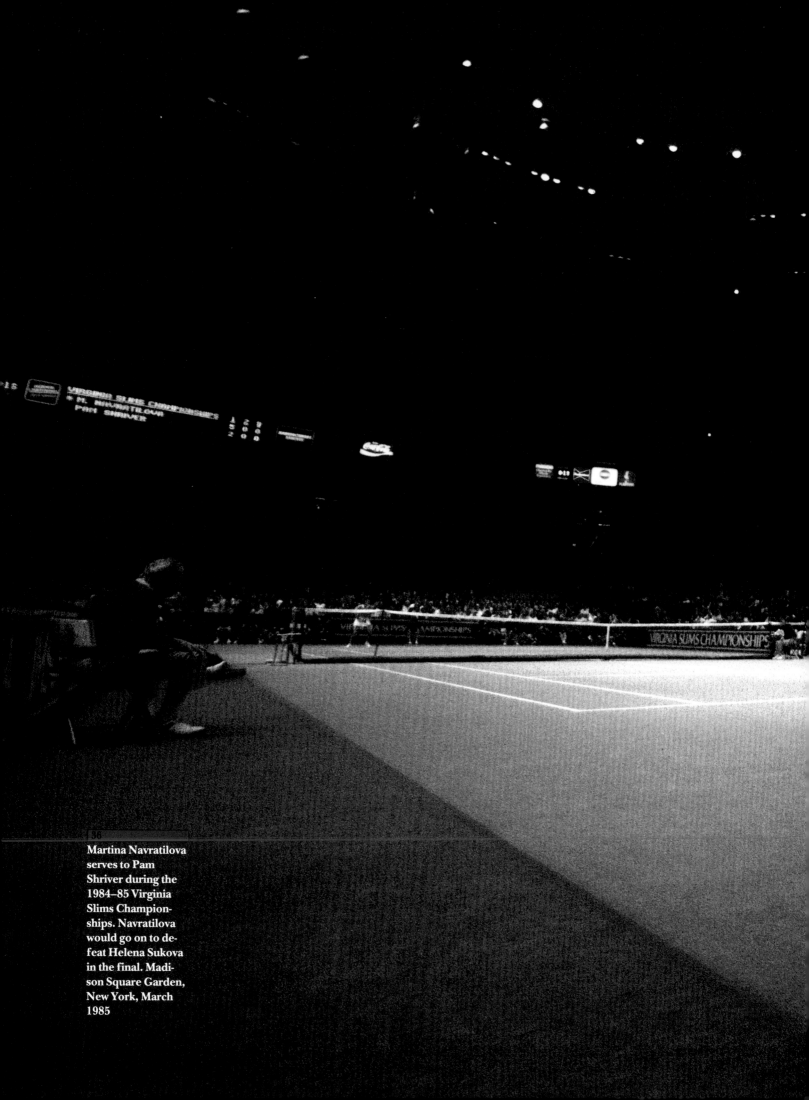

Martina Navratilova
serves to Pam
Shriver during the
1984–85 Virginia
Slims Champion-
ships. Navratilova
would go on to de-
feat Helena Sukova
in the final. Madi-
son Square Garden,
New York, March
1985

VIRGINIA SLIMS CHAMPIONSHIPS

Philadelphia, Pennsylvania, April 1968

Russell (left) and Wilt (then with the Philadelphia 76ers) chat before a game during the 1968 Eastern Conference playoffs. The 76ers were up three games to one, plus they had the advantage of playing two of the last three games at home, but they lost all three, and the Celtics went on to upset the Lakers, too. This gave Russell, in his second year of coaching, his first coach's championship.

In the seventh game of the Philadelphia–Boston series Chamberlain didn't try a single shot against Russell

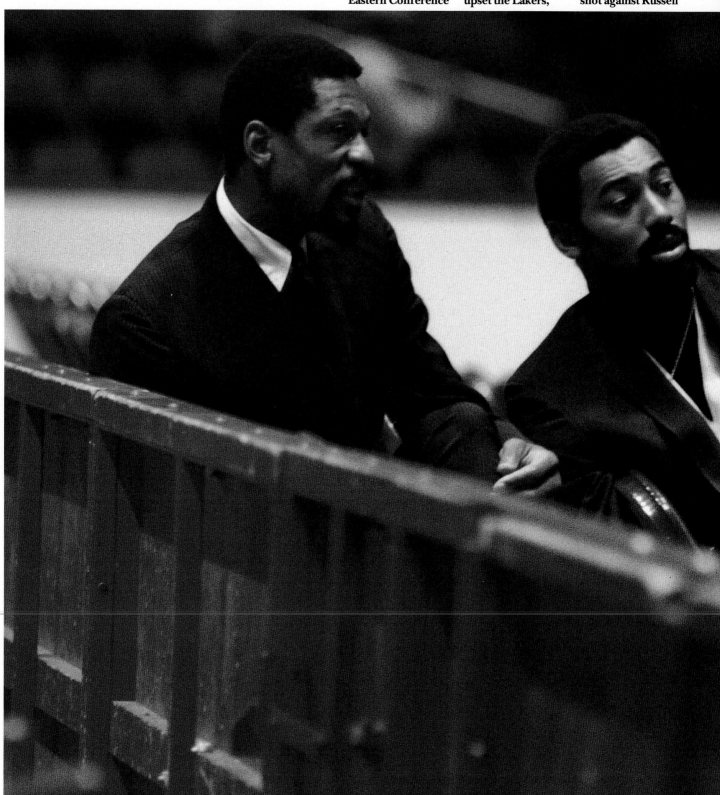

in the last half, and Boston won 100–96 because the rest of the 'Sixers couldn't hit. To this day Wilt maintains that he'd been successful all year passing out to the great shooters, so why should he change? I think the critics were absolutely right in lambasting Chamberlain this time. He should have adjusted when his teammates started missing. Within weeks, the Philadelphia coach had quit and Wilt had been traded back across the country, to Los Angeles. Russell and the Celtics beat Wilt and the Lakers in 1969, and then Russell quit.

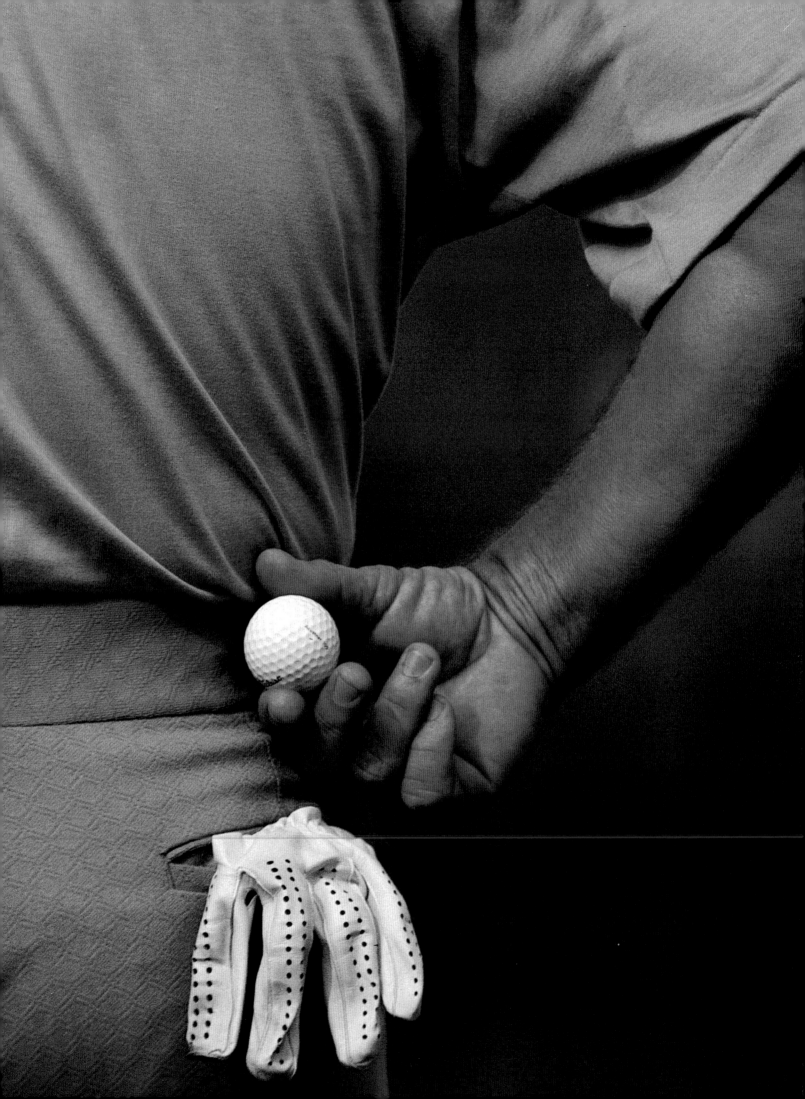

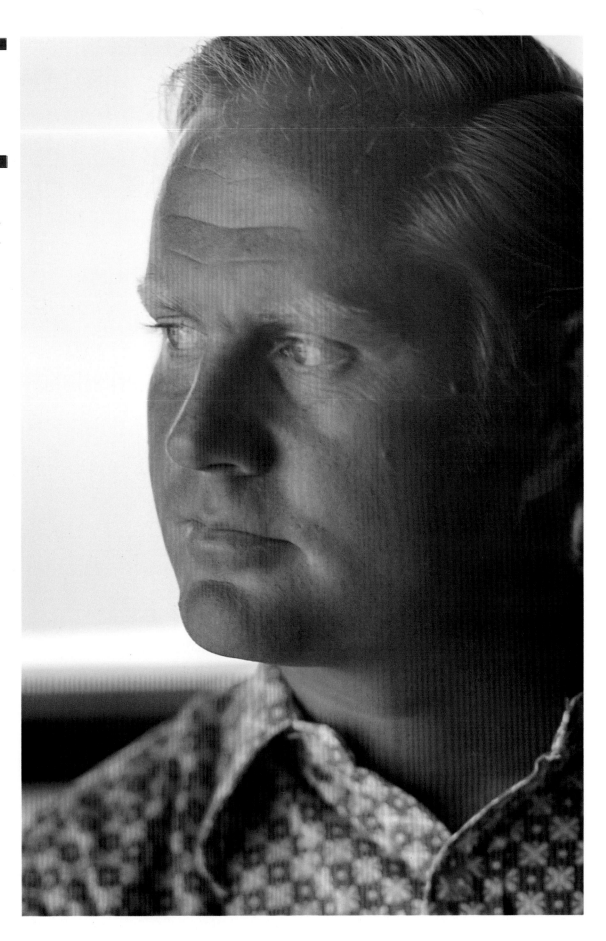

Arnold Palmer, 1973 U.S. Open. Oakmont Country Club, Oakmont, Pennsylvania, June 1973

Jack Nicklaus before the 1970 U.S. Open. Hazeltine Golf Club, Chaska, Minnesota, April 1970

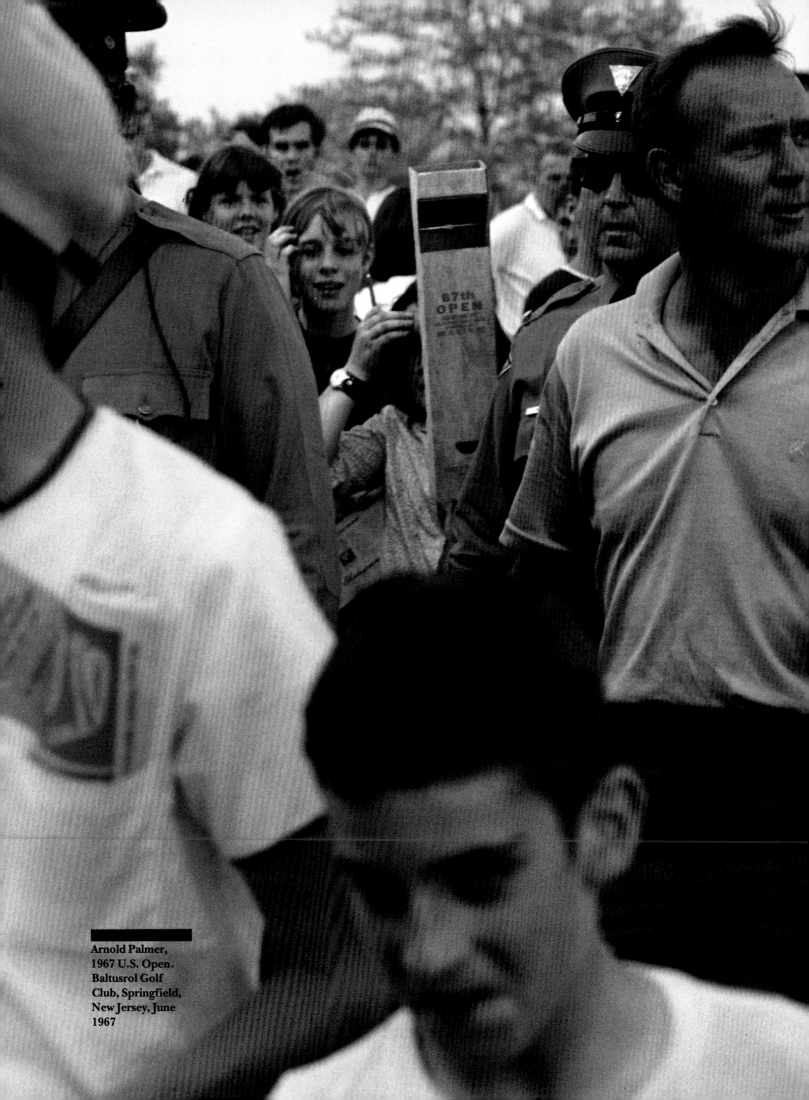

Arnold Palmer,
1967 U.S. Open.
Baltusrol Golf
Club, Springfield,
New Jersey, June
1967

THE
INTERNATIONAL
SCENE

Unlike nearly all other countries in the world, the United States has never paid much attention to international sports competition. We are much more devoted to our *city* team—or our college or high school or our son's Little League team—than to whether or not Uncle Sam can beat Belgium in something or other.

Part of this is that Sinclair Lewis lives still in sports more than he does anywhere else. The business of Main Street may have moved to the mall (better able there to dispense products from Japan), but the boosterism has shifted, whole, to the arena. Everybody wants his city to be praised as "a great sports town" even though usually that is euphemistic for meaning that the city is indiscriminate in taste, an easy mark, a sucker. This is because "a great sports town" invariably means that the people will go out and "support" the local teams, whether or not that product is any good.

In any event, whereas it's a matter of pride that each and every American hail from "a great sports town," the United States is simply too big for us to get fervid about being a great sports nation. We certainly should beat Belgium in everything, and so if we do, who cares? And, if we

don't, it's just some dumb foreign sport that doesn't really matter anyhow. But, hey, how did the Indians do against the Sox?

This attitude probably doesn't have much to do with ideology, either. Fans in the Soviet Union are, by now, pretty blasé when their country beats up on Belgium in something. Both Soviet and American fans get most excited when the tables are turned and their national teams are the underdogs. When America won the gold medal at the 1980 Winter Olympics in ice hockey, beating the Soviets in the semis, we went absolutely bonkers, even though most Americans have never even seen a hockey game and almost all the rest of us don't know high-checking from the blue line. The great victory had absolutely no impact on hockey's future, either. There was no carry-forward effect. No. It was just that, for once, we were the little fellow, the underdog. And that was an entirely different feeling. In fact, that was the one occasion when America was a great sports town.

The Soviets were the same way when they beat us in basketball at the 1972 Olympics. Beat the Americans in basketball! Beat them at their own game!

Of course, as every good American knows, the referees gypped us. Otherwise how could we lose? Right?

(And the referees did gyp us, too.)

(Of course, we also had a coach who botched up the team.)

In any event, the professional advantage that we gain from our relative lack of interest in world sport is that a photographer like Walter Iooss has so much more access to his subjects and his scenes. Unfortunately, this too is changing, as more and more photographers—and writers—are assigned to cover international events. The two things that can destroy a free press are a) no journalists and b) too many journalists. At the Olympics, for example, there are so many reporters accredited that, effectively, the organizers can argue that none could be granted reasonable access. So none are, and the athletes are insulated more than ever.

The same sort of thing happens with political conventions, presidential campaigns, and summit meetings. Once you have hordes of journalists they all must be kept at arm's length. Casualties in this process are the likes of perspective, originality, and, even, truth. Nobody ever caught Gary Hart trysting in the same hotel that was overflowing with journalists. And everybody understands this now: the way to control the press, in politics, sports, war, or whatever, is simply to hand out more credentials and more meal tickets. More is less.

As a consequence of this proliferation of journalists, it will become more and more difficult for instinctive photographers like Iooss to get the

sort of intimate and revealing pictures that appear in this section of the book. For example, truth (and a reverence for the ironic) obliges us to acknowledge that the picture of the arms arrayed down at the start of a sprint was staged. In fact, the photograph is exactly like the start of a real race, but sentinels of the Olympic ideal will allow no photographer access to the proper place where he could make such a shot. It would *a)* possibly get in the way of the television people, who have paid good rights money, and *b)* then every photographer would demand the same exemption. So, after trying unsuccessfully for years, Iooss was forced to pose the picture.

On the one hand, it's impossible not to admit that there's a certain amount of deceit involved in that. If I hadn't told you, you wouldn't have had the foggiest idea that it was posed, would you? But, on the other hand, thank God we can see this vision of reality—even if the bureaucrats forced Walter to re-create reality in order to show it to us. (This is, I think, the benign side of the explanation that the village had to be destroyed in order for it to be saved.)

Or perhaps, in a way, we have come full circle. Once, most of our impressions of events were formed by diaries that principals to the action wrote—and, even if subconsciously, prejudicially distorted. Now, the only way to depict the truth accurately is to construct it again after the fact with an instrument, as the diary writer did in his mind.

The picture of the sinister-looking fellow with the pistol illustrates all of this. His name is Erich Buljung, and he was on the U.S. pistol team at the Pan-American Games, which were held in Caracas in 1983. Despite the menacing countenance, Iooss found Buljung to be "a sweet guy," who cooperated magnificently in having his portrait shot. Almost certainly it never could have been a basketball player or sprinter or anybody with an endorsement contract in a popular sport, because they would have considered posing free for some photographer an absolute waste of time. But Buljung was delighted that some hotshot photographer like Walter Iooss actually wanted to take his picture, and he willingly posed for a long time.

When Iooss got set up, he took a Polaroid in order to check things out, as photographers do nowadays. Walter was wonderfully pleased, for the expression on Buljung's face was much like the one you see captured here. But when Iooss got back to New York and developed the film, there was not a single frame that managed to duplicate the expression on the Polaroid. Buljung's mouth was never quite the same.

So Iooss got back in contact with Buljung, met him at Fort Benning, Georgia, and had him pose again. Not only did Buljung agree, quite

willingly, to pose again, but he helped paint the wall behind him the same orange shade it had been in Caracas. And this time, after everything was perfectly re-created from the other continent, Iooss caught the original serendipitous, straight-mouthed expression just right.

People like Buljung, who participate in sports that don't attract much publicity, are often delighted to receive the attentions of a photographer. Says Iooss: "If you don't bother them, or, at least, if you explain what you're looking for, why you have to bother them—do that, then they're usually fine with you. Sometimes, then, I even get the feeling that they want you caring about them."

The picture of the boxer in the shadows by the door was also shot in Caracas. At least until recently, the Pan-American Games received much less attention than the Olympics or any major professional fight. Iooss had always wanted to get this sort of picture because "I'd seen it in the movies so many times," but he could never enjoy the access necessary to shoot someone like Sugar Ray Leonard or Larry Holmes or Mike Tyson. He had to settle for a nobody. So, in effect, the unknown boxer here—who was not posed—serves as a stand-in for the famous boxer Iooss could not shoot, doing what the photographer knew existed from having seen it in films of fictional fights. Life chases art's tail.

Generally, the more famous the personality, the harder to capture him because of the roadblocks set up around him by officious intermediaries. When Reggie Jackson was in his heyday with the Yankees, Iooss tried to shoot a photo essay of him. It shouldn't have been difficult; Jackson is hardly a shrinking violet where cameras are involved. And Iooss is a master at becoming a friend of his subject, building trust and confidence in the athlete. But the bozos who work for George Steinbrenner were naturally suspicious of anybody or anything new. (I shall never forget a public relations man for the New York Knicks proudly telling me he had refused to give credentials to *The London Times* to cover a game because: "How many - - - - - - - tickets can I sell in England?") And so, essentially, each day that Iooss showed up, more restrictions had been thrown in his path. By the last day, before Walter finally gave up the ghost, Yankee functionaries were running out, attempting to bar Iooss from shooting Jackson *outside* the stadium, *in the parking lot.*

You will take notice that there are no photographs of Reggie Jackson in this book.

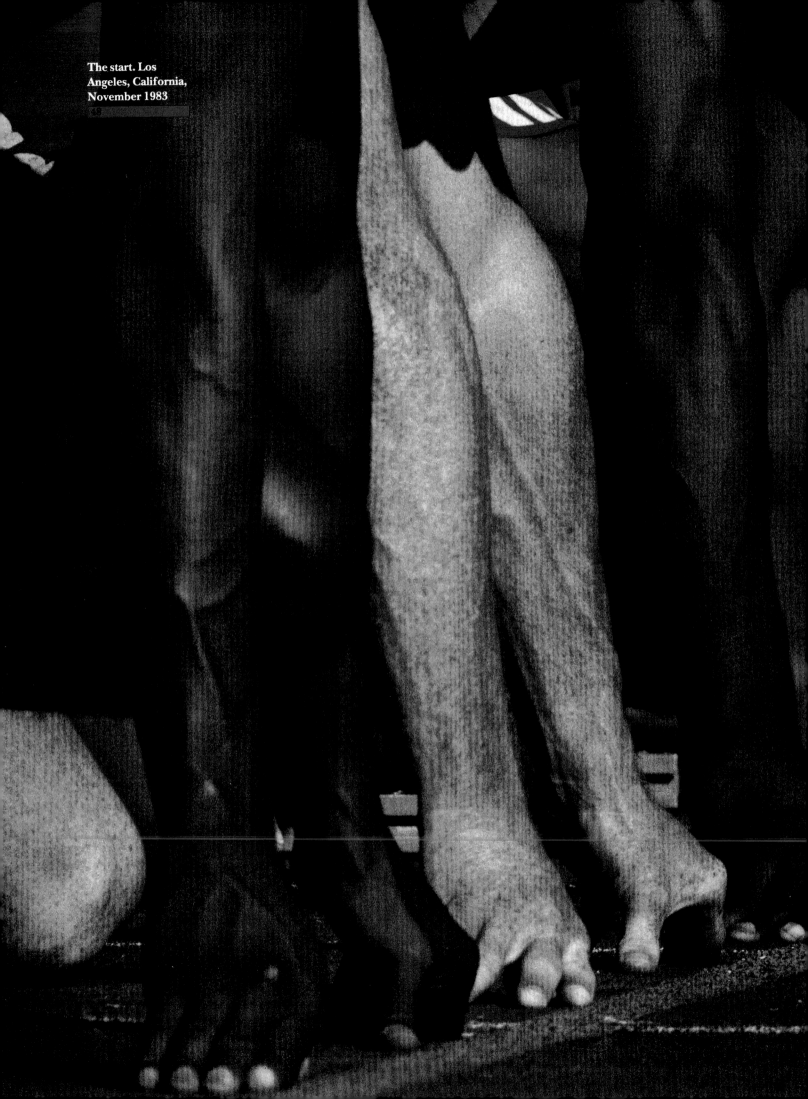

The start. Los
Angeles, California,
November 1983

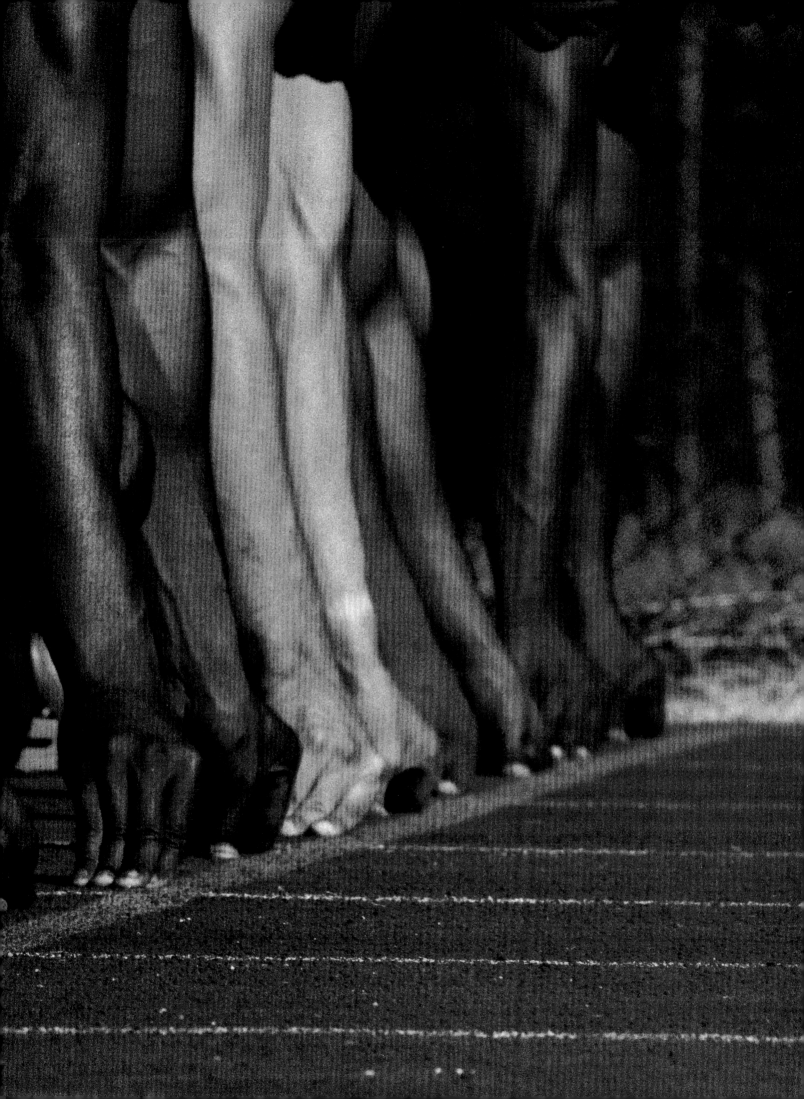

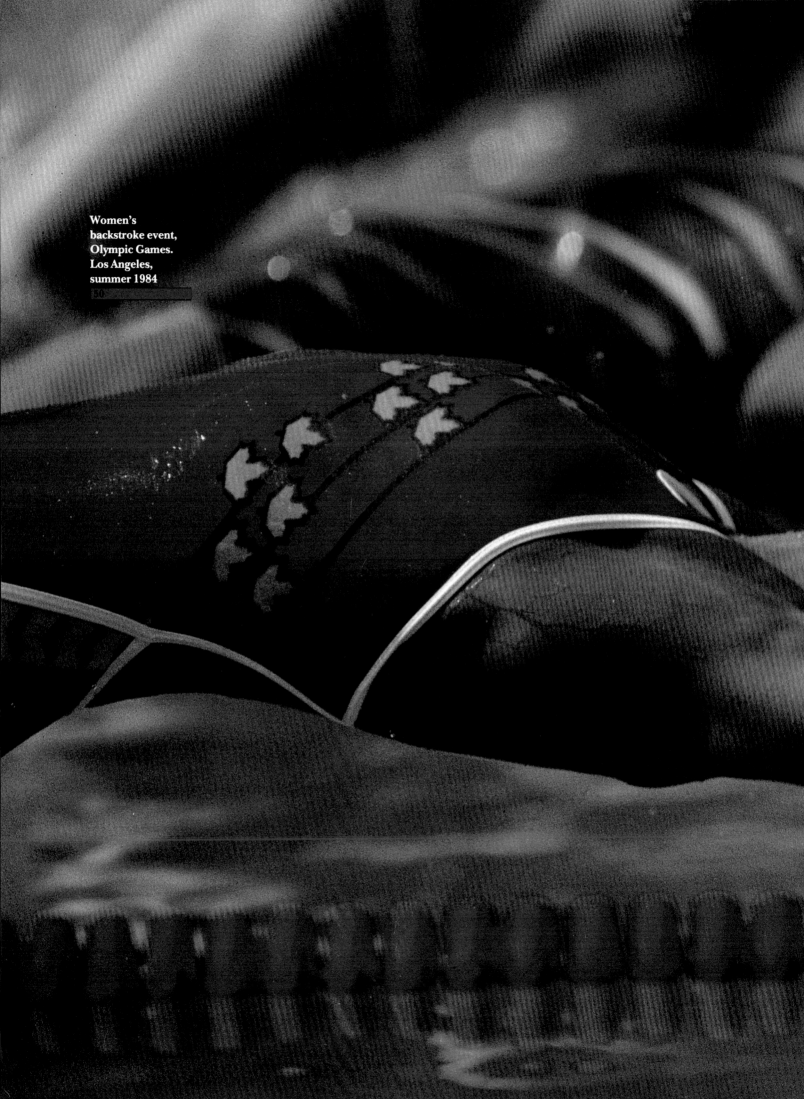

Women's
backstroke event,
Olympic Games.
Los Angeles,
summer 1984

50

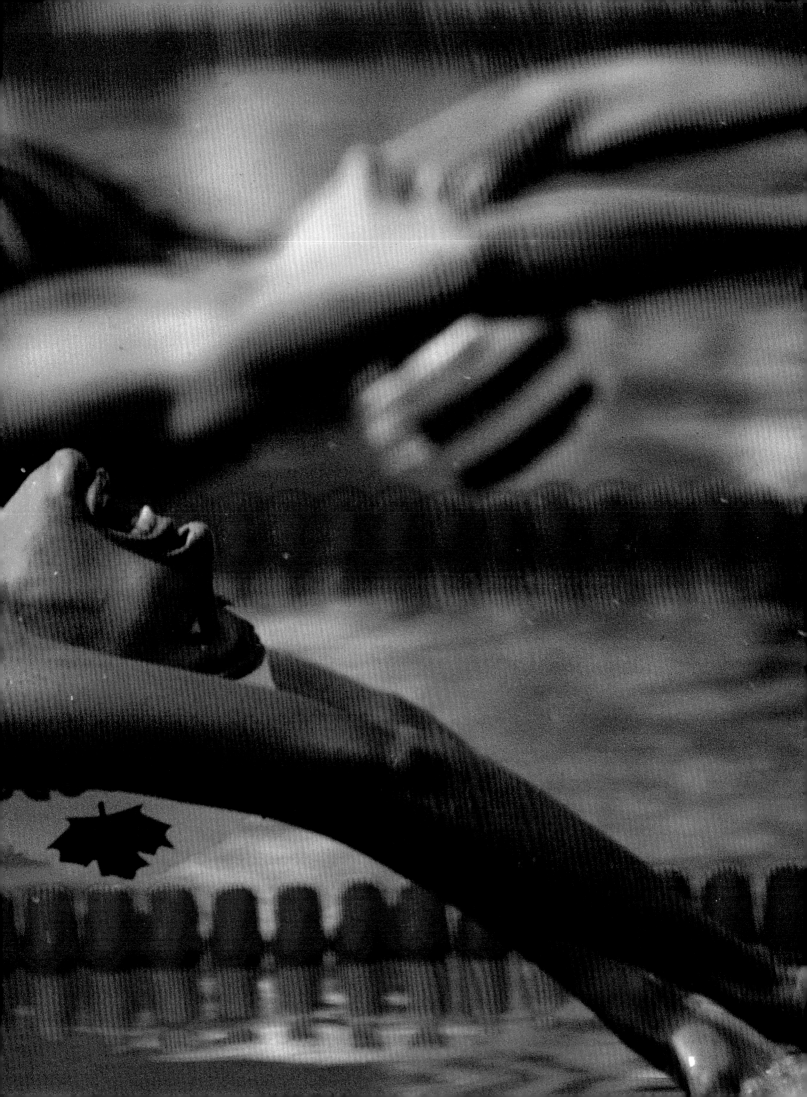

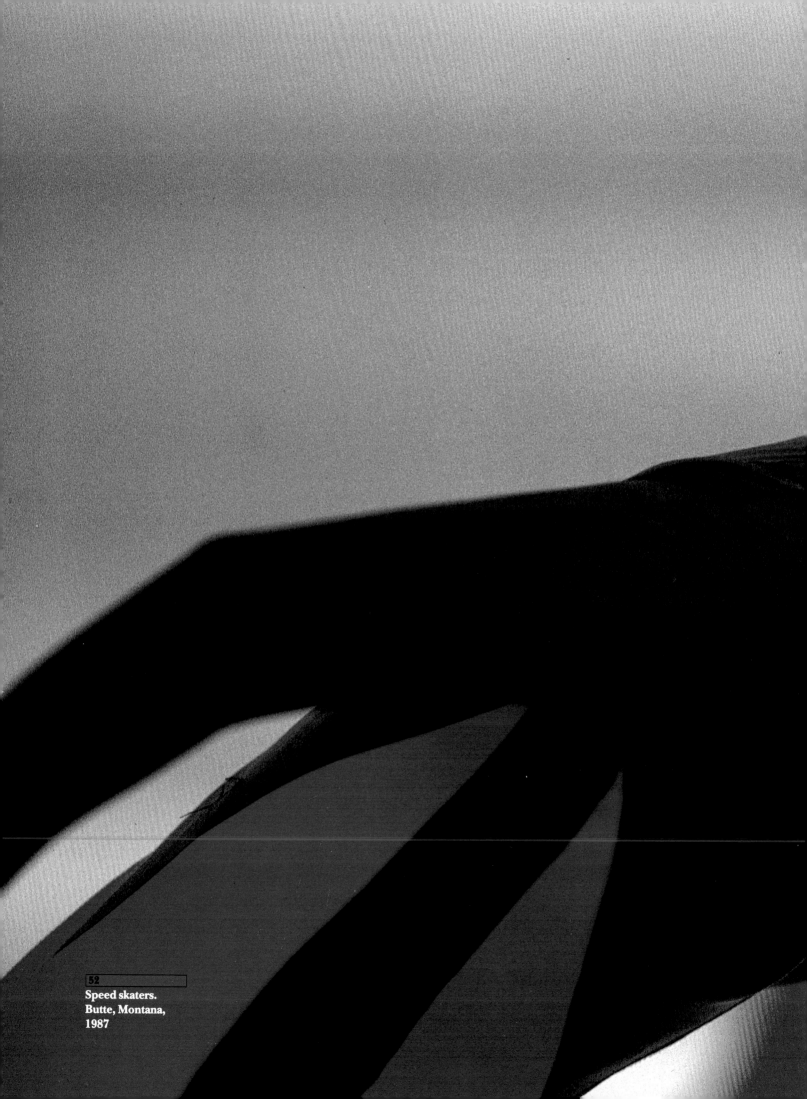

52

**Speed skaters.
Butte, Montana,
1987**

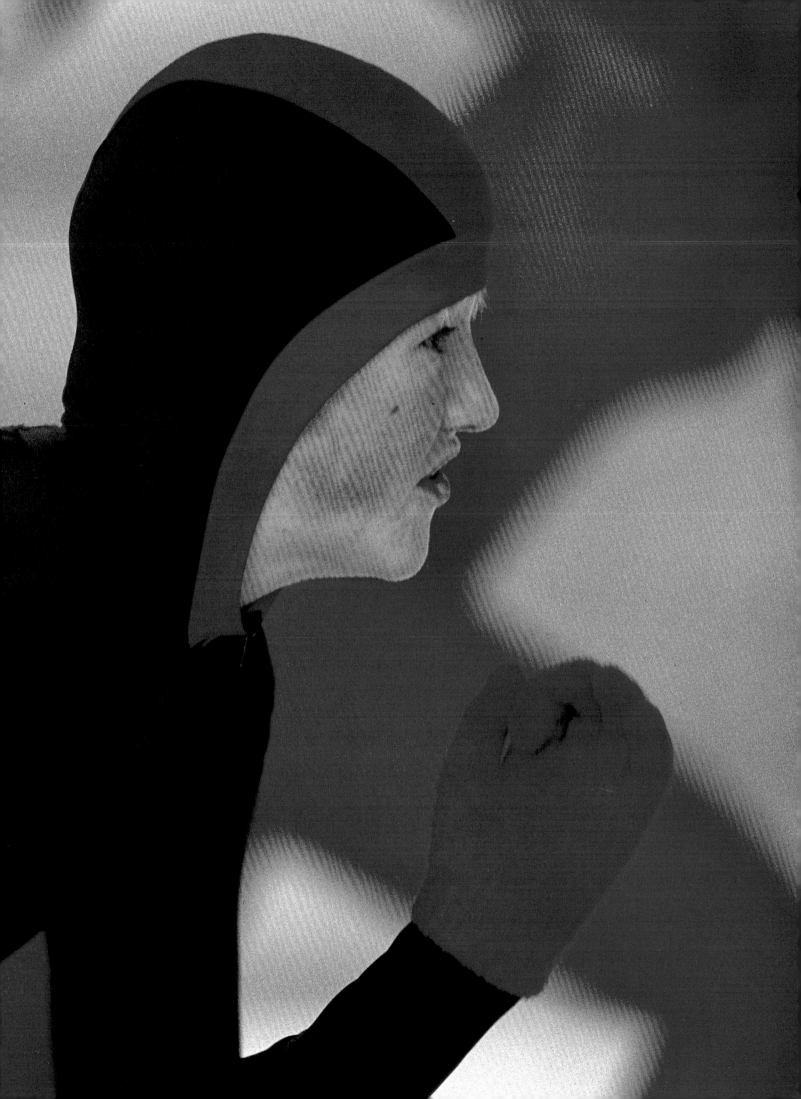

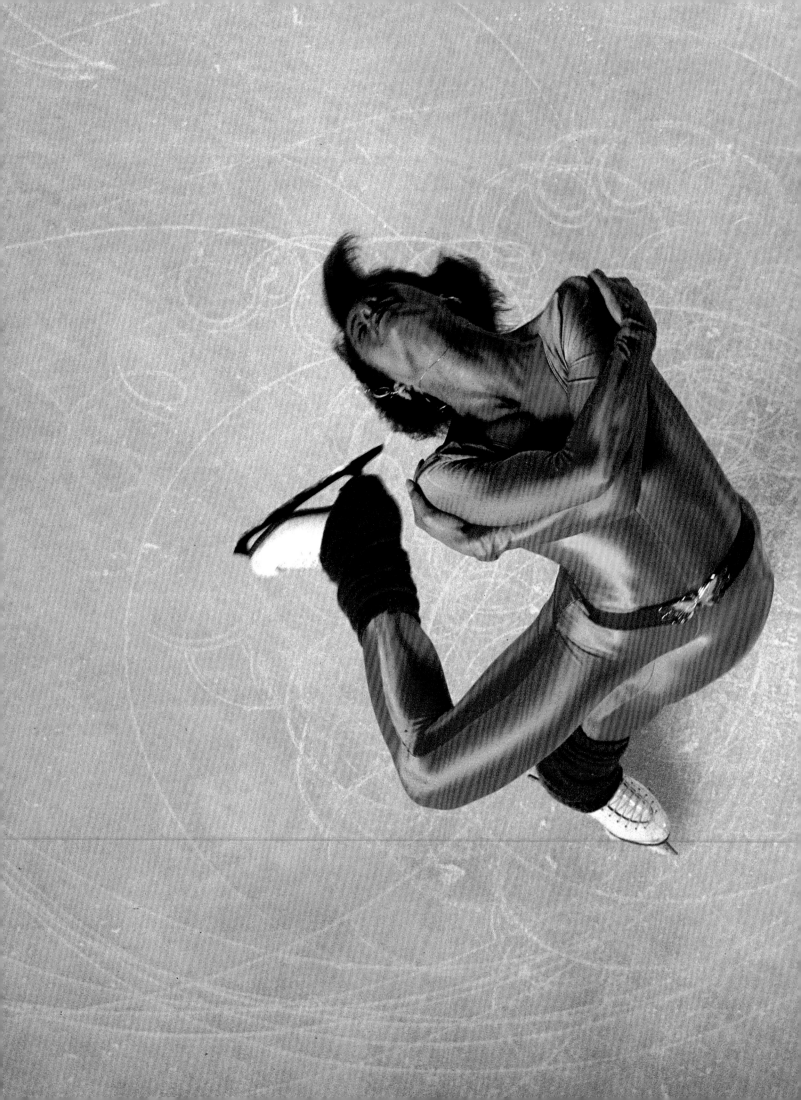

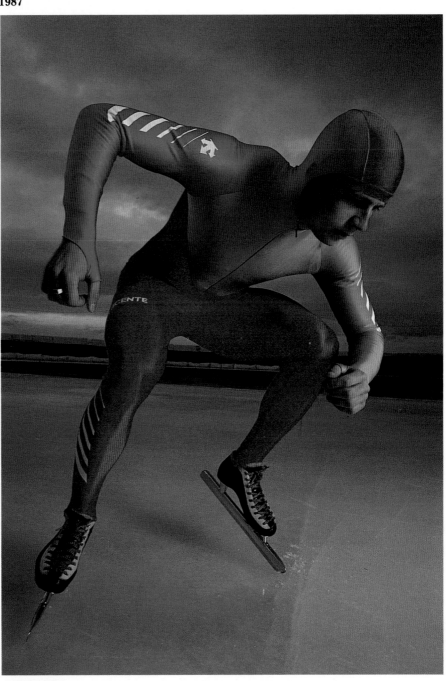

U.S. diver, pre-
Olympics. 1983–84

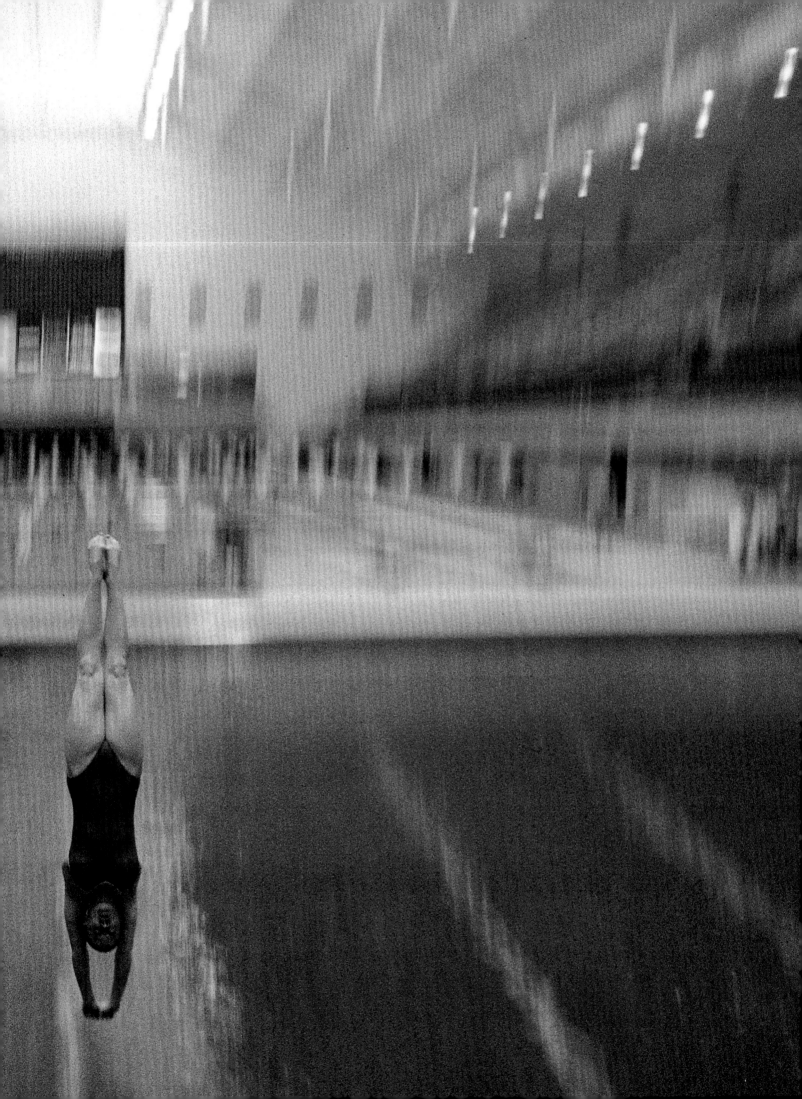

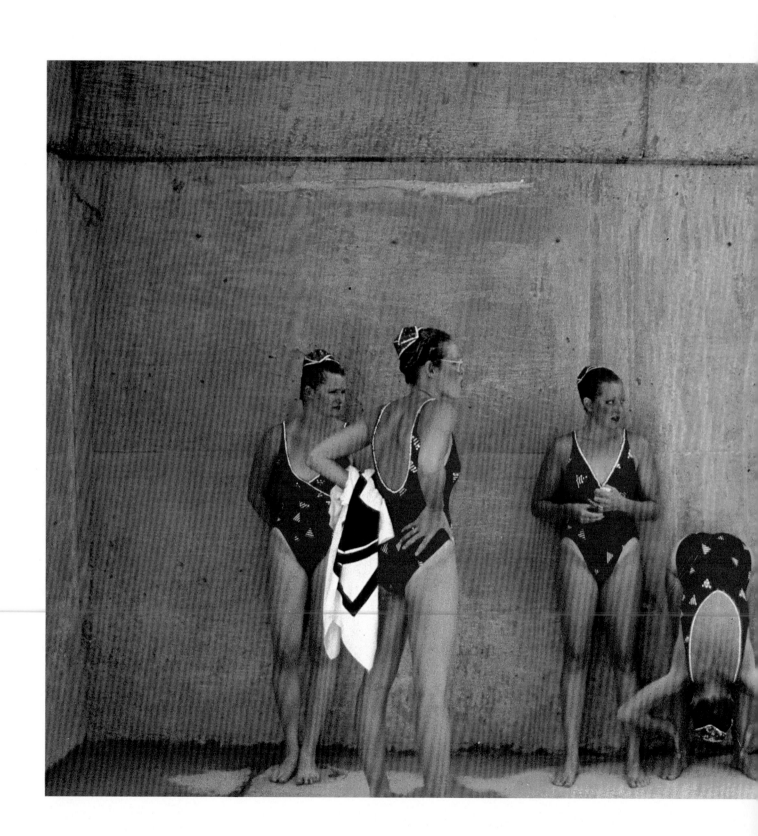

Pan-American Games. Caracas, Venezuela, 1983

These U.S. synchronized swimmers at the Pan-American Games are reminiscent to me of what a group of beauty pageant contestants looks like backstage.

U.S. swimmers. Honolulu, Hawaii, November 1983

Greg Louganis. Mission Viejo, California, 1984

This photograph of Louganis, the preeminent diver of this generation, was made at twilight, and the ropelight images on the side are fluorescent lights caught in slow exposure. Iooss, who is not much of a technician (anyway, as photographers go), thought that the shutter had been open for a full second, but a student of photography who studied the frame was able to count the sections of "rope" and reckoned that it was only half a second.

In any event, Iooss was especially delighted with the result. The picture was both distinct and beautiful, and, proudly, he took a copy to show Louganis. The diver glanced at the shot for barely as long as the shutter had been open. He saw nothing of the composition, the color, the originality, the beauty. All that Louganis saw was himself, the perfectionist diver. "I'm bent," he groused, handed the picture back to Iooss with disdain, turned on his heel, and walked away.

following page

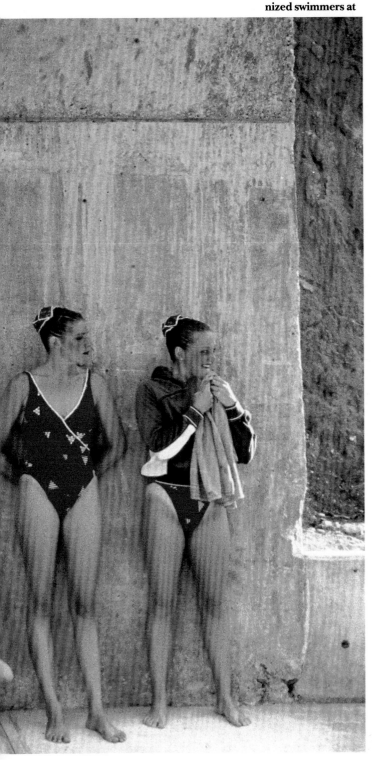

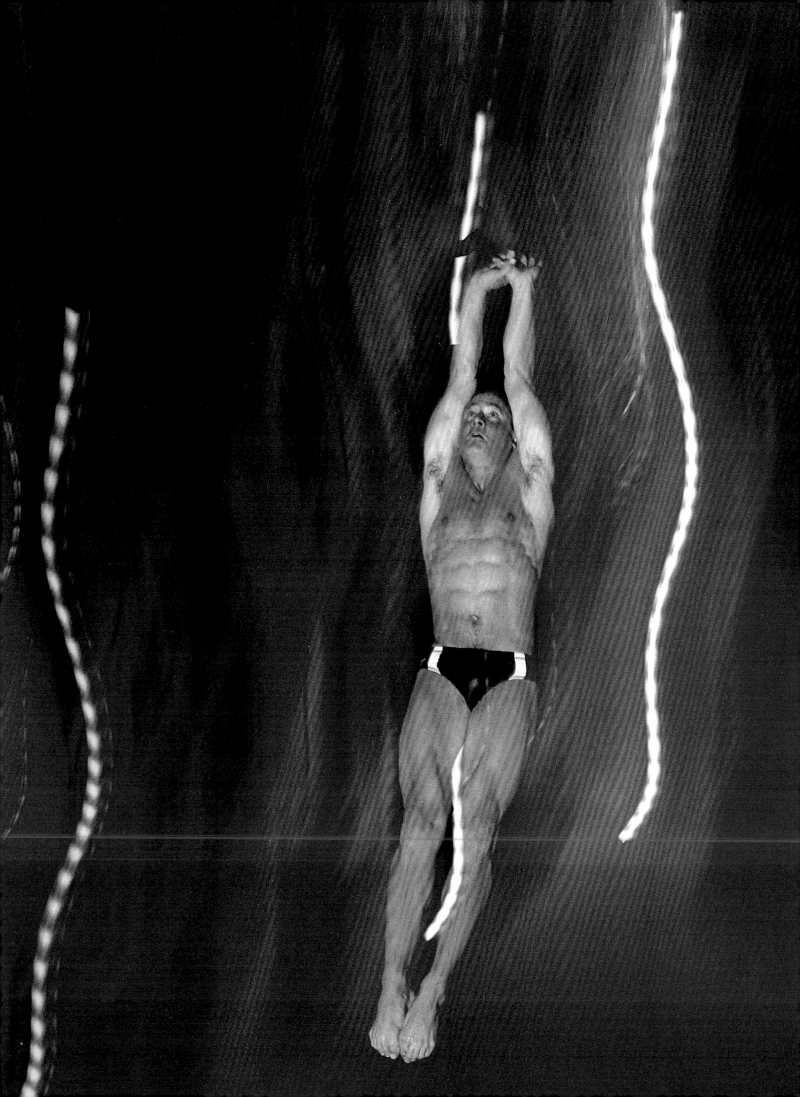

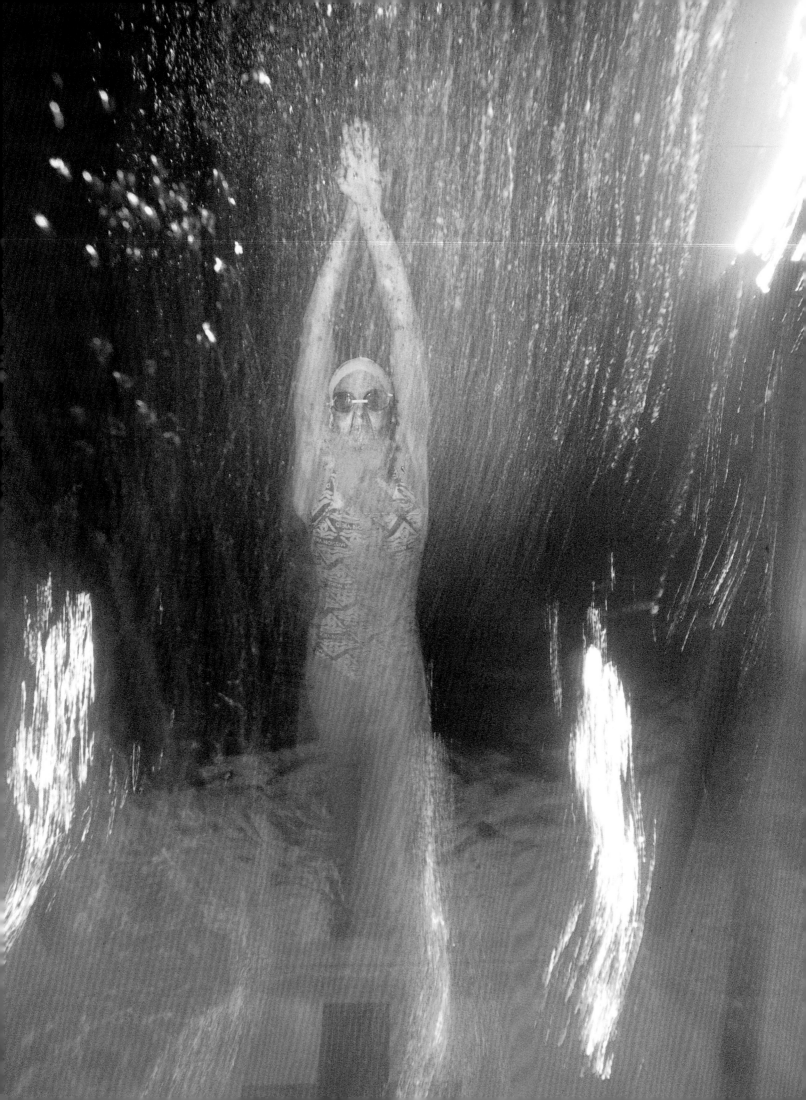

**Boxer
Dennis Milton,
Pan-American
Games. Caracas,
August 1983**

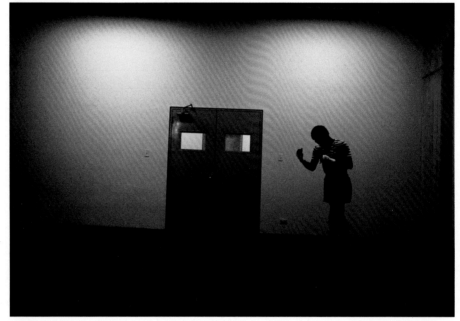

**Swimmer
Dara Torres.
Mission Viejo, 1983**

preceding page

**Mark Breland,
North American
Boxing Champion-
ships. Colorado
Springs, Colorado,
November 1983**

Breland has such a
strong face that it
is not surprising
he fared well in a
movie role (he play-
ed a military stu-
dent in *The Lords of
Discipline*) before
he achieved renown
as a boxer.

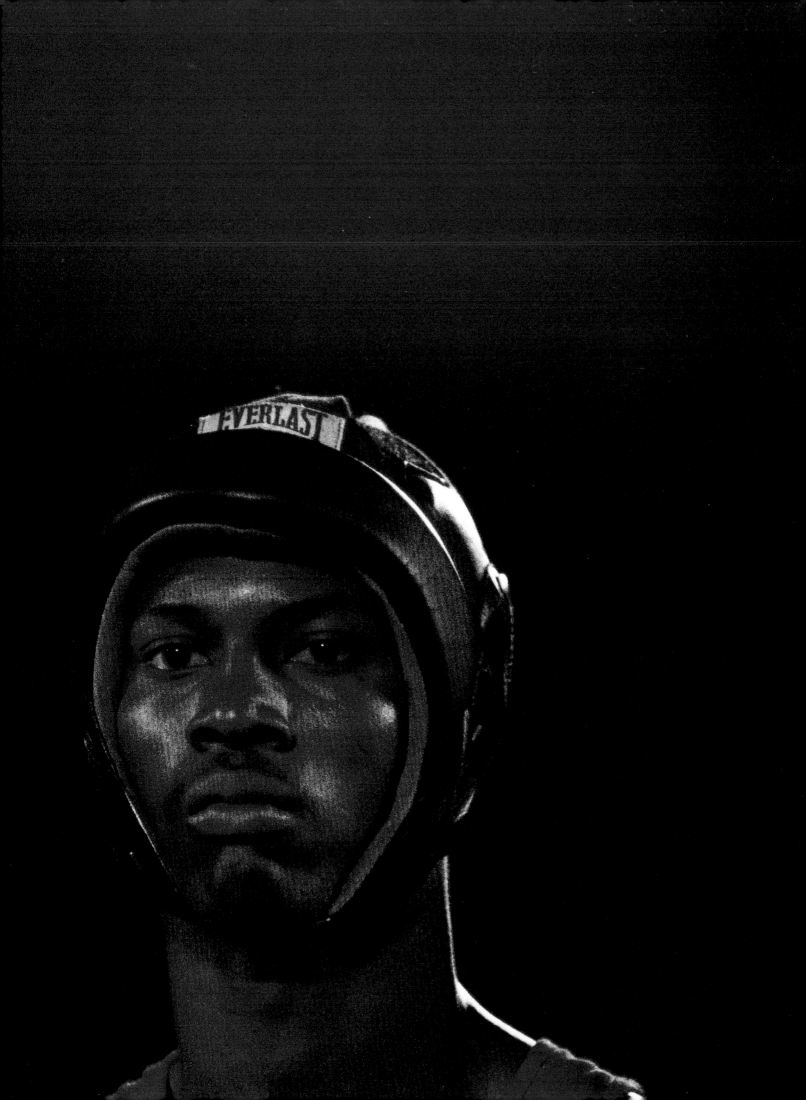

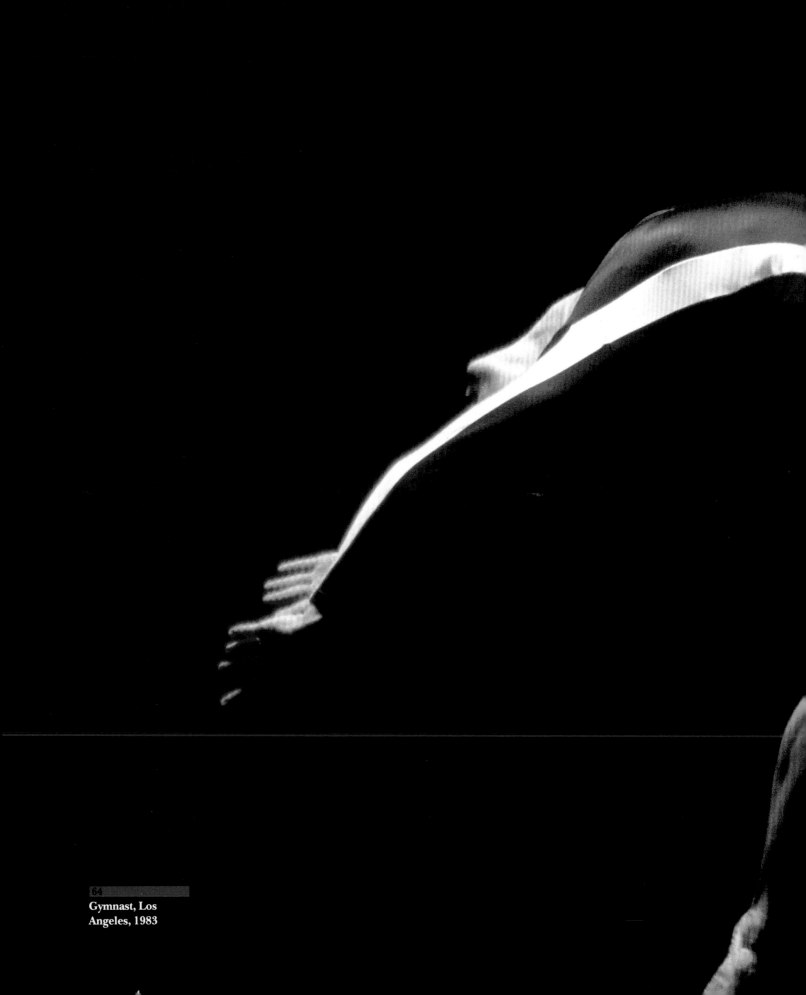

Gymnast, Los
Angeles, 1983

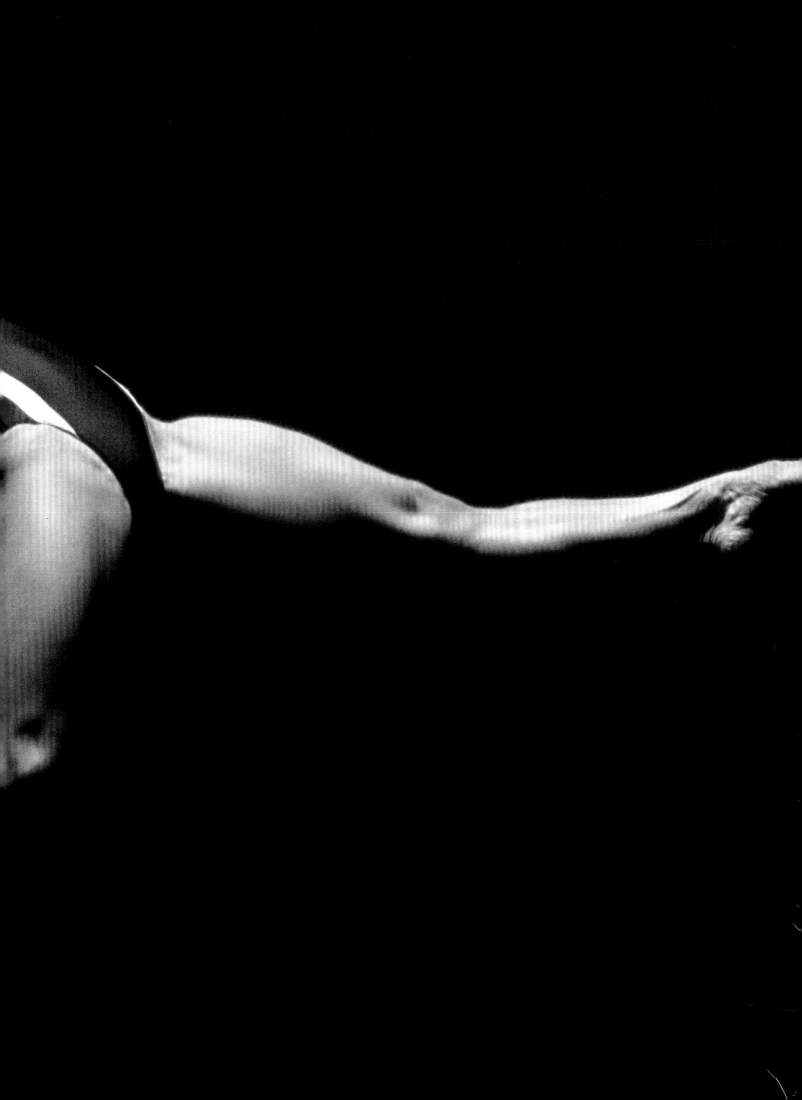

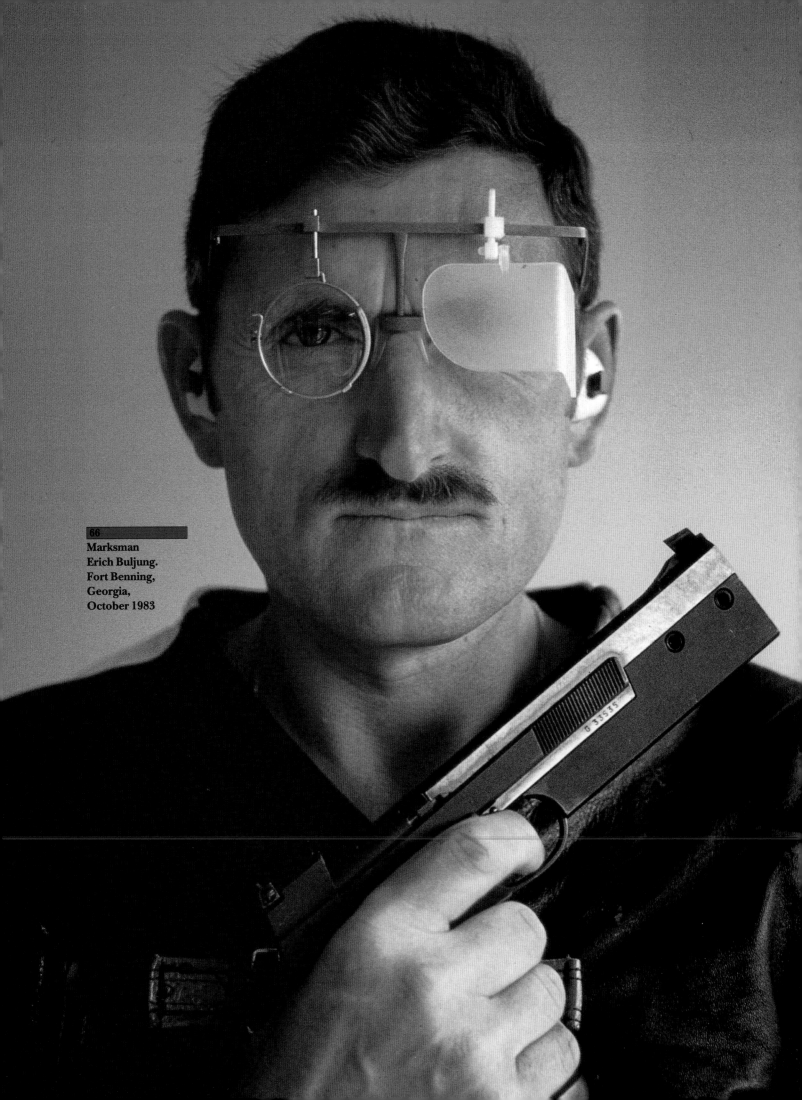

66
Marksman
Erich Buljung.
Fort Benning,
Georgia,
October 1983

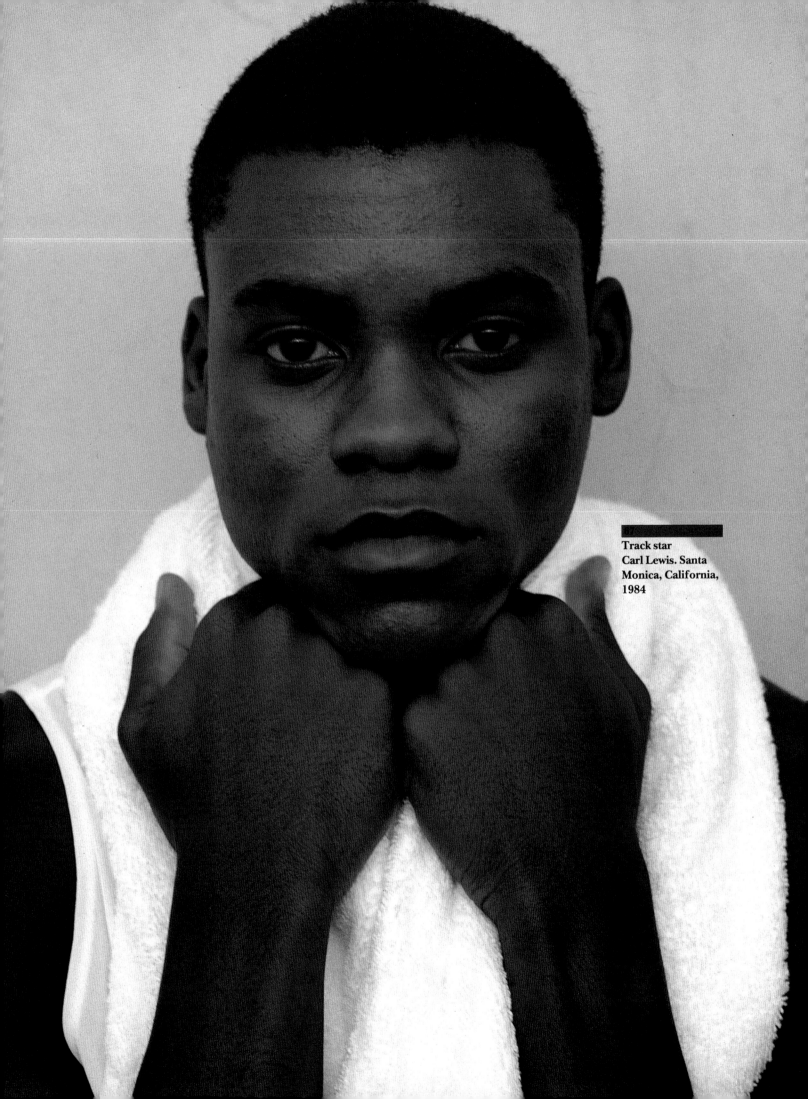

**Track star
Carl Lewis. Santa
Monica, California,
1984**

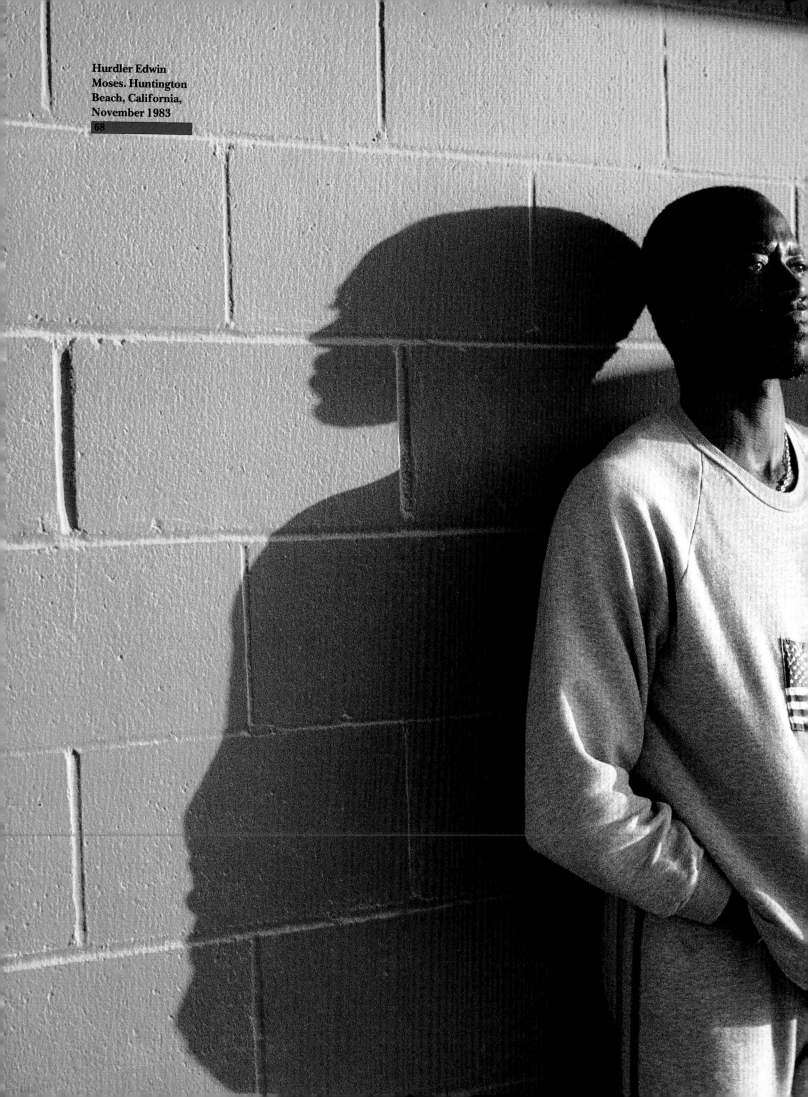

Sprinter Evelyn
Ashford. Indiana-
polis Invitational,
Indiana, June 1983

Bruce Jenner,
winner of the
decathlon event,
Olympic Games.
Montreal, Quebec,
July 31, 1976

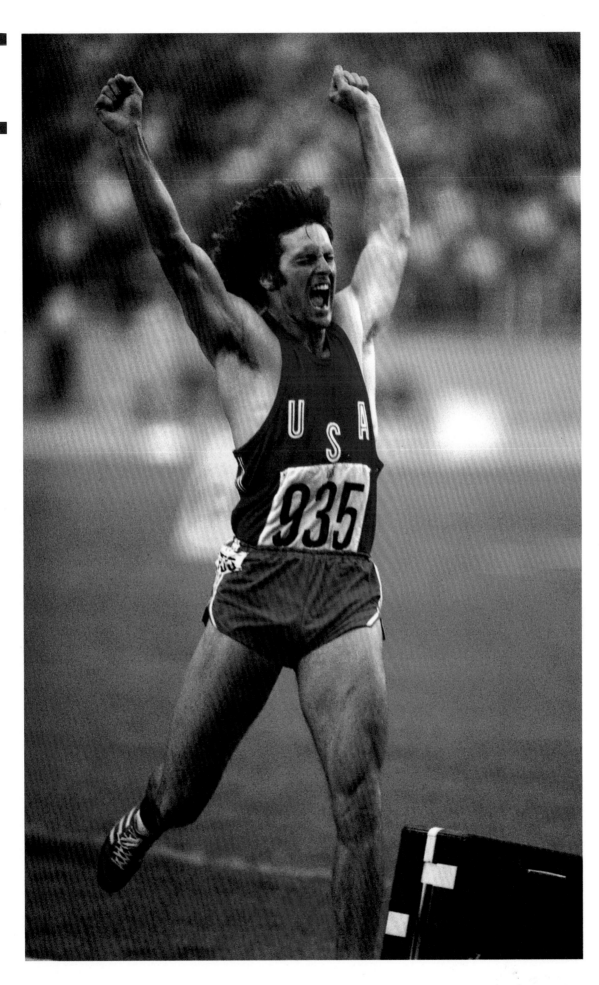

72

Sprinter
Calvin Smith.
Tuscaloosa, Alabama,
May 1983

73

The Italian team
competing in round
one of the 4,000-
meter cycling event,

Olympic Games.
Los Angeles, sum-
mer 1984

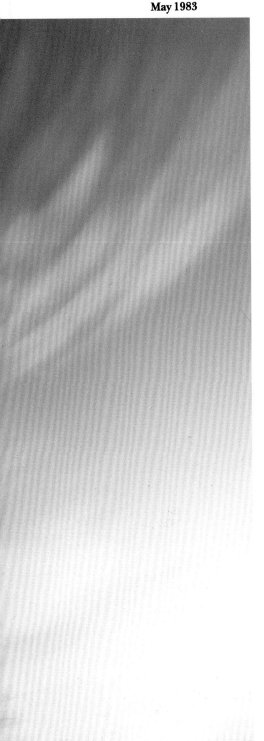

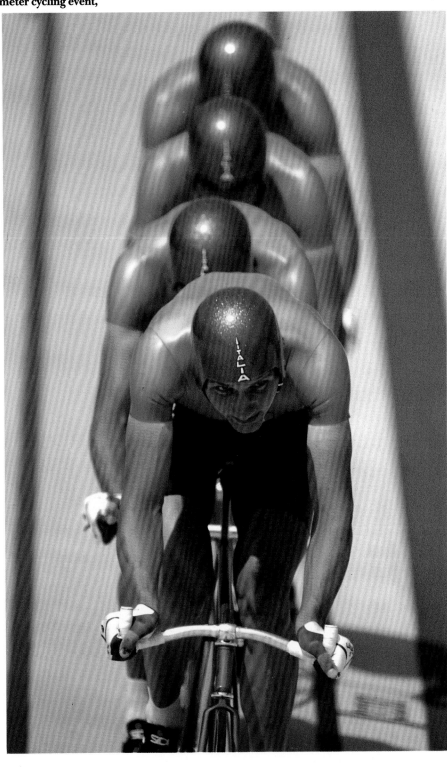

PORTRAITS

Increasingly, the modern athlete views journalists as adversaries, rather than as support troops or even as a necessary evil. Men who work as public relations officials for professional teams tell me that, as a general rule, if they tell an athlete that he has an interview with Joe Smith from the *East Cupcake Journal-Gazette,* the hero's instinctive reply will be: "---- him"—even if he's never heard of the writer or his publication. Writers and photographers used to be viewed by the players as colleagues, fellow roisterers; and who doesn't like a photographer? Who doesn't like having his picture taken? (I never like to have a photographer along when I'm doing a story because then I know I'll end up losing the competition to win the subject's attention.) Now, some weak-hitting first baseman will snarl at a photographer around the batting cage to make sure the photographer doesn't get his bad side.

There remain exceptions. I remember during the Kansas City–Philadelphia World Series of 1980 sitting in the dugout next to Pete Rose before one of the games. He was surrounded by reporters, and as each group would finish its questions or merely get its fill of Rosian badinage, another group would filter in, and he'd begin the process all over again. In the midst of this endless cycle, Rose would jump up, do a formal television interview, pose for pictures, babble into radio microphones . . . and, through it all, he would regularly pop over to the batting cage and take his cuts. Finally, during yet another mob interview, a new guy came over and reminded Rose that the limo would pick him up the next morning at 6:30 to take him to the local network affiliate for an appearance on *Good Morning America.* Rose cheerfully acknowledged the commitment.

Meantime, all around Rose, his teammates on the Phillies—an especially surly lot who acted as if playing in the World Series were a terrible

imposition—were grousing at the Fourth Estate. "Pete," I asked, "how do you do all this?"

"Are you kidding?" he said to me, poking me in the chest with his forefinger. "This is what you work for. This is what you hope will happen all your life. This is terrific."

It is properly symbolic, however, that Rose is recognized as a throwback, and few modern ballplayers assume that cheerful attitude in such matters. In future it will be more and more difficult for Iooss and his associates to freeze many of the images he obtained for this book. The art in sports depiction is being replaced by instant replay, the aesthetic by the merely instructive.

Just getting an athlete to pose can often be more difficult than actually shooting the picture. This is probably particularly true with players in team sports, for, among other things, teammates like nothing better than to razz another player about being a star, posing for pictures, showing off. I discovered myself that, ironically, some athletes would shy away from me when I was covering basketball for *Sports Illustrated* because they didn't want their friends to accuse them of currying favor with a national magazine at the expense of the local press.

At the time Iooss set out to get a portrait of Kareem Abdul-Jabbar, the player was particularly reluctant to be photographed. Not long before there had been a terrible assassination by some religious crazies, and it was indirectly connected with Jabbar's own Muslim affiliation. But Iooss, who possesses a genuinely abiding interest in music, knew that Jabbar shared some of the same tastes. Through a friend, he discovered that Jabbar favored the work of a musician named Les McCann. When Iooss got the opportunity, he told Jabbar that he would like to photograph him. Jabbar frowned. Quickly, then, Iooss told him he had a Les McCann album for him. The ice was broken, and Jabbar invited Walter to his house, secure in the knowledge that at least one photographer had some good taste.

Iooss took the shot of the topless Darryl Strawberry shown on page 130 when he was working on an essay on the Mets of '86. "When I'm doing a piece on a team, I move in very slowly," he says. "I don't want to create waves. At first, I just want to be an observer, maybe make a friend or two and go from there. Or maybe I already know one or two guys on the team, and they help me. For instance, when I did a feature on the Miami Dolphins, I knew Dan Marino, and he came to me and told me: 'You need anybody, just come to me.' But most times, even if you don't have an edge like that, they'll start to come to you. They get interested. They get curious about what you're

doing. Then, once you have a few pictures to show them, things really start to happen. Then they get upset if you *don't* want to take their picture. And the great thing about this profession: if you take one shot of a guy that he really likes, he's yours forever."

It took a lot of flattering, a lot of cajoling by Iooss to get Strawberry to pose with his shirt off. Then, when he finally agreed to go along, Strawberry enjoyed the assignment so much that he didn't mind staying around, until, finally, a furious coach ran into the room screaming that Strawberry was late for batting practice.

Iooss shot the photograph of Edwin Moses on pages 68–69 at a time, just before the 1984 Olympics, when he was at the height of his career and in the most demand. Reluctantly, he agreed to be photographed. When Iooss showed up at the site where Moses practiced, in Huntington Beach, California, he went into the men's room, and there he saw some shadows on the cinder blocks. He found another wall nearby where the light was marginally better than in the men's room, and, when Moses showed up, he put him up against the wall, fired off a few shots, and then told the surprised subject that that was fine, thank you. Moses, used to photographers saying "just one more" all day, was flabbergasted. By then, Iooss was already preparing to leave. "I just needed one shot," he says, "and as soon as I saw that in the men's room I knew I had it, so I just packed up then and left. I knew I wasn't going to improve on that."

As a sportswriter, I think the trickiest aspect of a sports photographer shooting action is to know enough to be able to anticipate. Obviously, if it's third and twenty-five, and you're lined up waiting for a fullback plunge, you are not liable to get a good shot. That goes without saying. But there's much more to it. Iooss got essentially the same shot of Bjorn Borg hitting a tennis ball and Keith Hernandez a baseball because, only if instinctively, he knows about serves and swings.

Consider, for example, if the angles had been reversed in these two photographs, if Iooss had been tight on Hernandez and wider on Borg. Well, I doubt then if either picture would have made this collection. It is vital to the picture of the baseball batter to see the bat. If you're going to take a batter without a bat, then go into the dugout and take still life, as Iooss did with the Willie Mays shot on page 130. But with the tennis serve, where the player is himself softly tossing the ball into play, then the instrument—the racket—is not nearly so consequential.

Still, from the technical point of view, note that the eyes of both players are utterly focused on the ball, just the way every coach has always told you.

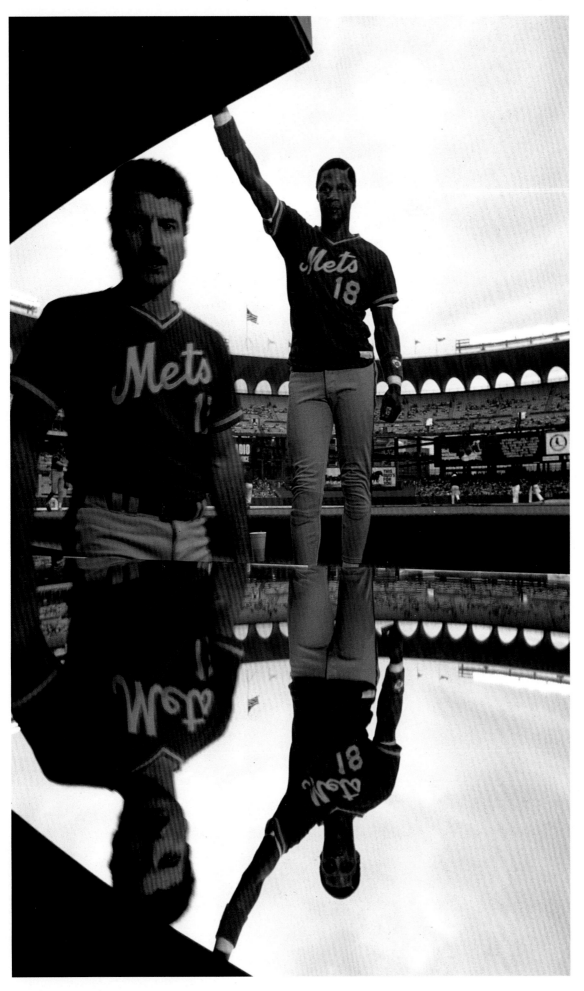

Keith Hernandez
and Darryl
Strawberry,
New York Mets.
Busch Stadium,
St. Louis, Missouri,
1986

following pages

Twin Towers:
Ralph Sampson
(left) and
Akeem Olajuwon,
Houston Rockets.
Houston, Texas,
September 1986

Wrestler Hulk
Hogan. New York,
1985

Professional wrestling is a stunt, of course, but humorless people who go around sneering at it miss a point: it is a very dangerous stunt. Iooss understood that. When he photographed an essay about wrestling for *Sports Illustrated*, he tried to mix the power with the fun. "I mean," he asks, "even if it is fixed, how many times can you get thrown and land on your back properly?"

And it's real enough. When Walter was photographing Hulk Hogan, something went wrong and Iooss cursed loudly. His assistant gulped and cried out to The Hulk: "He's only talking to the camera, Hulk! He's only talking to the camera!"

Actually, I have said for years that wrestling is real; it's the rest of the world that's fixed.

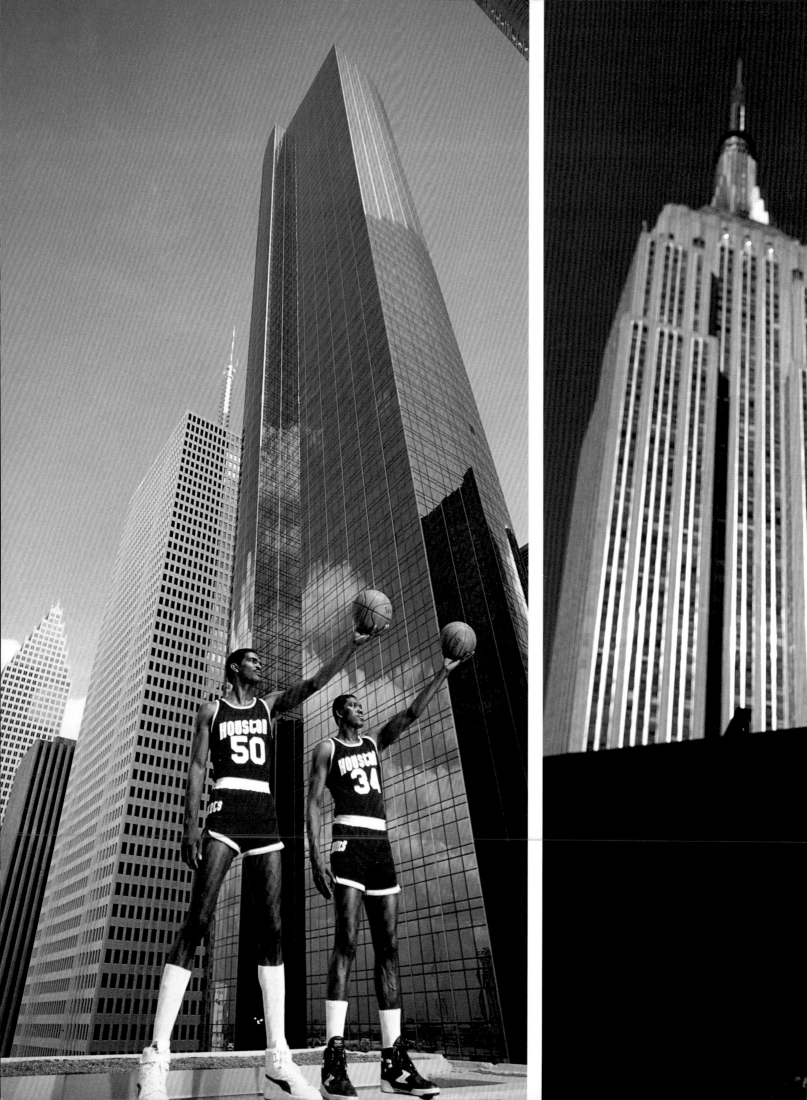

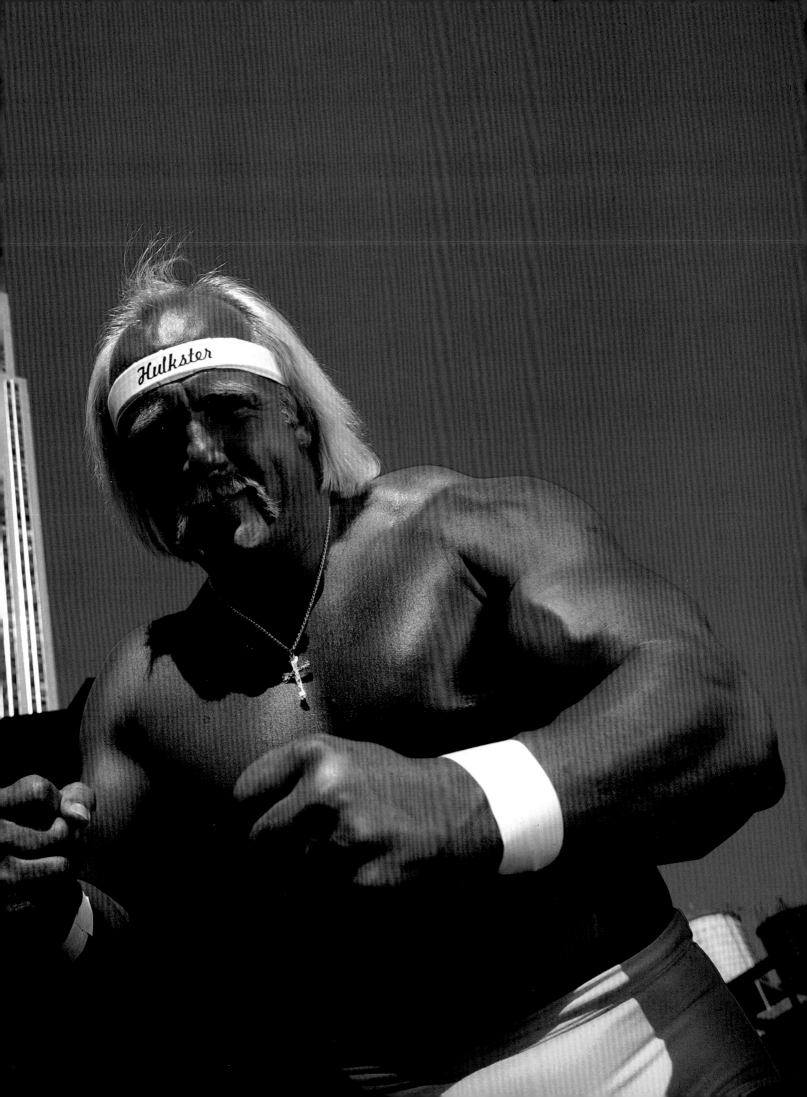

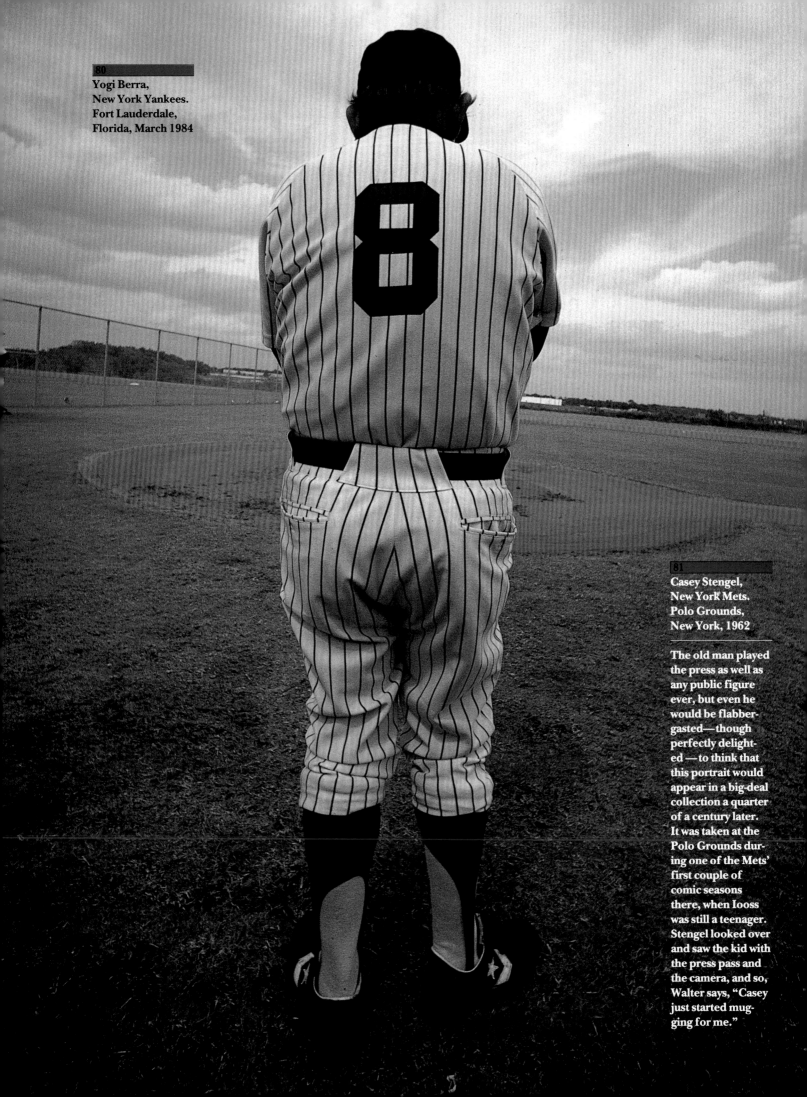

The old man played
the press as well as
any public figure
ever, but even he
would be flabber-
gasted—though
perfectly delight-
ed — to think that
this portrait would
appear in a big-deal
collection a quarter
of a century later.
It was taken at the
Polo Grounds dur-
ing one of the Mets'
first couple of
comic seasons
there, when Iooss
was still a teenager.
Stengel looked over
and saw the kid with
the press pass and
the camera, and so,
Walter says, "Casey
just started mug-
ging for me."

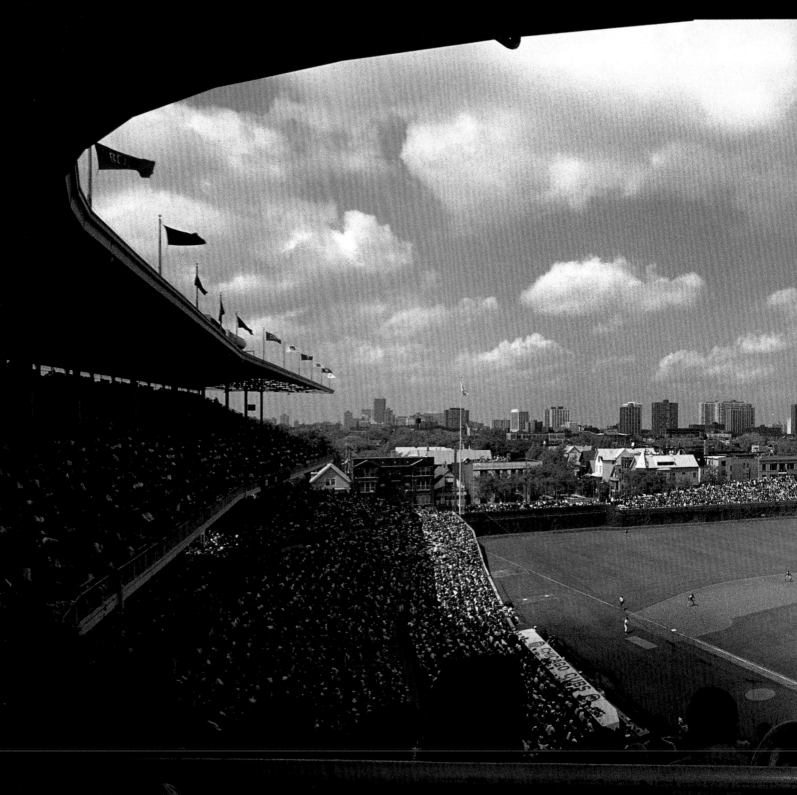

**Wrigley Field.
Chicago, Illinois,
May 1985**

This section con-
tains portraits of
other famous ath-
letes, in action and
repose. Also in-
cluded is this photo-
graph—landscape?
—of a place where
famous athletes
play: Wrigley Field,
with ivied walls and,
at least when Walter
took it, without
lights (giving us
Ioossian clouds).

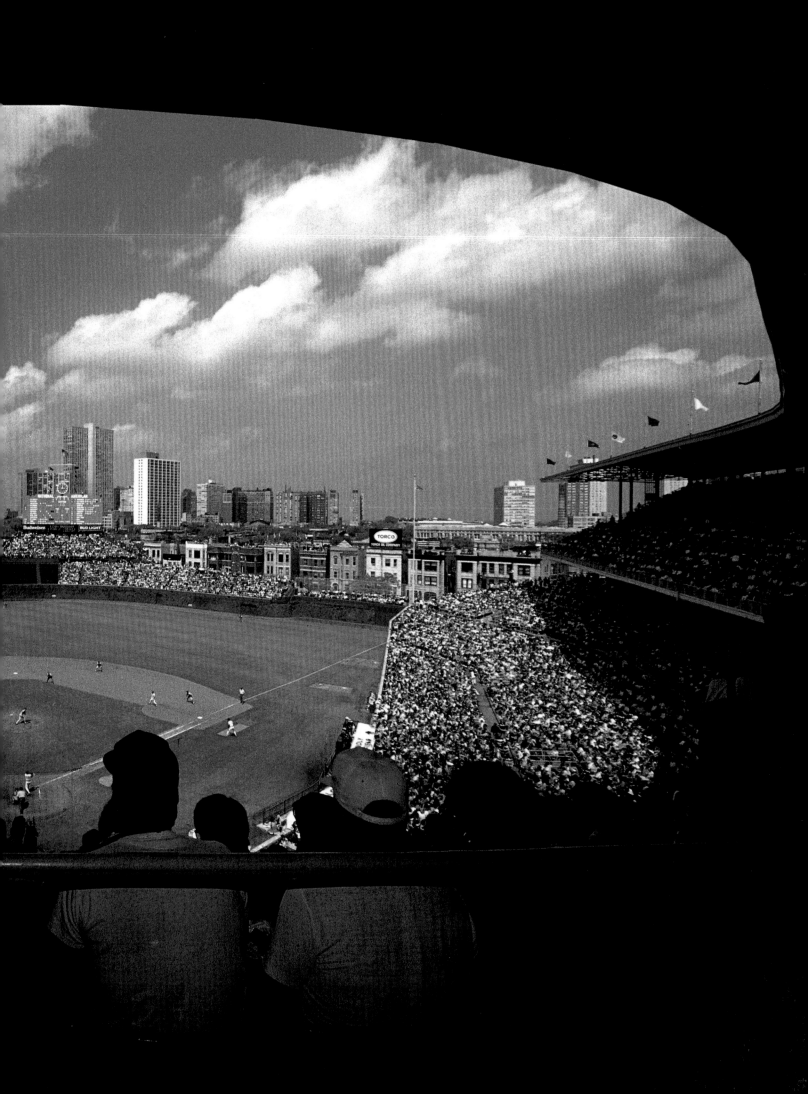

84

Dwight Gooden.
Al Lang Field,
St. Petersburg,
Florida, 1985

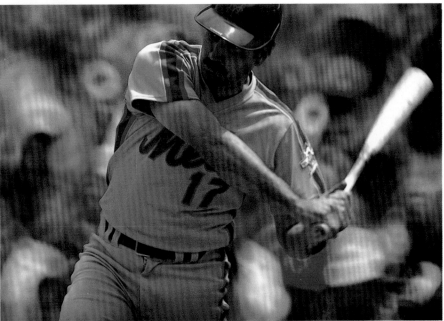

Keith Hernandez,
New York Mets.
June 1986
85

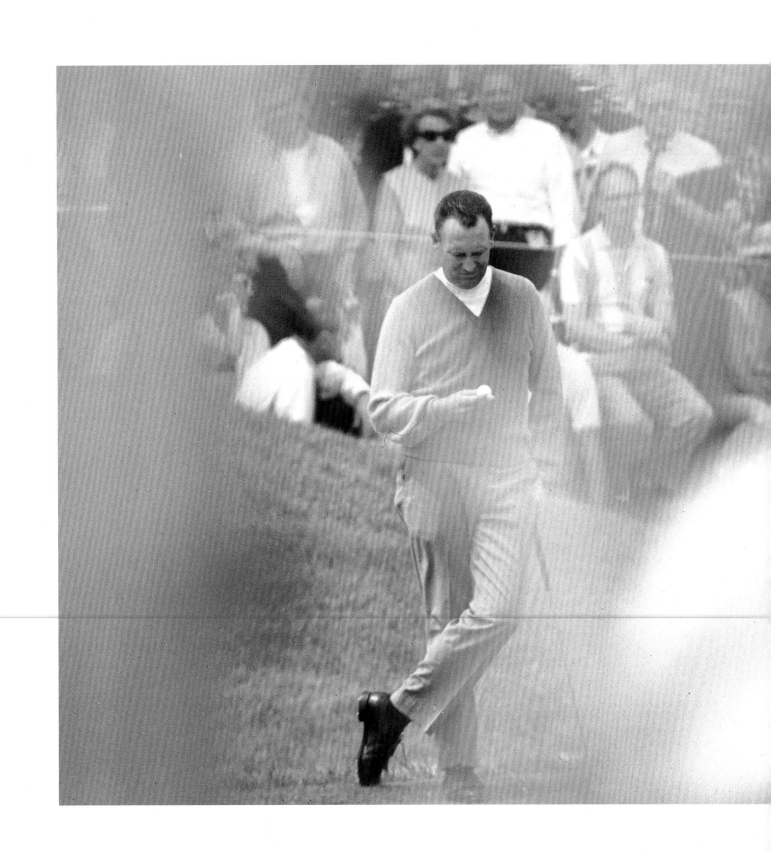

**Billy Casper, U.S.
Open. Baltusrol
Golf Club, June
1967**

**Rod Laver. Florida,
1974**

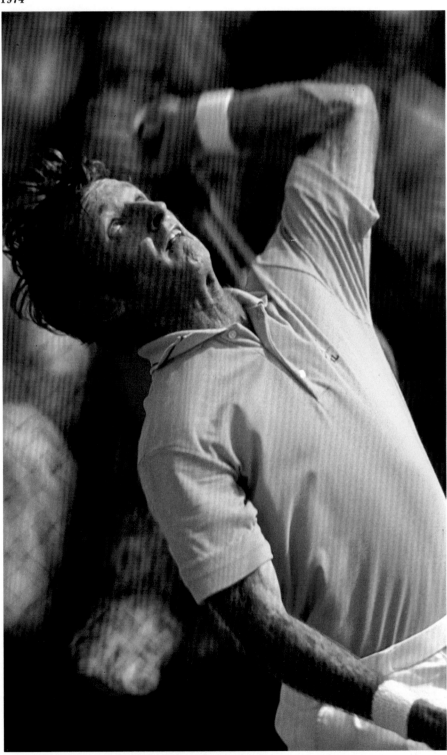

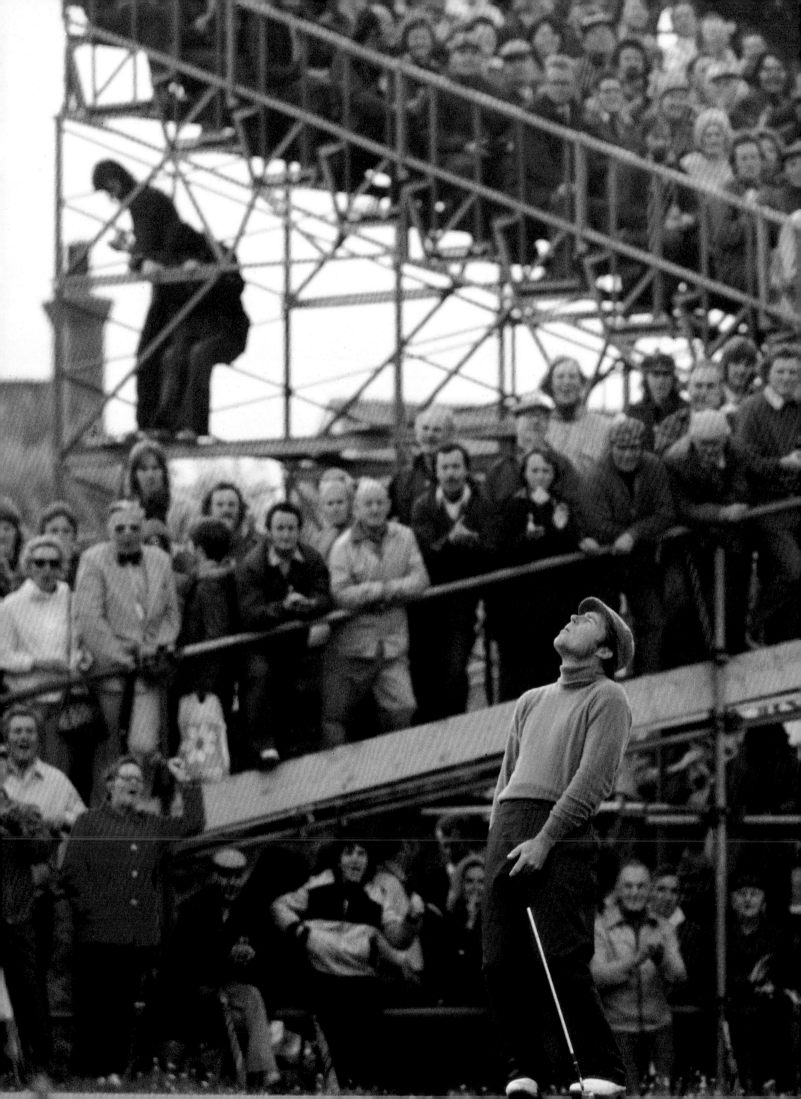

89

Gary Player, win-
ner, British Open.
Royal Lytham &
Saint Anne's Golf
Club, Saint Anne's
on-the-Sea, En-
gland, 1974

Gary Player had just
missed a long putt
at Royal Lytham, in
the British Open.
Iooss says he par-
ticularly likes this
shot because "it's so
British." I would
disagree with him.
Golf fans are uni-
versal and would
react the same no
matter where.

No, what I like
about this shot is
that it is so un-golf a
photograph. That's
because all golf pic-
tures inevitably
show the trees and
grass of God, not
the faces and scaf-
folding of man. The
photograph is so su-
perbly composed—
especially since the
photographer
didn't have the time
to set it up. It is all
the better that
Player, in his pre-
ferred muted col-
ors, is almost lost in
the crowd.

Rich Cruz with his
dog, Bruno, at the
City of Los Angeles
Marathon. Los An-
geles Coliseum,
March 6, 1988

Wheelchair competitor, City of Los Angeles Marathon. March 6, 1988

Red Auerbach watches his Celtics defeat the New York Knicks at Boston Garden. March 28, 1967

The erstwhile redhead, beneath the championship pennants, with his cigar, in 1967, the first year he retired from coaching and stepped up into (as they always refer to it in sports) the *front* office. If the picture were taken today, it would be in the same spot, the same building, with a similar cigar, and the same championship pennants (albeit more of them) —and guaranteed Auerbach would be in a similar brown or gray jacket. Rarely does he wear anything but drab earth-tone duds— which is, of course, in direct contrast to the animated, even profane, public character that he portrays. I kidded Red about this once, and he gave me back the regular sort of grunt that he saves for fools like me. But years later, I was talking to a young man who had wanted to be a basketball coach and had admired Auerbach. This fellow happened to be Jewish. He told me when he had finally gotten to meet Auerbach, to sit at the master's feet, Auerbach had given him one piece of advice to usher him through his chosen career on the basketball bench. And it was this: "Son, coach Jewish, dress British."

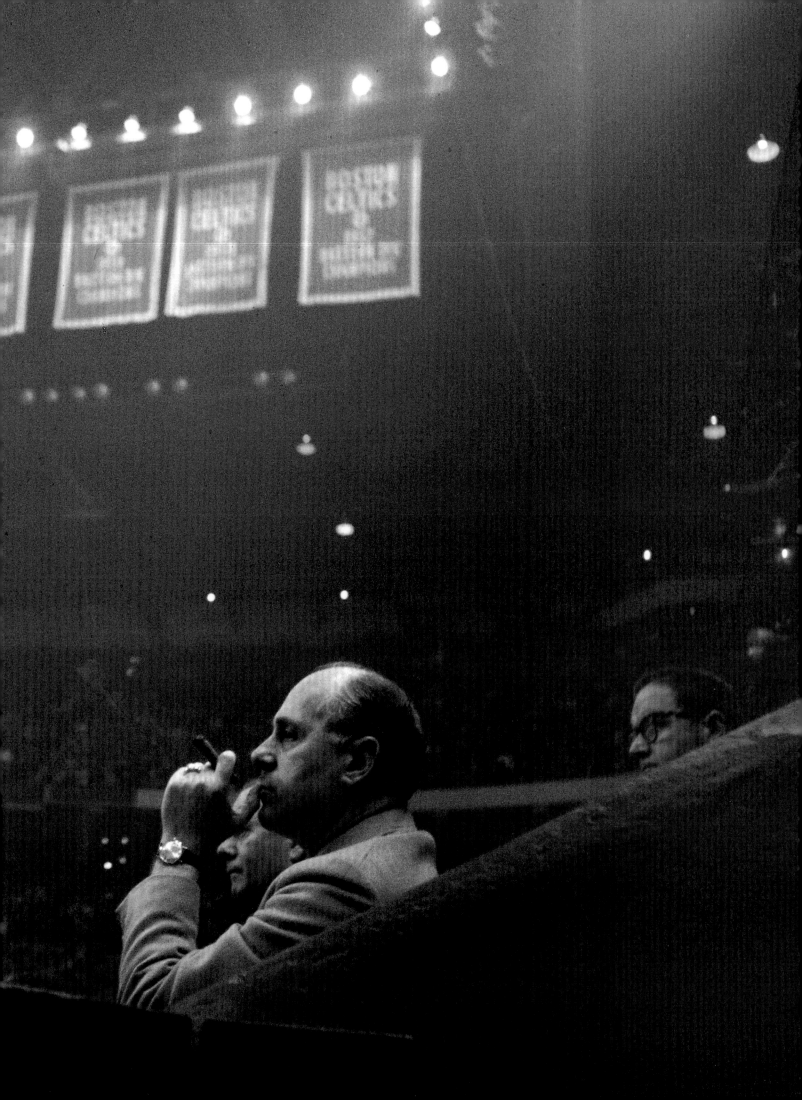

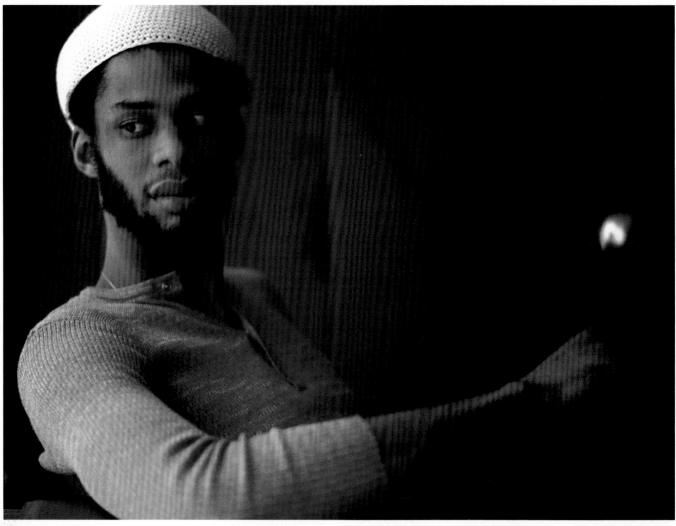

Kareem
Abdul-Jabbar, then
with the Milwaukee
Bucks, at home.
Milwaukee,
Wisconsin,
February 1973

Walt Frazier.
New York, 1974

Walt Frazier was
something of an
anomaly. Somewhat
like The Big O, he
was not flashy in
and of himself. He
certainly could run
a dashing fast
break, but his much
greater value was in
his basic silent
skills, setting up an
offense, playing

tenacious man-to-
man, that sort of
thing. Yet Frazier's
persona was the
opposite. He fa-
vored a dandy's
clothes (witness the
picture; that's not a
costume, but every-
day attire) and he
was known almost
exclusively as
Clyde, from the
swashbuckling cox-
comb of Bonnie
and…. Frazier's

greatest renown was
that he could go
about snatching
houseflies before
they could gather
themselves up to
escape his allegedly
human clutches.
Here, Frazier, the
very essence of pa-
tience, finally wore
down when Iooss
was shooting him.
Notice his hand on
the top of the ball.
The fingers were

slightly raised—a
tiny sign that his for-
bearance was being
tested. In the previ-
ous shots, Frazier
had kept his fingers
on the ball. Finally,
he drummed them
just a smidgen.
Iooss snapped,
ended the session,
and chose this shot.

John McEnroe at
the WCT Finals.
Connors defeated
McEnroe to win the
men's singles final.
Reunion Arena,
Dallas, Texas, May
1980

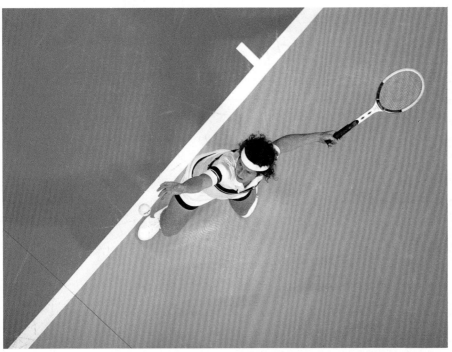

John McEnroe at
Wimbledon. He was
defeated by Jimmy
Connors in the
men's singles final.
July 1982

John McEnroe has
always been per-
turbed by photogra-
phers. In fact, two
years after this pic-
ture was taken at
Wimbledon, at the
1984 French Open,
McEnroe was up
two sets to love in
the finals against
Ivan Lendl, but he
decided to get both-
ered by a television
cameraman, lost
his concentration
and a great deal of
energy arguing with
the fellow, and, at
last, lost the
match—and with it,
almost surely, the
Grand Slam.

That earlier time
at Wimbledon he
also had it in for
photographers, and
he snarled at
Iooss—and many
others—for the en-
tire Fortnight. Iooss
would not back
away. "I purposely
harassed him right
back," he says. In
fact, when Walter
took this picture of
McEnroe, the
player was the bull
and the camera the
red cape. McEnroe
had not only been
cursing at Iooss, but
he continued to do
so the entire time
Iooss snapped the
shutter.

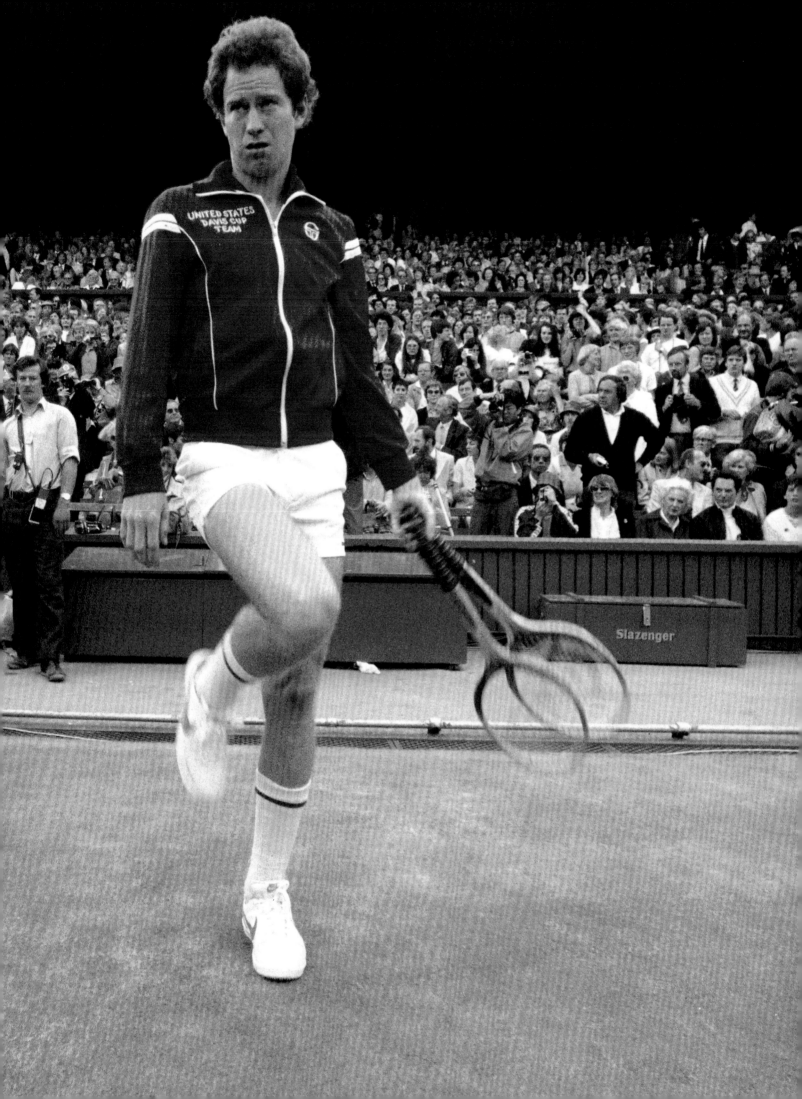

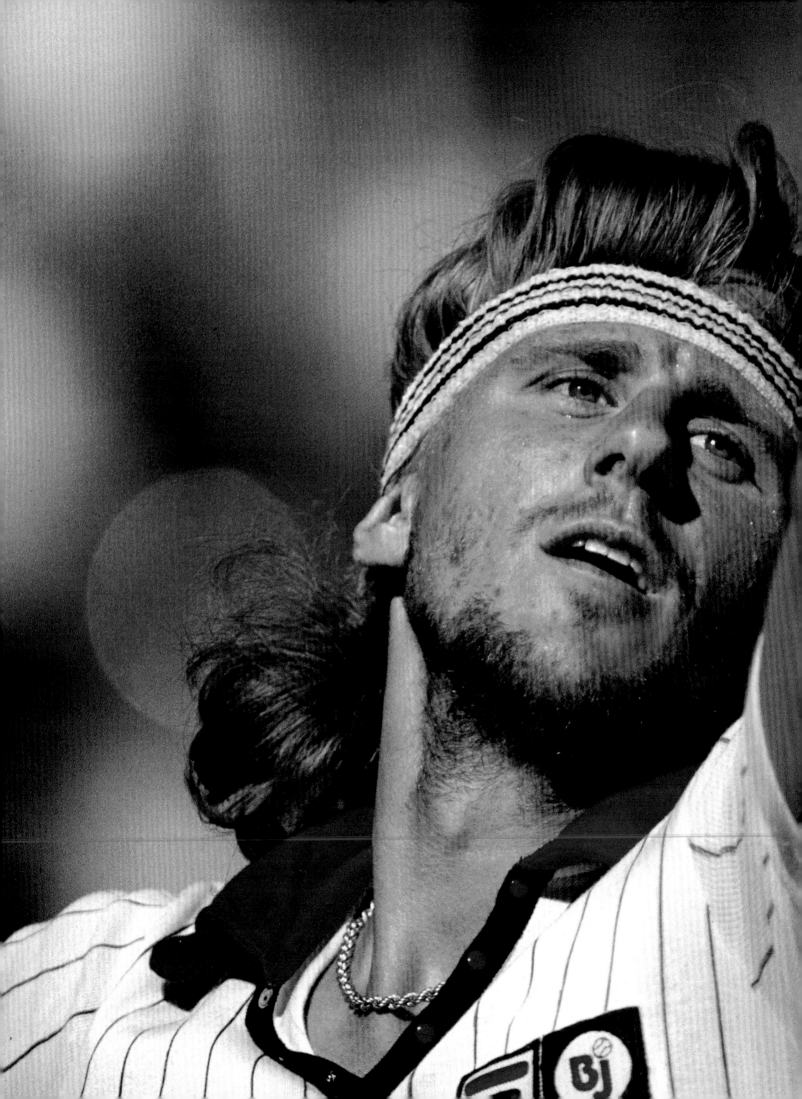

Bjorn Borg at the
1978 U.S. Open
Tennis Champion-
ships. Borg lost to
Jimmy Connors in
the men's singles
final. National Ten-
nis Center, Flushing
Meadows, New
York, September
10, 1978
98

Retired tennis star
Bjorn Borg with his
son, Robin, and Jan-
nike Bjorling.
Antigua, British
West Indies, 1988
99

BASKETBALL
ACTION

As basketball has evolved, largely to be dominated by black players who learned the game in the playgrounds, it has become unique in that show-off stuff is not only accepted, but, indeed, praised. In most other games the best players are supposed to be sturdy types *who get the job done* without a great deal of flourish. They are, in the favored modern lexicon, *blue-collar types,* and heaven forbid that they should ever be *hotdogs*. Paradoxically, in basketball the best players are rather expected to be flashy, and there is a high correlation between those who are the best at the game and those who are the most exciting.

To be parenthetical for a moment, I'm convinced that the reason soccer has never taken hold as a spectator sport in America—despite experts assuring us that it must become popular because it always has been favored everywhere else in the world—is essentially because soccer pales beside basketball. High-school basketball players can regularly perform feats with their hands that Pelé or Diego Maradona can manage with their legs only once in a blue moon. Rather than soccer finally overcoming this last bastion and becoming popular with Americans, I think it's much more likely that basketball will start to supersede soccer in many countries where soccer has been, till now, the only game of consequence.

In any event, basketball was once a matter of proficiency, played horizontally; it became, with the black urban influence, a thing of vertical

beauty. It is no surprise that most of the photographs in this section focus on the aesthetics of the game and, to some extent, upon the most theatrical stars.

Ironically, the first in that line (who even predated the adolescent Iooss) was a white French Canadian–American, Bob Cousy, of the Celtics. Elgin Baylor brought leaping and twisting into the game a few years later, and the late Gus Johnson, although not quite so good as Baylor, raised that brand of play to a new level. Earl The Pearl Monroe joined Johnson on the Baltimore Bullets, and, in his way, spread the new style to the backcourt—along with Dick (Fall Back Baby) Barnett, who played his best years with Baylor for the Lakers. It is hard to imagine this now, but when the likes of Monroe and Barnett came into the NBA from small southern black colleges, many experts doubted that they could make the transition. The whispered knock against the black players then was that whereas, sure, they might be flashy (the athletic equivalent of possessing rhythm), none of them could be expected to shoot the ball worth a damn.

Curiously, the black player (along with Russell and Chamberlain) who first made a great impact was Oscar Robertson—photographed here in a classic pose when he was near the end of his career—and Oscar wasn't the least bit spectacular to watch. As a matter of fact, Robertson was the great white ballplayer who just happened to be black; Baylor was the harbinger.

Jerry West (shown here making a layup over Bill Bradley) was Robertson's contemporary, and, by the end, his equal, and West was white and more fun to watch than was The Big O. As for Bradley, he was called The White O by black players, which attested to what a wonderful throwback he was. By the time Bradley reached the NBA, though, the sport was starting to evolve into the game/show it became—with, ultimately, Julius Erving, Doctor J, becoming the undisputed best player and the best performer.

Today, Magic Johnson and Michael Jordan, each in his own style, can make the same claim. Even Larry Bird, slow and pasty white, who bridged from Doctor J to Magic and Michael, has been a terrific showman (if almost entirely with sleight of hand).

This development of basketball was perfect for the young Iooss, who himself was prized by his colleagues for possessing the same sort of superior hand-eye coordination that so many of the best players in many sports must own. Iooss is drawn to the form and grace of sport, and basketball brought him that as much as any game (although he also always seemed to have the affinity and the intuition to get fingertip catches in football). Walter knew what he was after. It would drive his competitors

crazy that he would literally show up for a game during the national anthem, some of his equipment Scotch-taped together, and then start cranking out right away. In his trade, Iooss—Coast-to-Coast Iooss, they called him—was the equivalent of some Earl The Pearl showing up in the NBA from Winston-Salem State.

As Iooss has gotten older, he has grown more organized and prepared . . . and more patient. During one basketball season, for example, he saw a moment he wanted to shoot. On the free-throw line, many players take the ball down low, inhaling deeply, relaxing their muscles, before bringing it up and shooting. Iooss wanted to get that, just so, with the clock blurred in the background. The player he wished to frame was Monroe. So Walter sat in the same spot at Madison Square Garden for three or four games, waiting for the instant he knew must come. But though Monroe was sent to the free-throw line many times, he never gave Iooss exactly what he was looking for. Walter was able to get a photograph of another player in that pose during the last game he lay in wait, but Monroe, with his mournful countenance, was the one he had wanted.

It occurred to me that, like Monroe, many of the flashier basketball players on the court—Cousy, Baylor, Erving, Jordan—are the very soul of evenness off the court. Basketball is almost certainly more of an outlet for expression for those who play it than is any other sport.

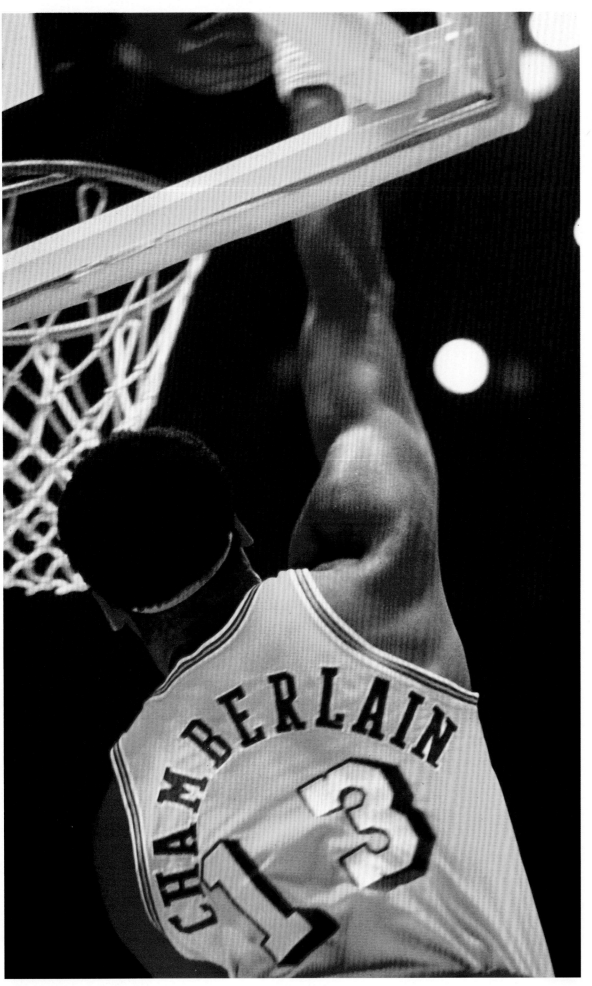

Wilt Chamberlain of the Los Angeles Lakers in action during the Lakers' 33-game winning streak, which lasted from November 5, 1971, to January 7, 1972. The Forum, Inglewood, California, December 1971

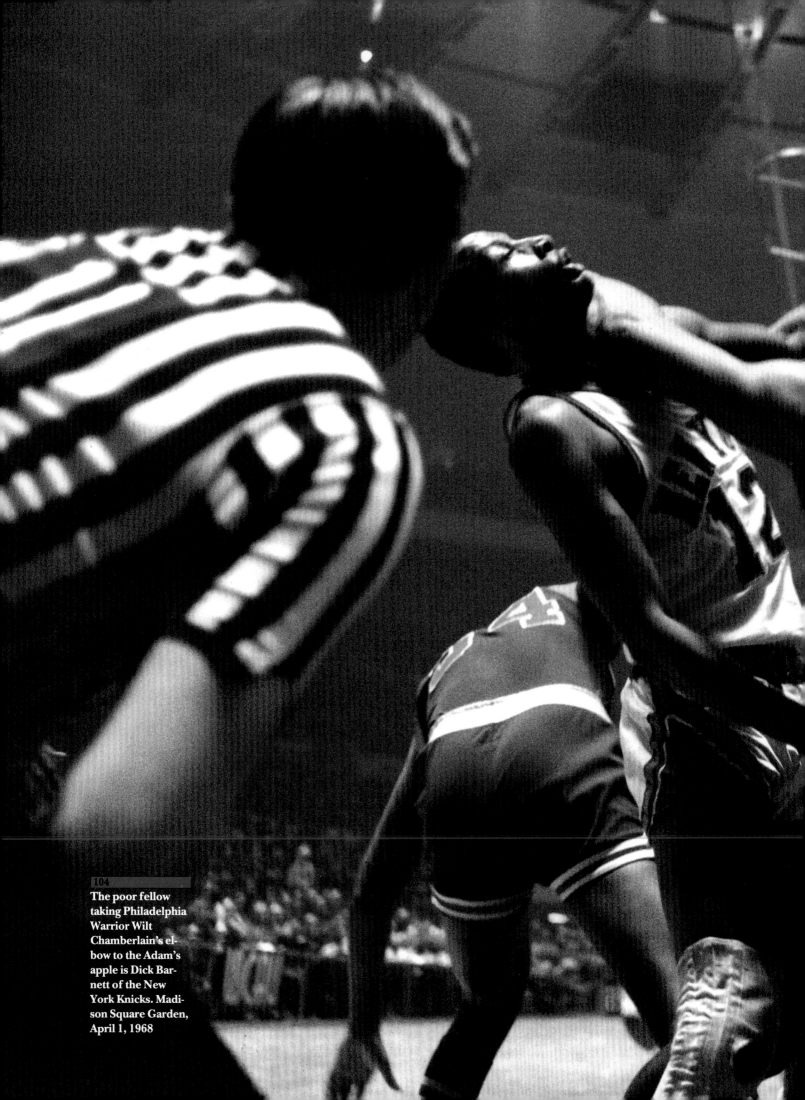

The poor fellow taking Philadelphia Warrior Wilt Chamberlain's elbow to the Adam's apple is Dick Barnett of the New York Knicks. Madison Square Garden, April 1, 1968

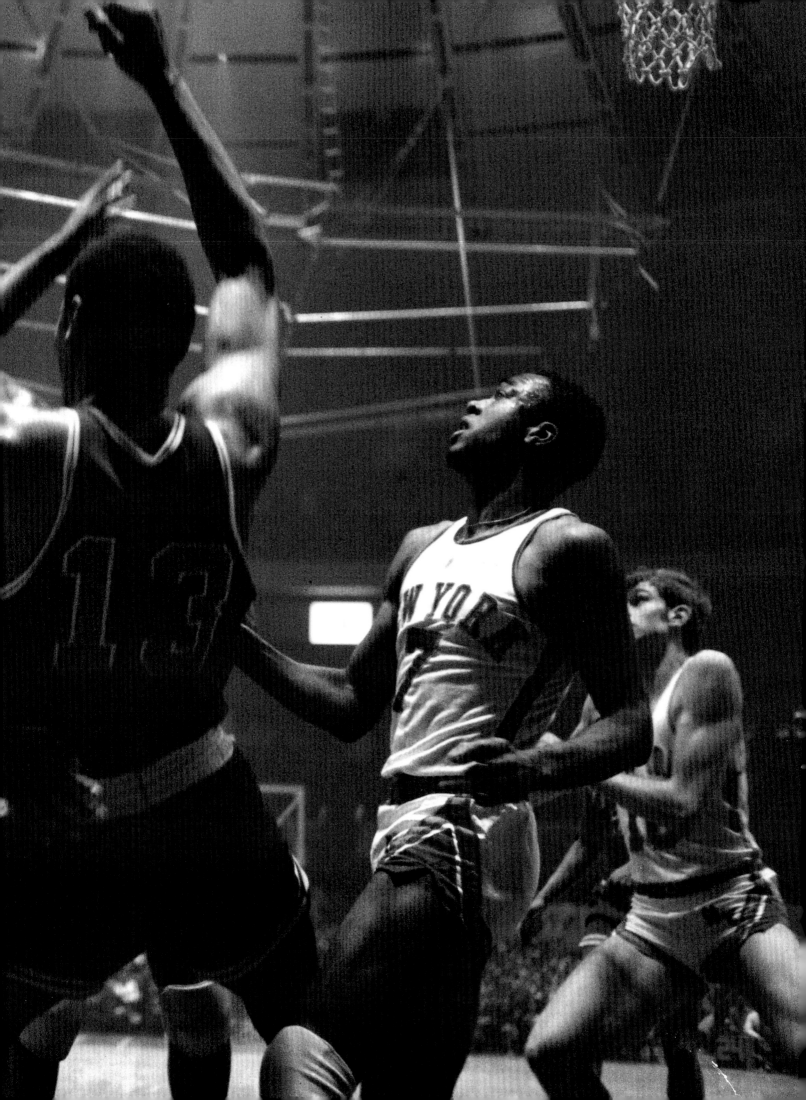

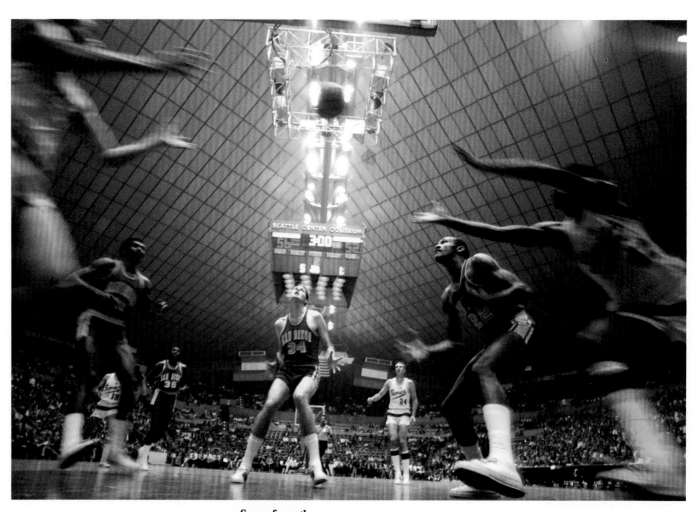

Scene from the
free-throw line dur-
ing an exhibition
game between the
San Diego Rockets
and the Seattle Su-
personics. Seattle
Center Coliseum,
Seattle, Washington,
late 1960s

106

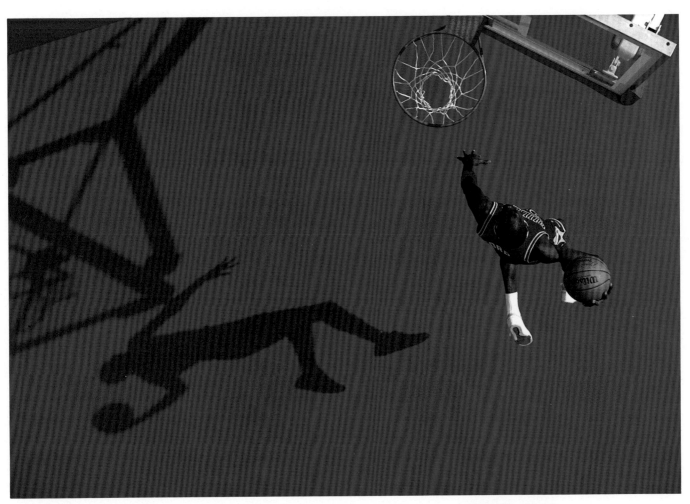

Michael Jordan of
the Chicago Bulls
practices at Illinois
Benedictine Col-
lege, where he held
his 1987 summer
camp for young ath-
letes. Lisle, Illinois,
1987

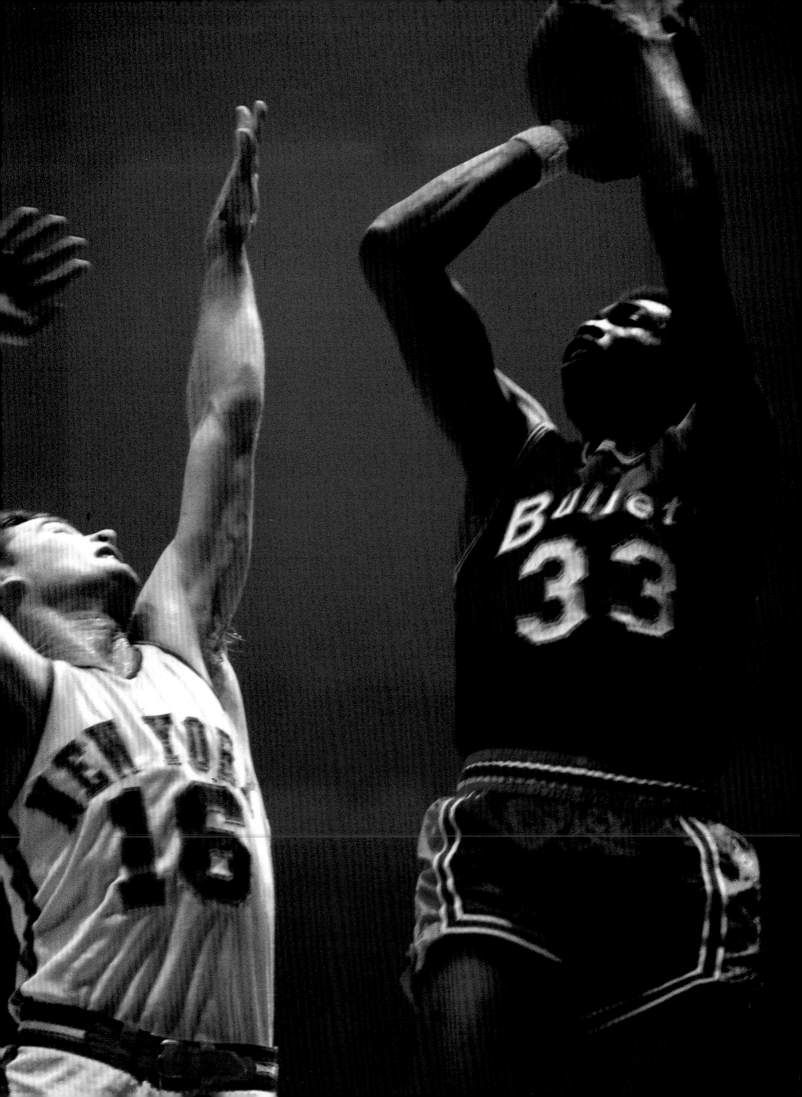

Madison Square
Garden, March 12,
1968

Earl Monroe (right)
of the Baltimore
Bullets goes for the
basket as Howard
Komives of the New
York Knicks at-
tempts to block the
shot.
 I was lucky
enough to be one of
the few white jour-
nalists ever to see
Monroe play at
Winston-Salem. The
crowd would chant:
"Earl, Earl, Earl The
Pearl! Earl, Earl,
best in the world!"

Bill Bradley of the
New York Knicks
attempts to block
the shot of Jerry
West of the Los
Angeles Lakers.
Madison Square
Garden, April 1972

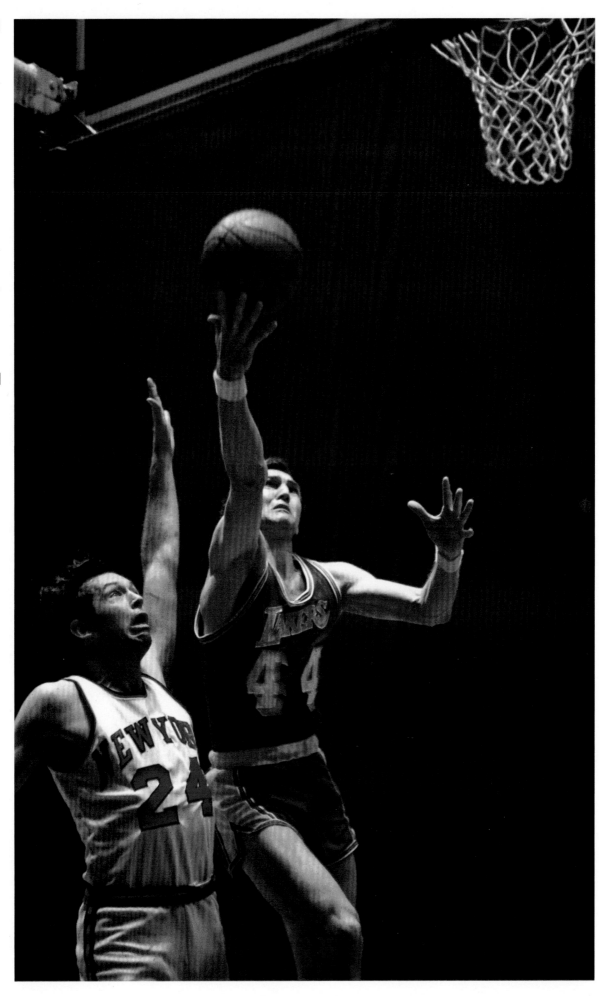

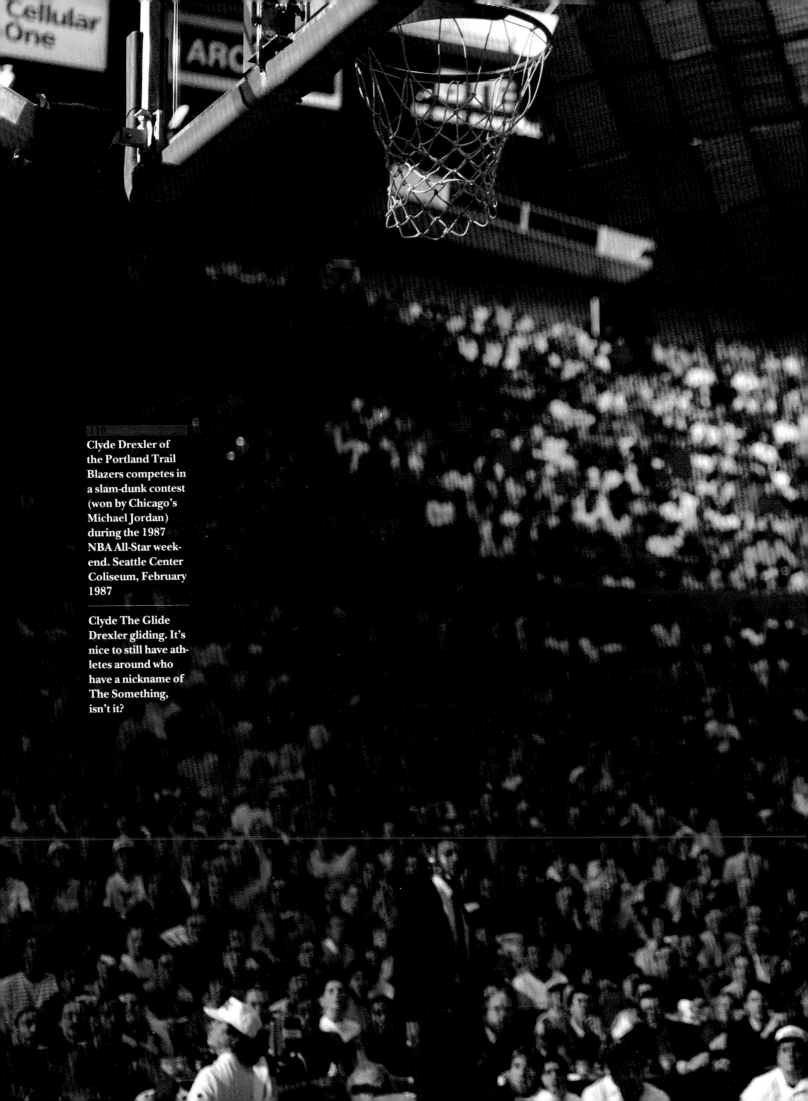

Cellular
One

Clyde Drexler of the Portland Trail Blazers competes in a slam-dunk contest (won by Chicago's Michael Jordan) during the 1987 NBA All-Star week-end. Seattle Center Coliseum, February 1987

Clyde The Glide Drexler gliding. It's nice to still have ath-letes around who have a nickname of The Something, isn't it?

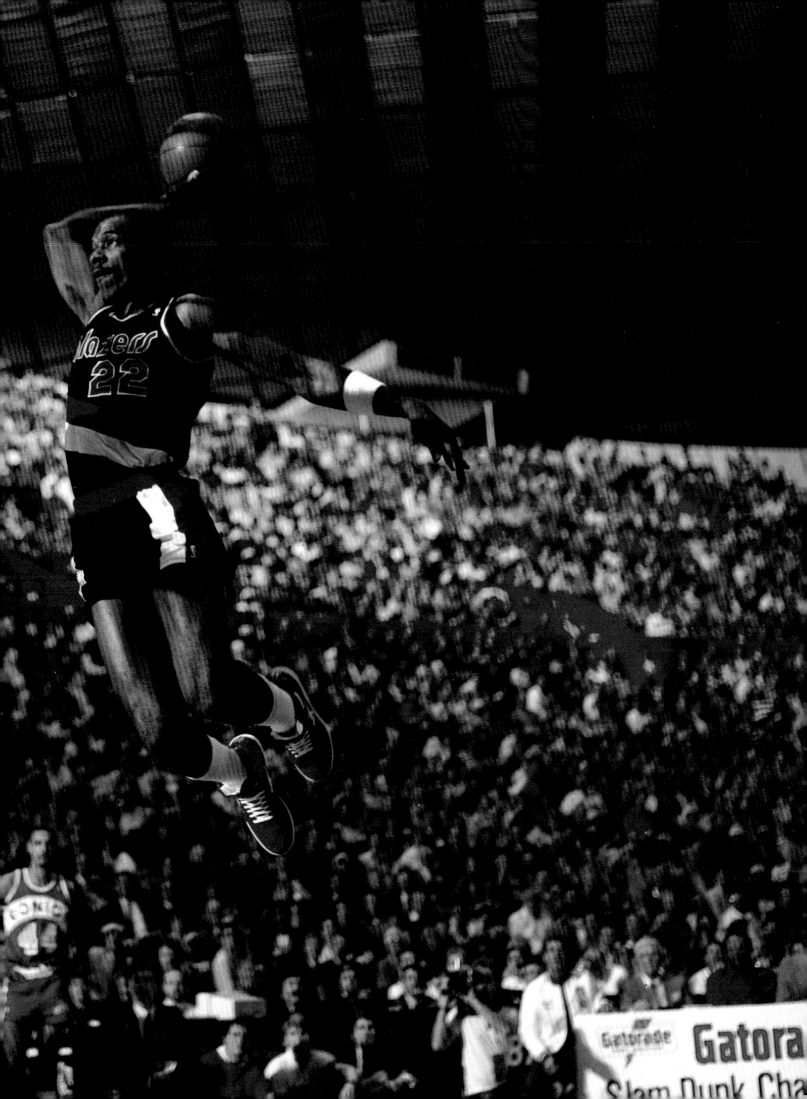

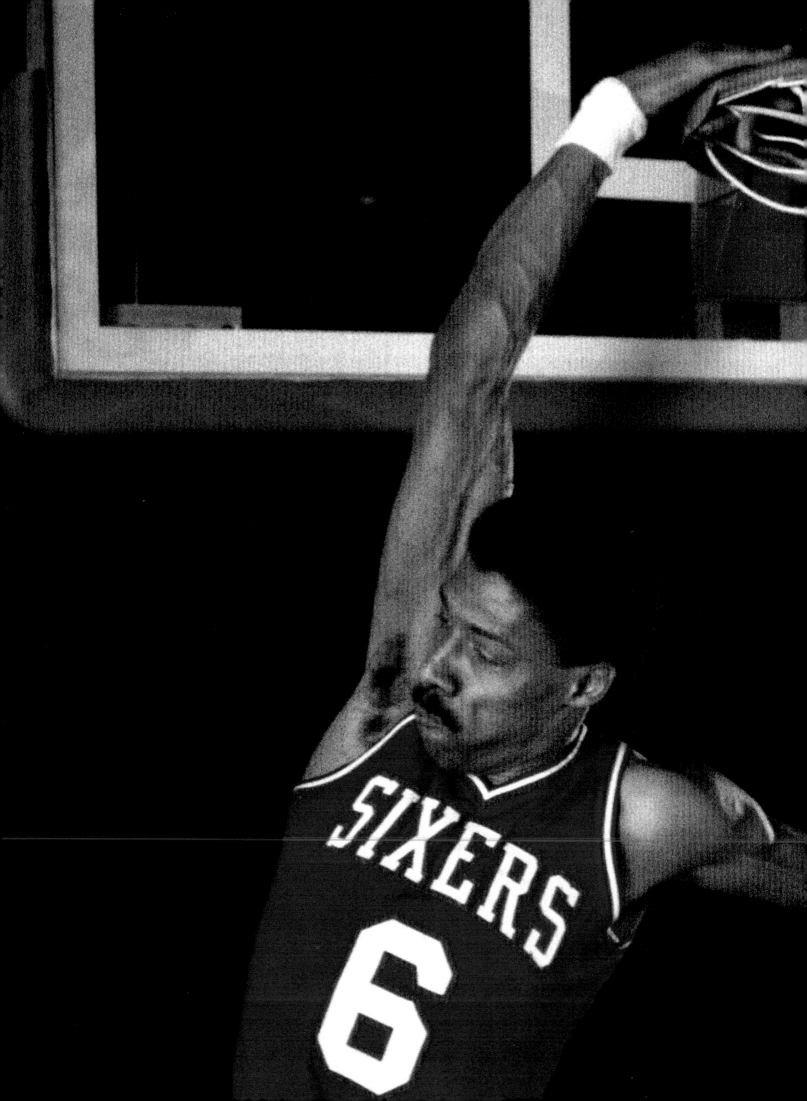

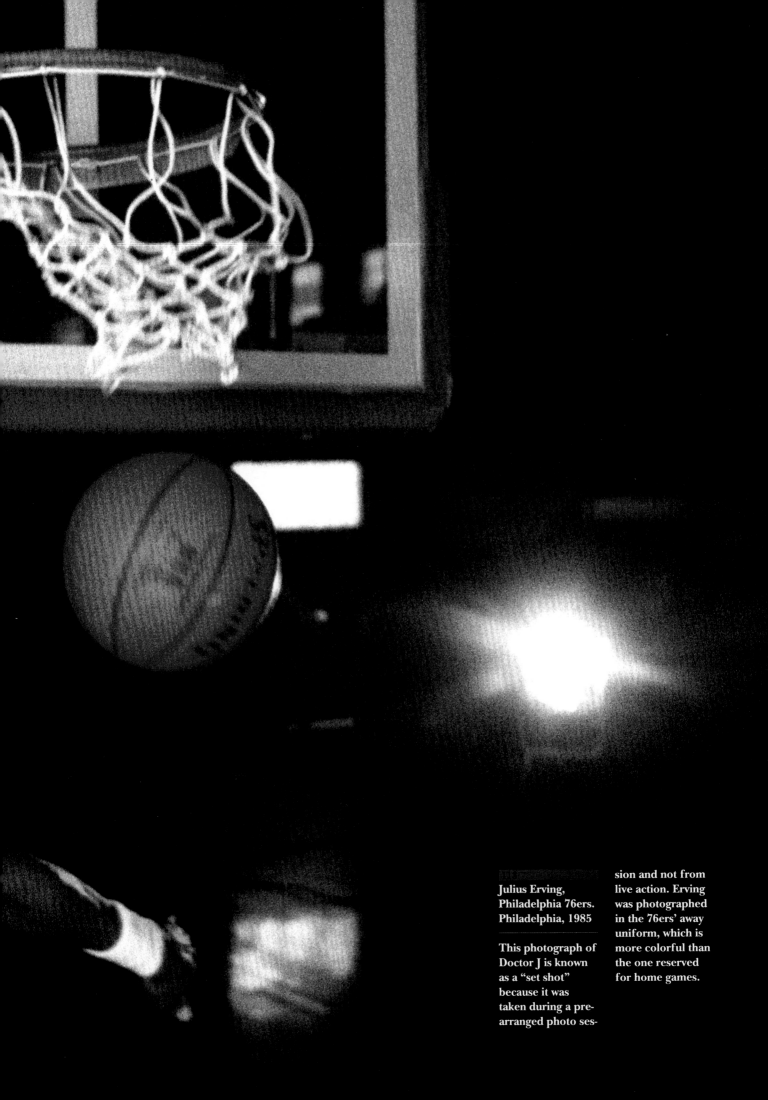

Julius Erving,
Philadelphia 76ers.
Philadelphia, 1985

This photograph of
Doctor J is known
as a "set shot"
because it was
taken during a pre-
arranged photo ses-
sion and not from
live action. Erving
was photographed
in the 76ers' away
uniform, which is
more colorful than
the one reserved
for home games.

Willis Reed of the
New York Knicks
during an NBA
Championship
game between the
Knicks and the Los
Angeles Lakers,
which was won by
the Knicks. The
Forum, 1970

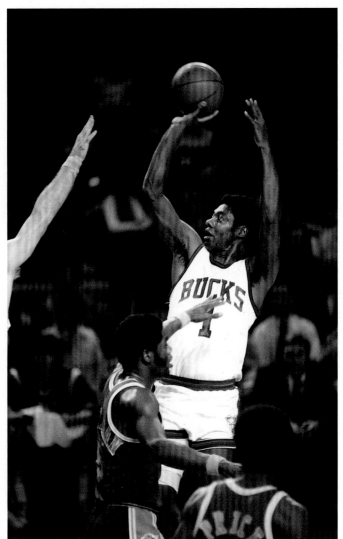

Oscar Robertson
of the Milwaukee
Bucks in a game
against the Los
Angeles Lakers.
Milwaukee Arena,
February 1973

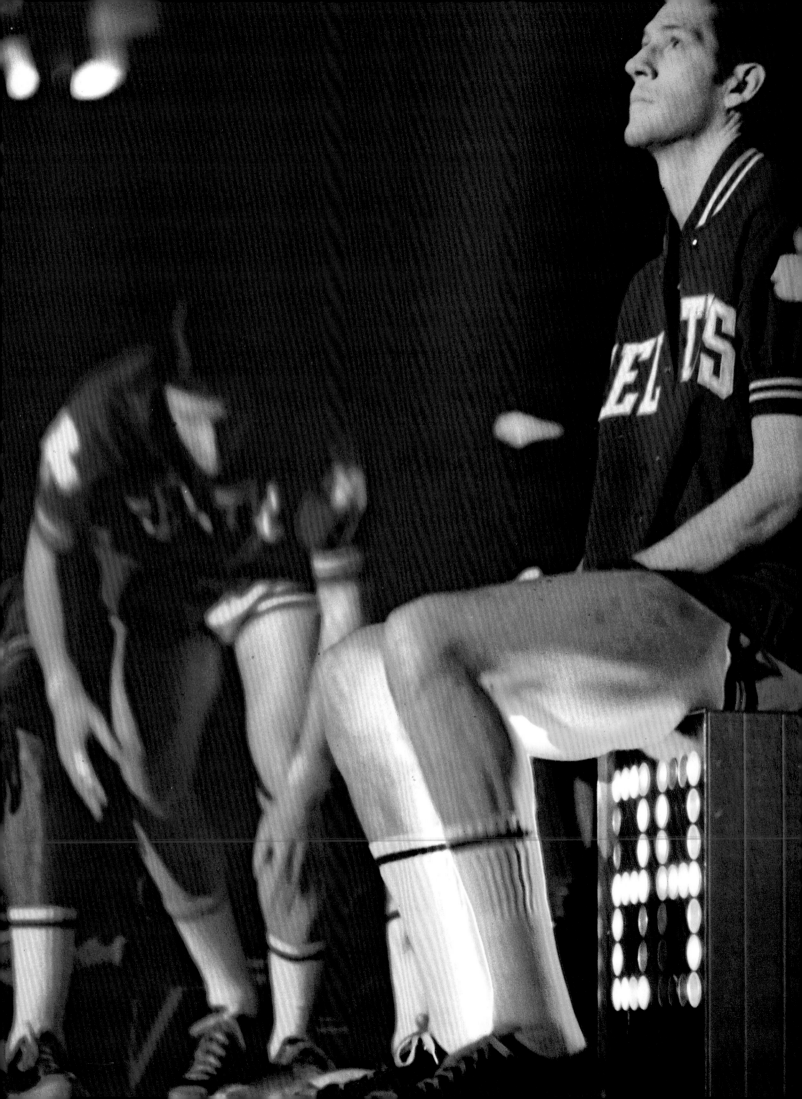

John Havlicek, Boston Celtics. Boston Garden, 1967

This was taken, Iooss says, "during my psychedelic era." Havlicek is sitting on the 24-second clock, while the team is being introduced before a game. Since that is Larry Siegfried just going out and Sam Jones beside him, it is possible that Havlicek was still being employed as a sixth man at this time. Celticologists may wish to discuss this point further.

Unidentified Phoenix Sun player in Milwaukee. February 1978

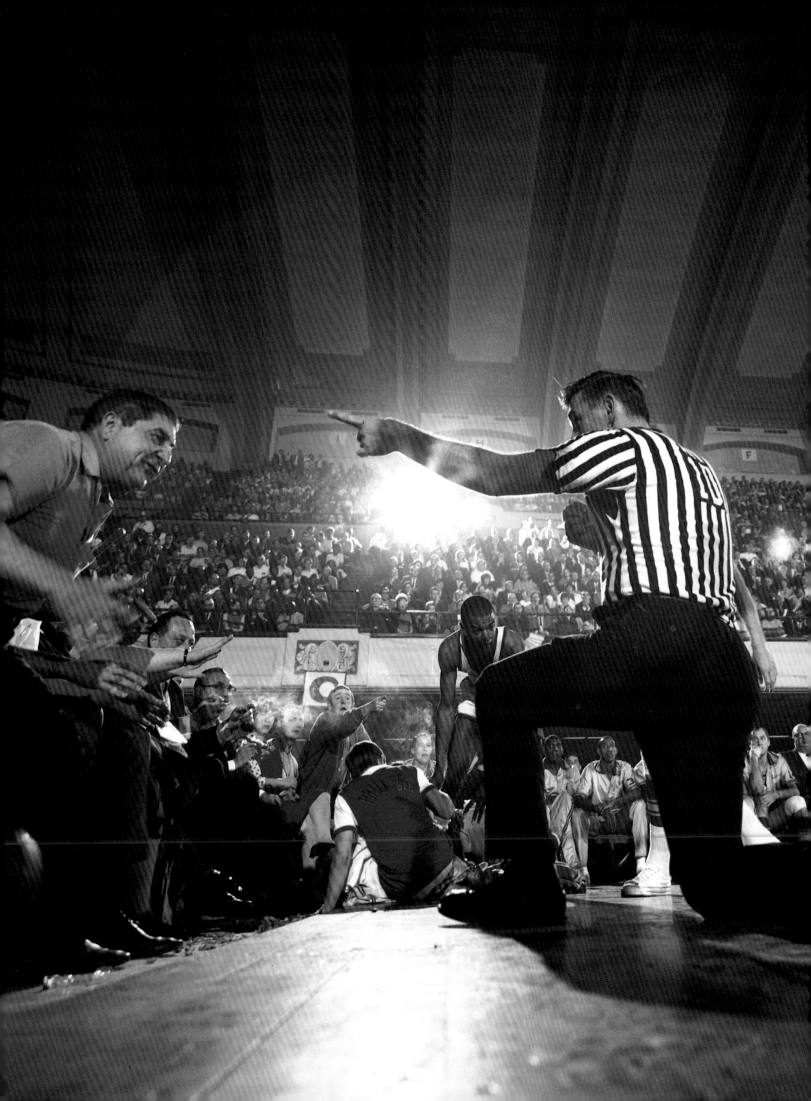

118
Referee Earl Strom.
Convention Hall,
Philadelphia, 1966

119
Bill Russell with
referee Mendy
Rudolph during a
game between the
Celtics and the
Cincinnati Royals.
Boston Garden,
March 23, 1966

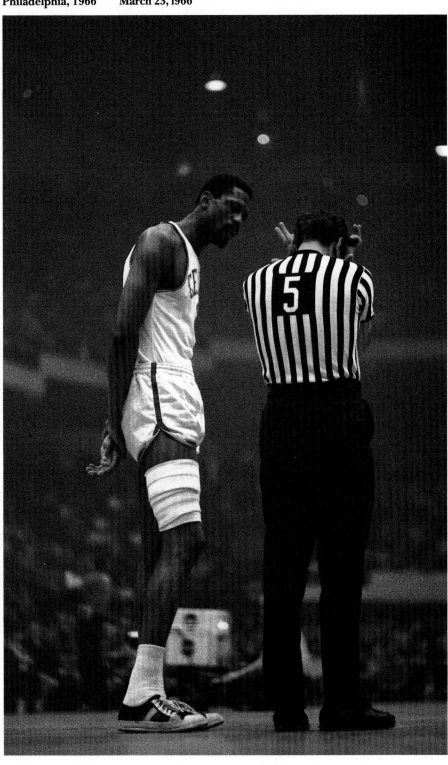

Marvin Webster
of the Seattle
Supersonics in the
locker room after
his team lost the
1978 NBA Champi-
onship to the Wash-
ington Bullets.
Seattle Center Coli-
seum, June 1978

BASEBALL & FOOTBALL . . . THE NATIONAL PASTIME & THE NATIONAL GAME

Everyone from philosophers to comedians has dined out on the differences between baseball and football and how that might relate to the national psyche. Football is a locker room. Baseball is a clubhouse. Football is time. Baseball is infinity. You go with your father to a baseball game and then you take your own son. You take a girl to a football game and buy her a corsage. Baseball is beer. Football is a nip out of a flask. A baseball is at the letters. A football lands on the numbers. But baseball is awash with numbers—statistics—and football is letters—*x*'s and *o*'s. And so on and so on. Baseball is the poet in us, football the warrior. Baseball the dreamer, football the pragmatist.

Jacques Barzun wrote: "Whoever wants to know the heart and mind of America had better learn baseball—the rules and realities of the game."

Teddy Roosevelt wrote: "In life, as in a football game, the principle to follow is: Hit the line hard."

Yet for all the hard-hitting hard noses, football is our greatest spectacle, and for all that baseball might reveal about our hearts and minds, how do we explain this: the two places outside the United States where baseball has taken hold are Latin America and Japan—surely the most disparate cultures and temperaments as there are in the world.

Literally until the last five years, when football has become a popular television attraction in Europe, it remained strictly American. Apart from football, it is difficult even to name any other prominent American institution that could not find appeal abroad. By contrast, not only has baseball been accepted, selectively, elsewhere, but basketball (the most all-American game of all, with no foreign antecedents) has proved the most popular American export of all, taking hold in almost all the dusty corners of the globe.

I think foreigners quickly catch on that there is nothing much to be taught by football—whether about America or about football. However intricate the plays and formations may be, there is nothing arcane to them. By contrast, so much of baseball is what you don't see but what you must consider. If Herzog brings in a righthander, then does Craig send up his last lefty pinch hitter now or save him on the chance that Herzog will come back with Smith in the next inning? Appreciating football is like getting a green card and becoming a citizen; catching on to baseball is more like getting into the American club.

Curiously, though, the two sports have been heading in different directions almost from the time they invaded the American consciousness a century ago. Whereas baseball was, from the first, a town game, genial and democratic, football was primarily collegiate, the brawniest part of what was called muscular Christianity. Essentially, the college boys used football to show that they could be every bit as tough as the unschooled *hoi polloi.* The lower classes then didn't play football for the same reason they don't jog now. Work was too damn hard without working again after work.

Baseball was another game altogether. It was for playing, and it was also for bonding. Baseball served as mucilage to bring a city together, like the trolley lines, which developed about the same time. It has been said that the best ways for an immigrant to make his mark in American society were with the Catholic church, the Democratic party, organized crime, or baseball. College boys played baseball too—early on, in fact, it was as much a spectator sport on campus as was football—but from the start college baseball was subsidiary to the professional leagues. By contrast, football didn't even throw up an embryo professional league until a half century after baseball was firmly established as a vocation.

Although the term we always hear to describe baseball—"national pastime"—didn't gain currency until well into the twentieth century, baseball was pastime as much as sport almost from the beginning. It took a while to be truly national, though, for the rural South did not lend itself to baseball home teams nearly so well as the industrial North. Indeed, when the minor leagues first began to expand into the larger southern cities, most of the players were Yankees who were exported to Dixie in the same way that ice hockey shipped in Canadians to stock U.S. teams when it first moved south of the border.

By the beginning of this century, the South was turning out its own stars, like Ty Cobb—The Georgia Peach—and Shoeless Joe Jackson, but the South always cottoned more to football. Besides the difference in population distribution, this has been attributed to everything from the debilitating summer weather to the more warlike Celtic streak that is most prominent in our southern regions. I've also always found it especially interesting that whereas football (and basketball, as well) is a popular spectator sport in high school and college—often, indeed, the largest social focus in some small communities—baseball is played almost in private all the way up the ladder to the big leagues. Baseball is enjoyed much more for itself by the players, but football needs the crowds and the panoply. When the point is regularly made that football is analagous to war the connection is usually seen in terms of strategy, taking territory, battling in the trenches, that sort of thing. But I am reminded more of what some old general once said: "We only fight wars for the women watching." Who, in their right minds, ever would have blocked and tackled, *for fun,* as amateurs, if beautiful southern belles weren't there to admire those labors?

But as time has passed—and especially since World War II—the two sports have reversed roles to a large extent. Football, which began as an upper-class indulgence, has become the sport of greatest mass appeal—taking not only a large chunk out of baseball but some of the blood lust from boxing and the gambling thrills from horse racing. Football players, like boxers of the past, tend increasingly to come from the lower economic classes. Something approaching three-quarters of the rosters in the NFL are black, while in the suburbs the heirs of the first All-American gridders now play soccer, a foreign game.

Meanwhile, baseball, which started out as the proletarian sport, is now recognized as a very intellectual pursuit, a sweaty game of chess. Baseball's major-league population is much more representative of a national cross section, and the president of Yale—where football was first shaped and

cosseted, and then given to the world—departed academia and his specific discipline, Renaissance literature, to become the president of the National League. The latest difference between football and baseball is this: football televises well; baseball reads well.

Moreover, baseball has not only become accepted as cerebral, but it has all but taken a place in the national charter. Momentarily one expects to learn that Ben Franklin invented it, George Washington led his troops in it at Valley Forge, Thomas Jefferson designed Fenway Park, and Hamilton and Burr were arguing the merits of DiMaggio and Williams. Indeed, not only has baseball managed to have itself identified as a major strain in the American cavalcade, but (an even neater trick) it has also managed to worm its way into the Gregorian calendar—replacing robin redbreasts, jonquils, and a young man's fancy as the very manifestation of spring.

Peruse Iooss's photographs in the football and baseball sections. Two of the eleven baseball pictures here—and the shot of Dwight Gooden on page 84—were taken during spring training. Now look at the football selections. Rest assured all the photographs were shot in the heart of the season, the heat of the action: during big games, before big games, preparing for big games, after big games. Football is all big game. Nobody ever takes photographs of preseason football. Nobody ever writes about it either. Very few people even know where it is.

Ah, but spring training, for pen or lens, is lyrical, lovely, nostalgic, precious, Rupert Brookian. Also, it is warm and sunny. At spring training, *every year* there is a great deal that must be said about the rhythm of life. The sportswriter who hasn't gone to the Grapefruit League and solemnly discovered renewal and rebirth doesn't deserve to get a suntan and a night at the dog track.

Sometimes I think that the "regular" season, so-called, exists simply so that baseball can have spring training before it. But what the hell is football preseason? And why doesn't anybody ever write lovely paeans to it? Of everything different about football and baseball, nothing distinguishes them more than their annual period of gestation. Football simply reinvents itself every year, like a new product line. But in a perverse way, spring training is not so much a starting over as it is a return. Spring training is not only the most timeless part of baseball but also its most direct connection to the past—which is so important to baseball.

Above all, spring training is a going back, which is why everybody does, why Walter will lug his camera back some other year, and me my notepad, and all of us our memories.

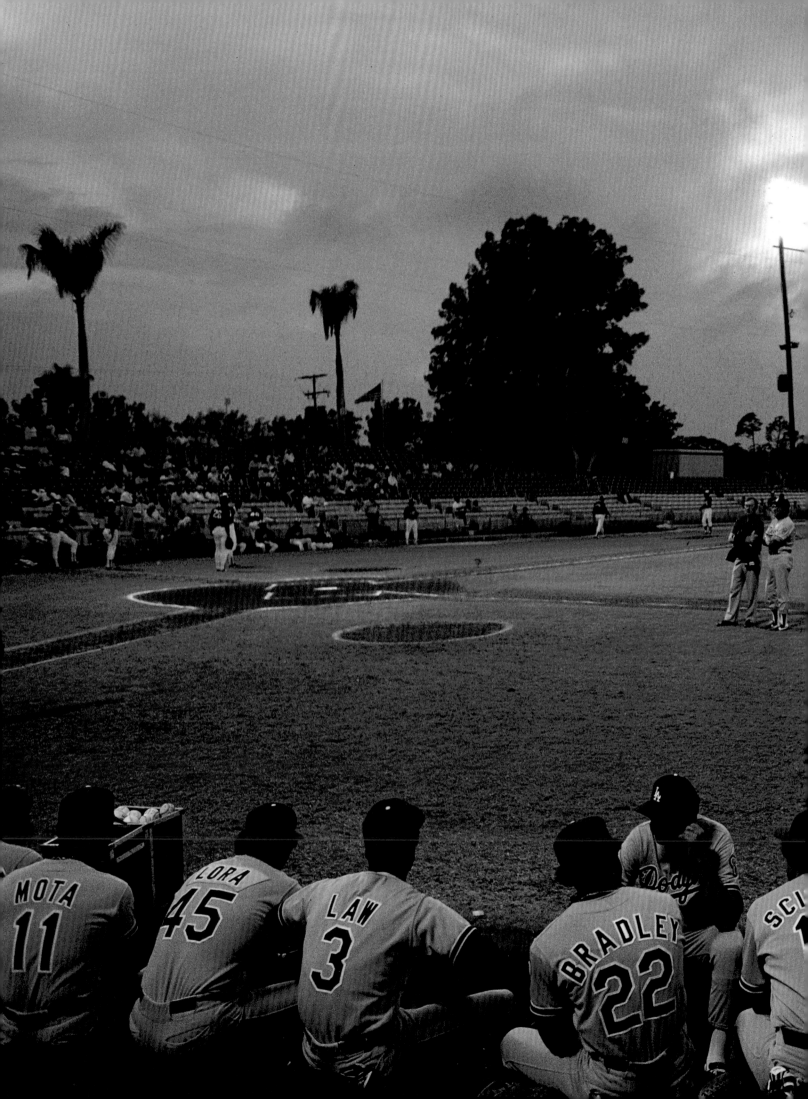

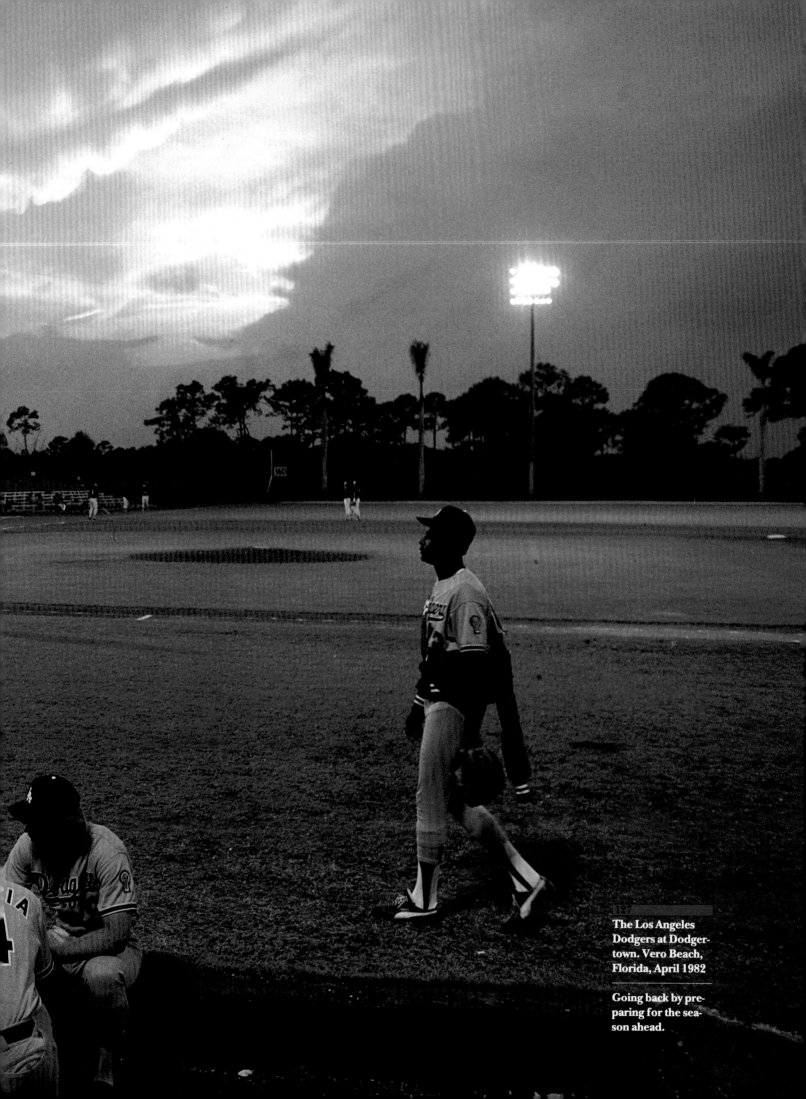

The Los Angeles Dodgers at Dodgertown. Vero Beach, Florida, April 1982

Going back by preparing for the season ahead.

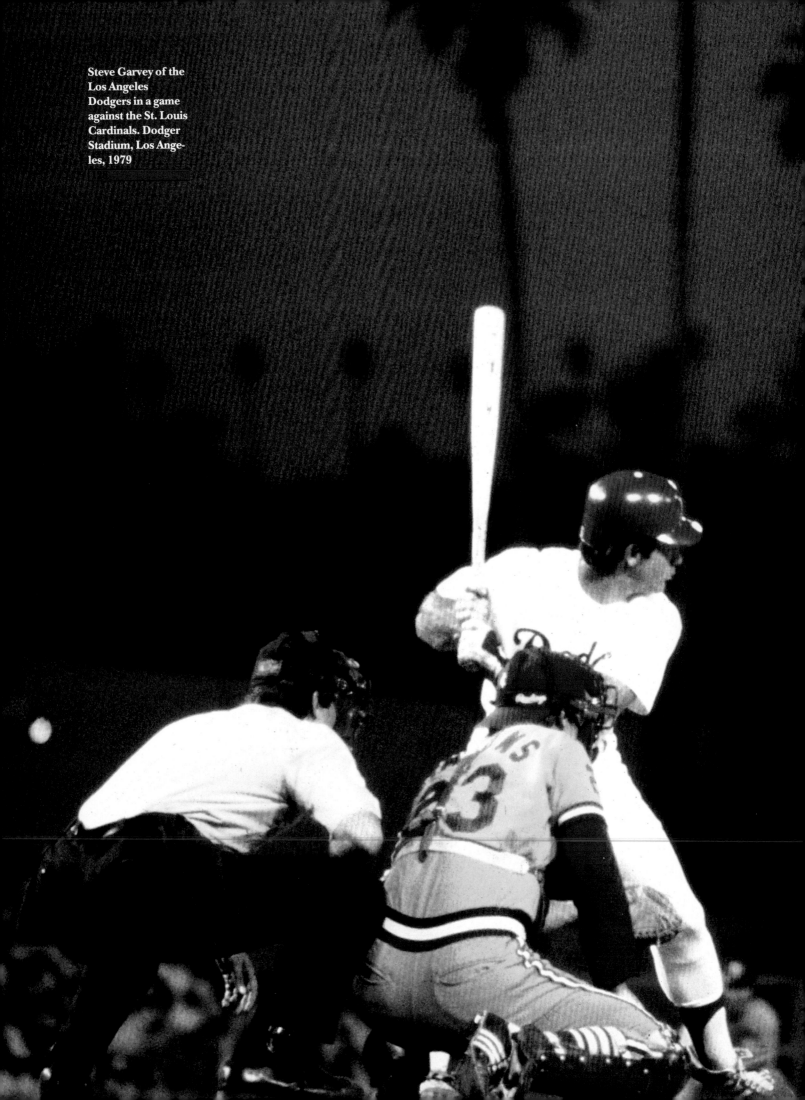

Steve Garvey of the
Los Angeles
Dodgers in a game
against the St. Louis
Cardinals. Dodger
Stadium, Los Ange-
les, 1979

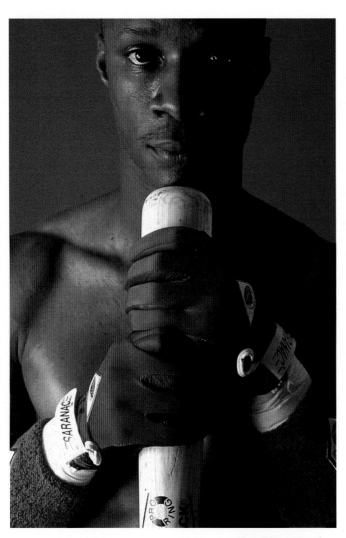

Darryl Strawberry, New York Mets. Shea Stadium, Flushing Meadows, New York, August 1986

Willie Mays, San Francisco Giants. 1965

Bob Ojeda, New York Mets. Dodger Stadium, 1986

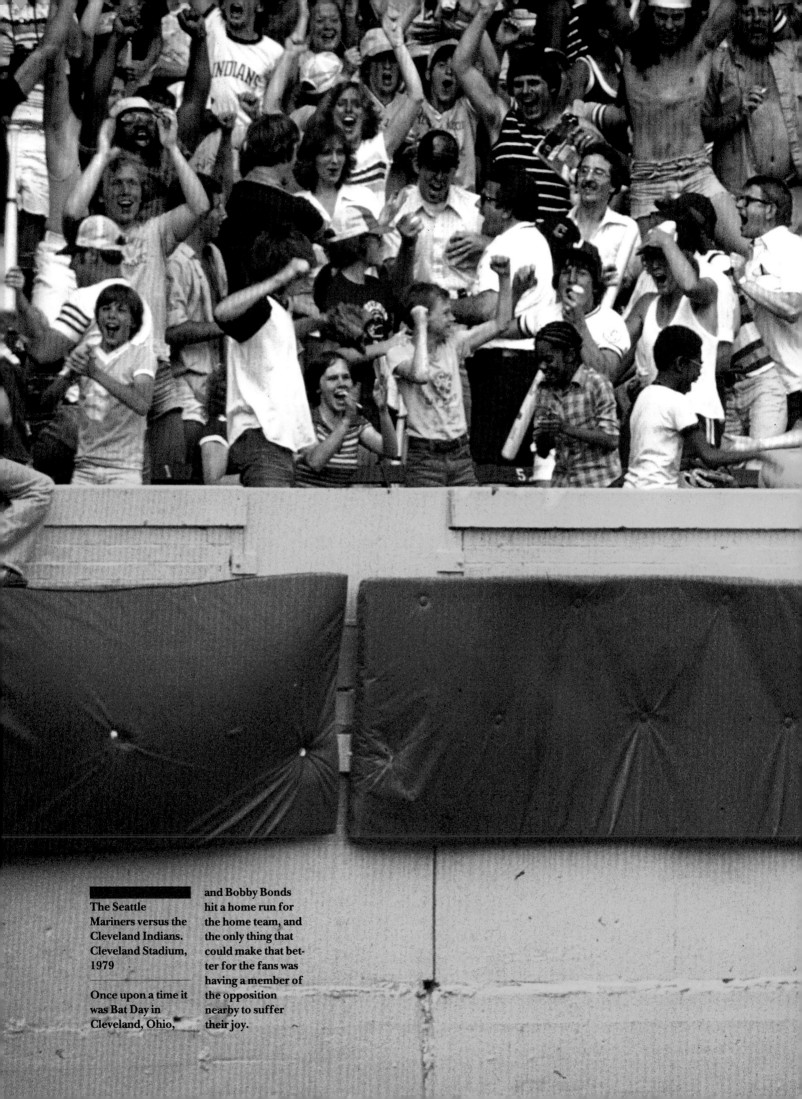

The Seattle Mariners versus the Cleveland Indians. Cleveland Stadium, 1979

Once upon a time it was Bat Day in Cleveland, Ohio, and Bobby Bonds hit a home run for the home team, and the only thing that could make that better for the fans was having a member of the opposition nearby to suffer their joy.

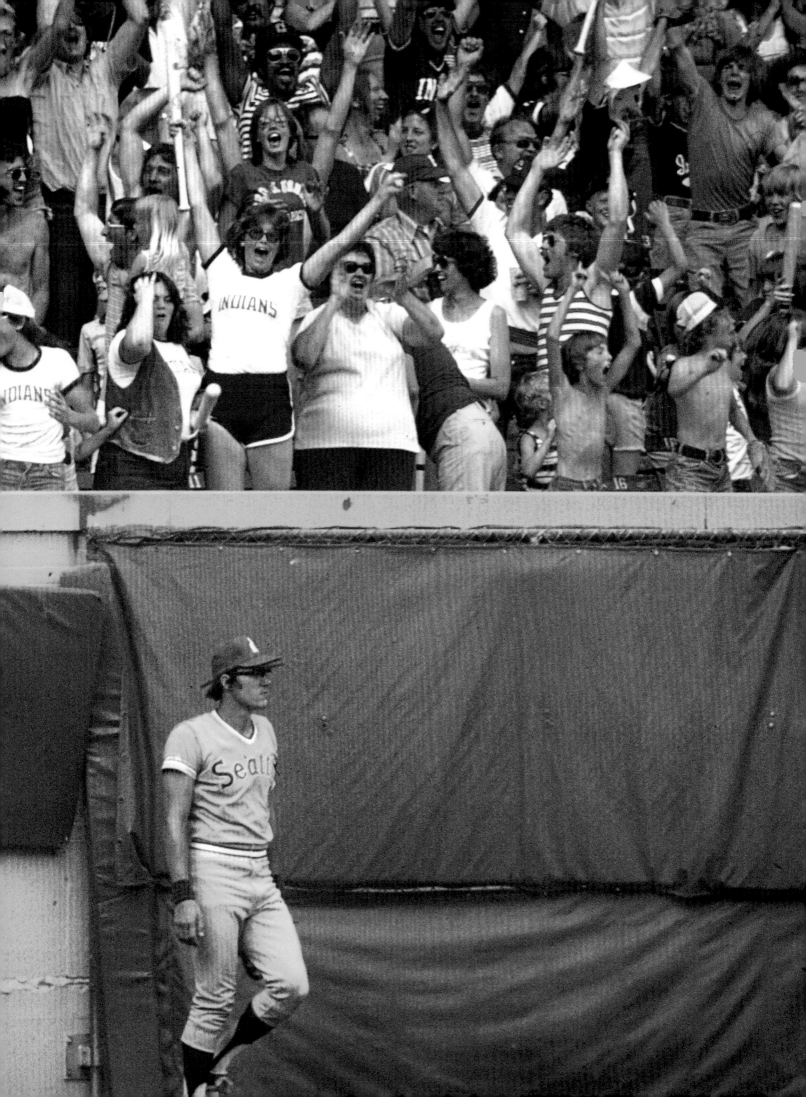

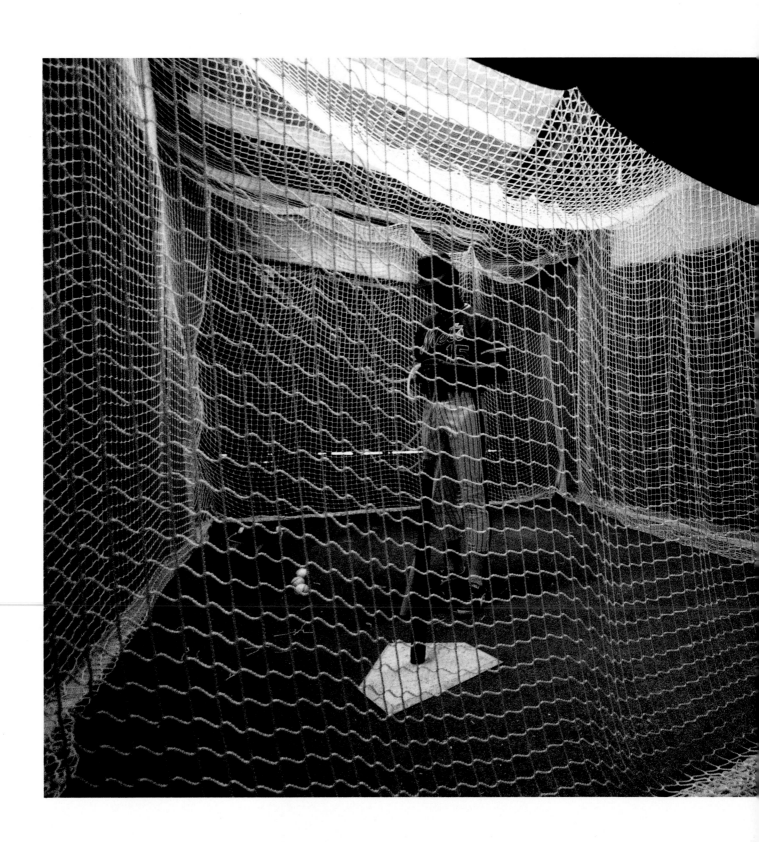

George Foster, New York Mets. Shea Stadium, May 1986

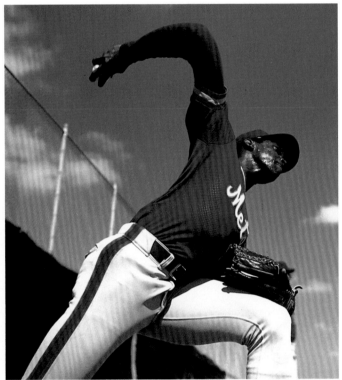

Dwight Gooden, New York Mets. St. Petersburg, 1985

A great many people have pointed out that throwing a ball underhand, as, for example, softball pitchers do, is the natural human motion. Throwing a baseball overhand is physiologically perverted, and looking at this picture you only wonder why more pitchers aren't ruined early by bad arms. Dwight Gooden was only twenty years old when this shot (complete with some of Walter's favorite clouds) was taken. Iooss looked at the shot and assumed that Gooden was turning over a curve, but when Gooden saw the picture himself he said it was a change-up.

136

Eric Davis,
Cincinnati Reds.
Candlestick Park,
San Francisco,
California, August
10, 1987

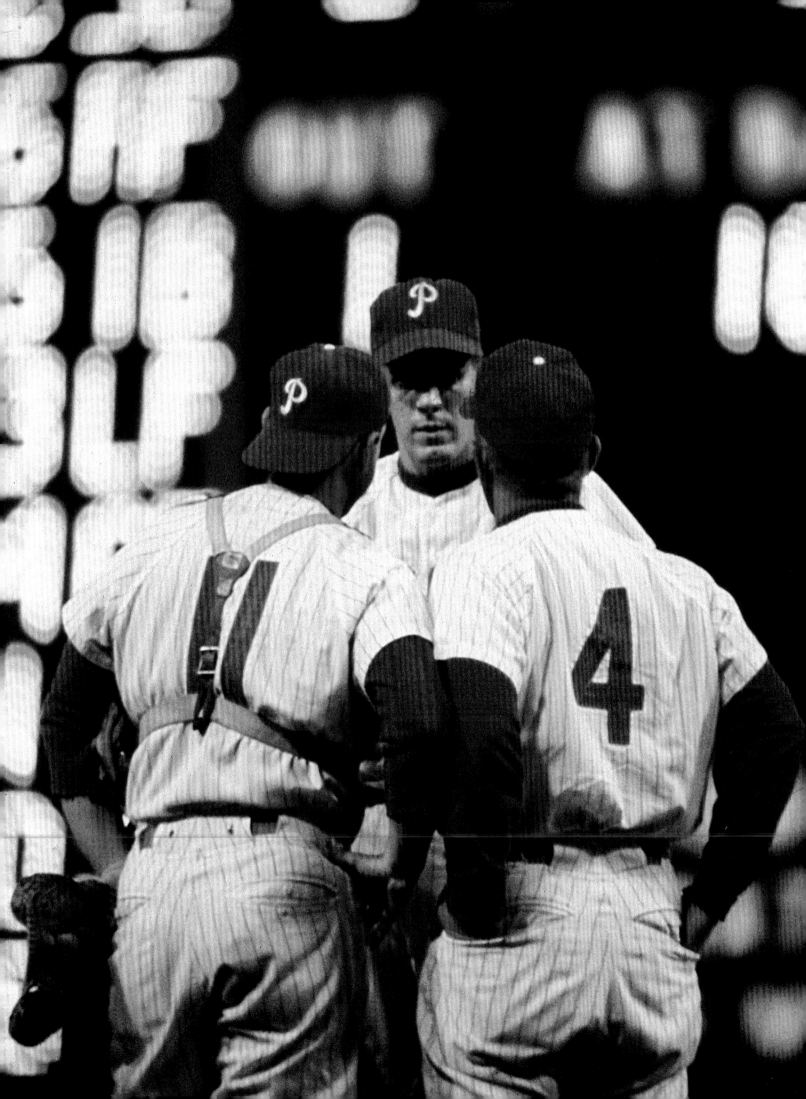

Catcher Clay Dalrymple and pitcher Art Mahaffey of the Philadelphia Phillies confer on the mound with manager Gene Mauch (number 4). Connie Mack Stadium, Philadelphia, 1963–64

Memorial Stadium, Baltimore, Maryland, October 1971

Roberto Clemente led the Pittsburgh Pirates to victory over the Baltimore Orioles in the 1971 World Series, but he died fifteen months later, in a plane crash, taking food to disaster victims in Nicaragua.

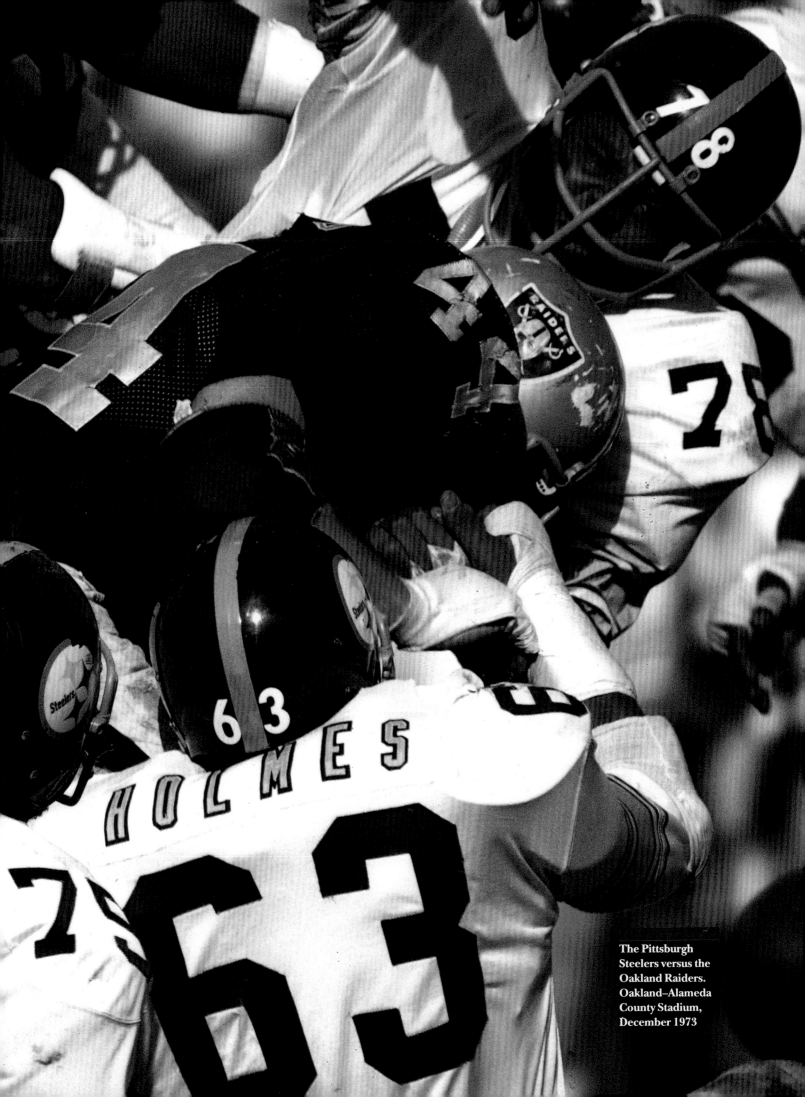

The Pittsburgh
Steelers versus the
Oakland Raiders.
Oakland–Alameda
County Stadium,
December 1973

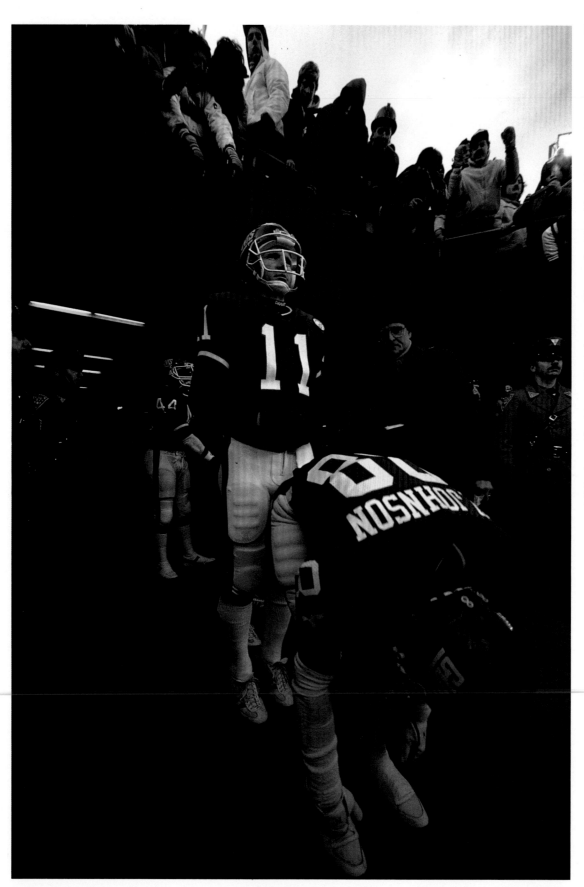

New York Giants quarterback (or field general, as they are called) Phil Simms before the 1986 NFC Championships, in which the Giants defeated the Washington Redskins 17–0 to go on to Super Bowl XXI. Giants Stadium, East Rutherford, New Jersey, January 1, 1987

Orange Bowl, Miami, Florida, January 1969

Joe Namath takes a break during Super Bowl III, in which he led the New York Jets to victory over the Baltimore Colts, 16–7. This may well be the most famous photograph ever of Namath.

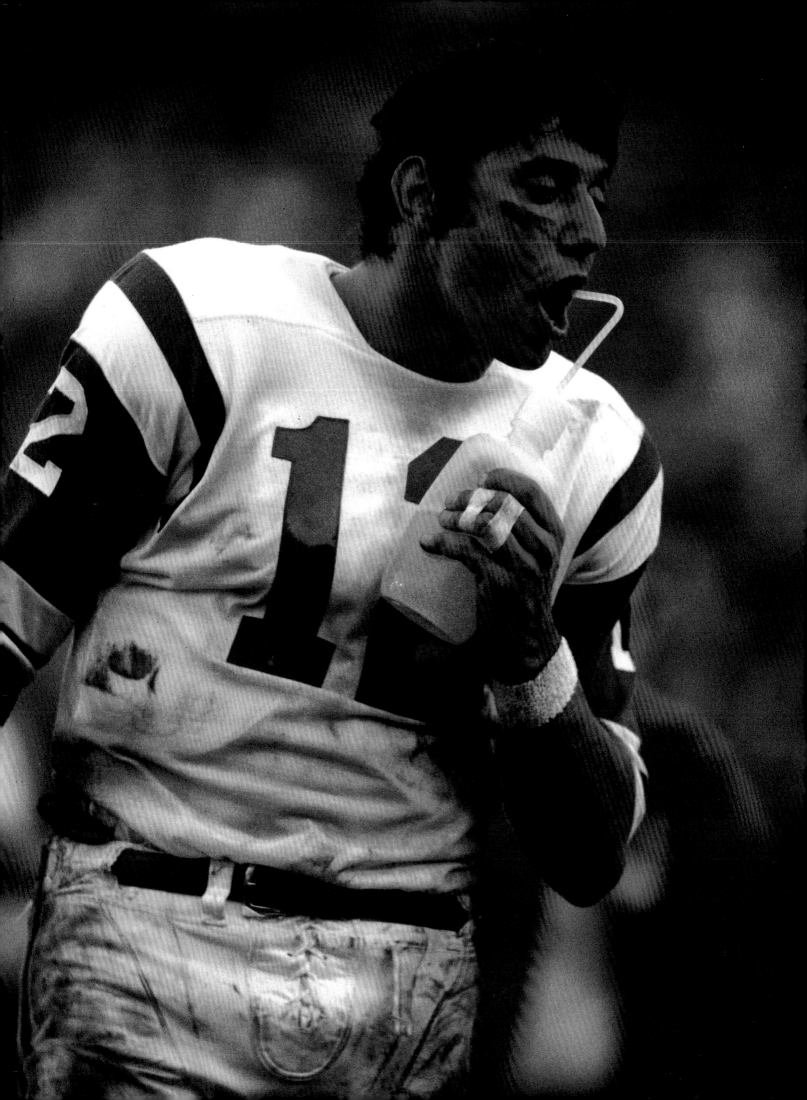

Mark Bavaro of the Giants crosses himself after scoring in Super Bowl XXI against the Denver Broncos. The Giants defeated the Broncos 39–20. Rose Bowl, Pasadena, California, January 25, 1987

This is the sort of picture that drives other photographers batty about Iooss. It is the single best known shot to come out of the 1987 Super Bowl and is already one of the most famous of all Super Bowl shots. But the facts are these: most football players nowadays drop or spike the ball after scoring. Most are immediately encircled by teammates. Most look back, toward the field. How did Iooss happen to be standing at the end of the field when a player scored a touchdown, kept the ball, remained by himself, looked in the wrong direction—and then prayed? In the Super Bowl?

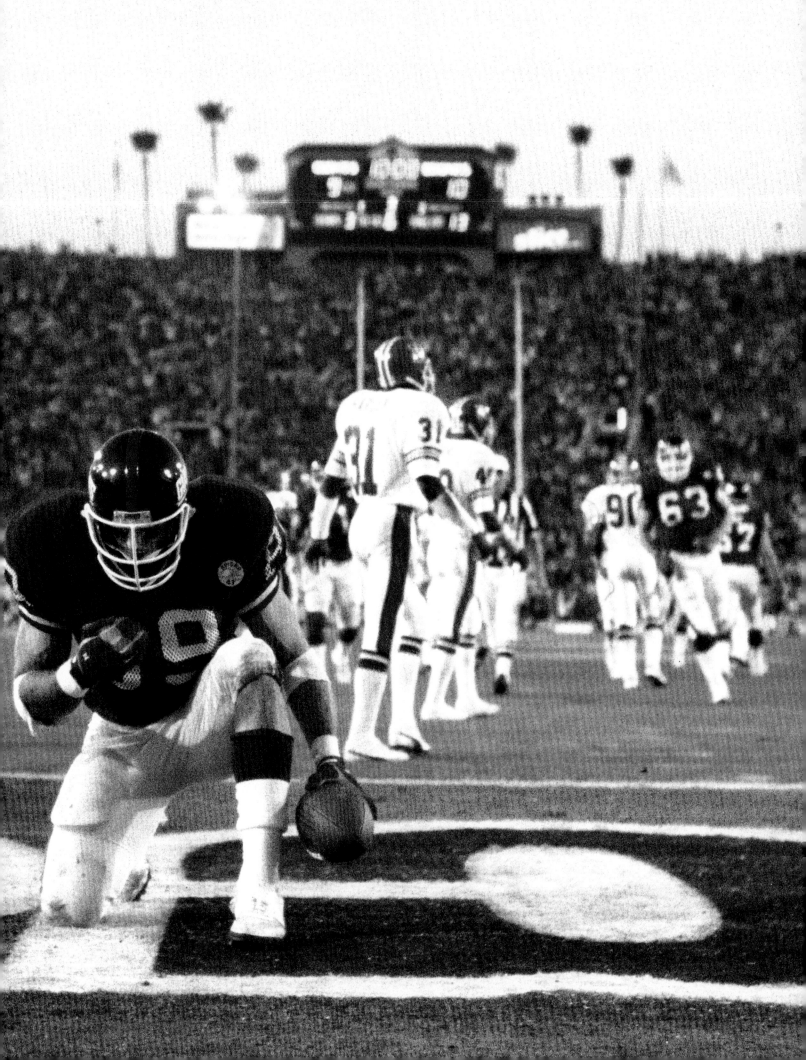

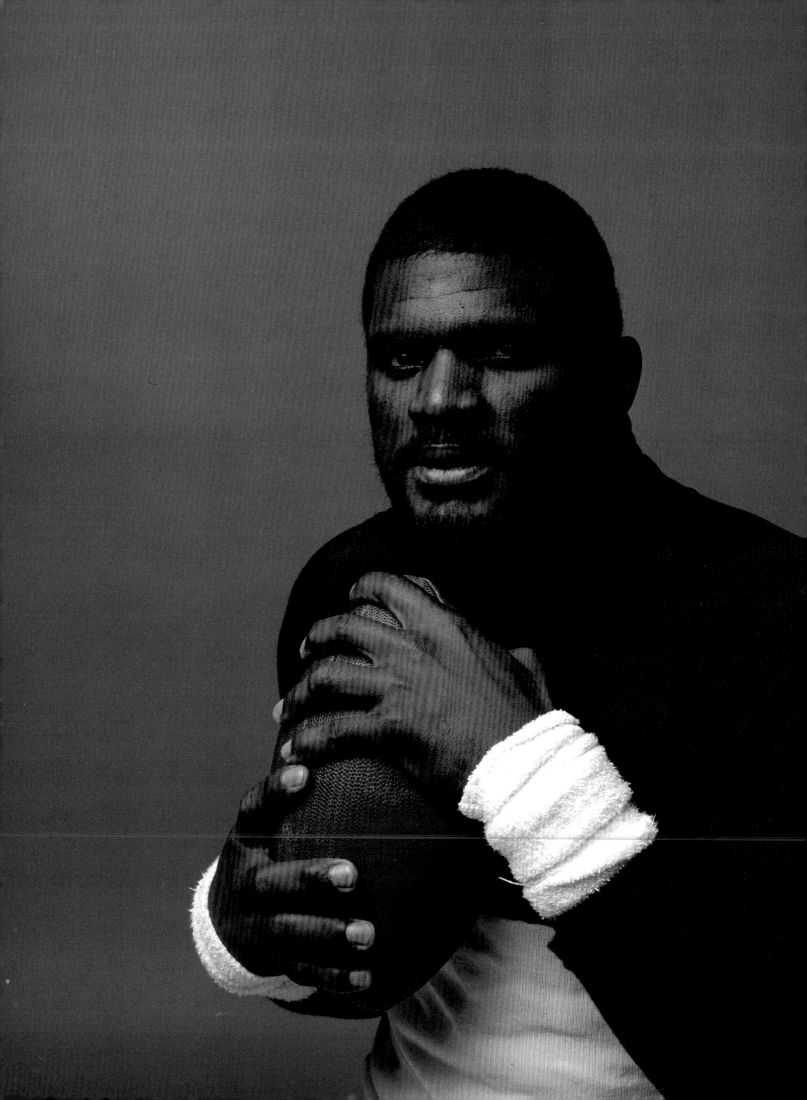

**Miami Dolphin
Mike Charles.
Orange Bowl, Sep-
tember 1985**

**Lawrence Taylor,
New York Giants.
Locker room,
Giants Stadium,
January 1987**

Taylor told Walter
he had a "couple of
minutes" to shoot
him—then timed
the 120 seconds.

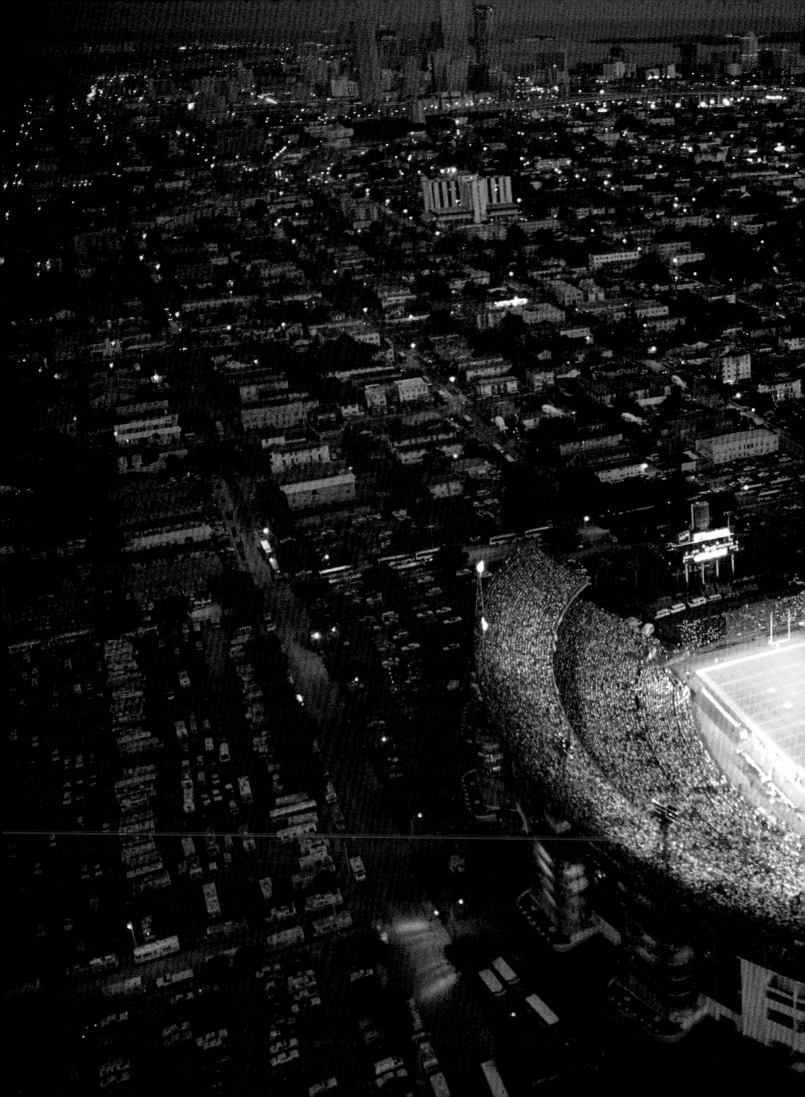

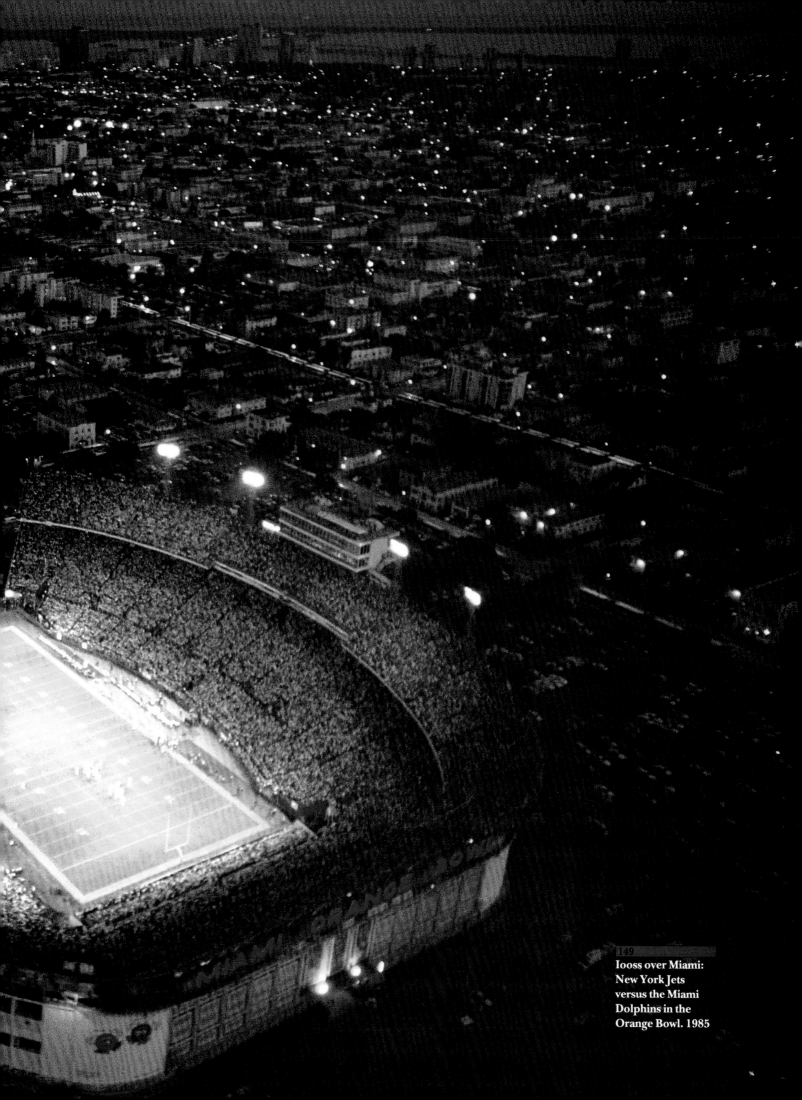

Iooss over Miami: New York Jets versus the Miami Dolphins in the Orange Bowl. 1985

The Miami Dolphins versus the New England Patriots. Orange Bowl, Miami, Florida, October 1985

The Miami Dolphins versus the Green Bay Packers. Lambeau Field, Green Bay, Wisconsin, 1985

VICTORY
&
DEFEAT

There is very little to say about victory and defeat that isn't terribly pretentious. In fact, originally brilliant things said about victory and defeat have grown hackneyed by now (see especially Kipling, Rudyard, and Rice, Grantland). However, if you look at these pictures, I believe that what is most fascinating is how close the two extremes are—or, anyway, appear to be. The only way, for example, you can guess that Guillermo Vilas won the U.S. Open is by the expression on the face of the happy fellow *next* to Vilas. Vilas himself looks to be in anguish. Compare the photograph of Jimmy Connors after winning (another U.S. Open) and the shot on page 120 of Marvin Webster after losing (an NBA championship). The similarity is amazing. If there were that much difference between victory and defeat, I don't think athletes would keep playing games. I suspect athletes—who are, after all, young people for the most part—are more resilient to defeat than we would think. Sure, we all like to win, but I suspect we'll settle just to play. There's much truth, I believe, in what compulsive gamblers always say, that the best thing is winning, and the almost best thing is losing. Something you hear in sport all the time is that some people can't stand to lose and other people don't know how to win. I used to think that was a lot of smoke that coaches liked to blow in pep talks, but I've come to believe it's really quite true. Whatever defeat may be, victory usually must be learned.

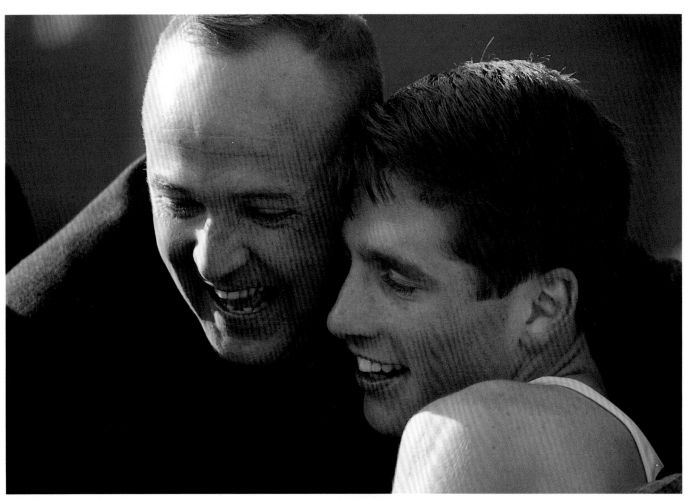

Marty Liquori,
Penn Relays.
Franklin Field,
Philadelphia, April
1967

Essex Catholic High
School track star
Marty Liquori and
his father celebrate
after the younger
Liquori won a race
at the Penn Relays.

It's an absolutely
joyous picture, isn't
it? My sense is that
they love each other
much more than
they loved the vic-
tory that led to this
expression of
affection.

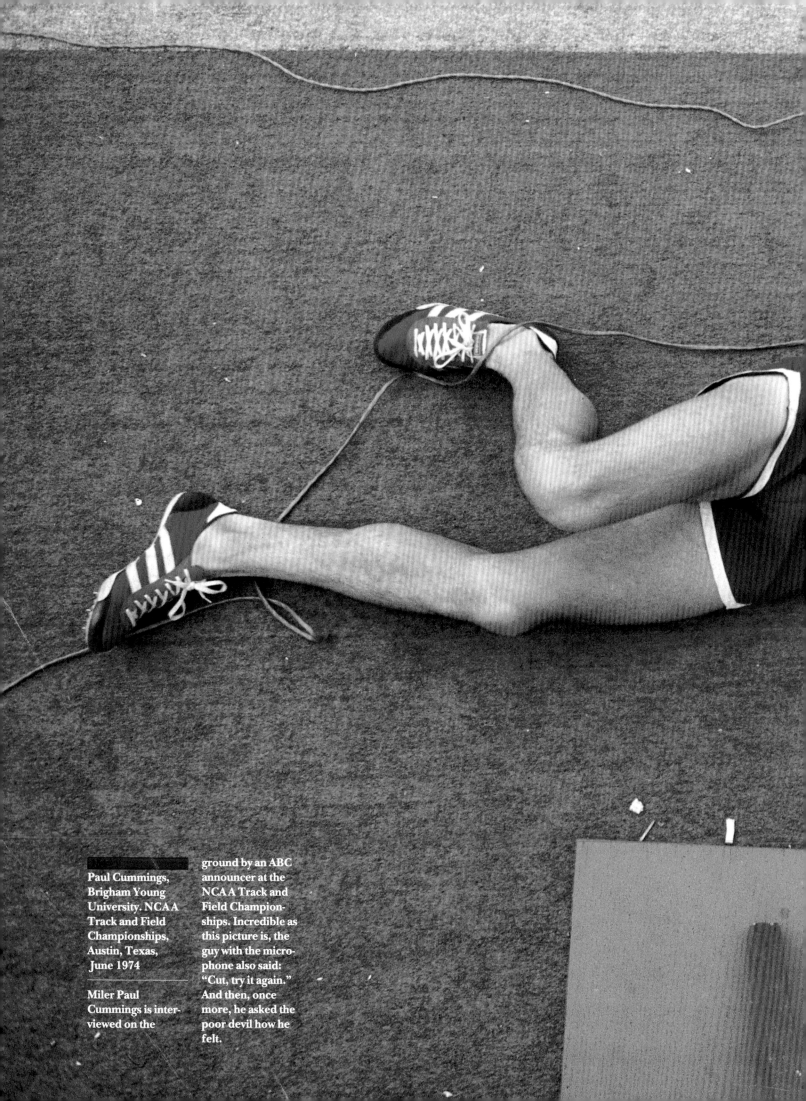

Paul Cummings,
Brigham Young
University. NCAA
Track and Field
Championships,
Austin, Texas,
June 1974

Miler Paul
Cummings is inter-
viewed on the

ground by an ABC
announcer at the
NCAA Track and
Field Champion-
ships. Incredible as
this picture is, the
guy with the micro-
phone also said:
"Cut, try it again."
And then, once
more, he asked the
poor devil how he
felt.

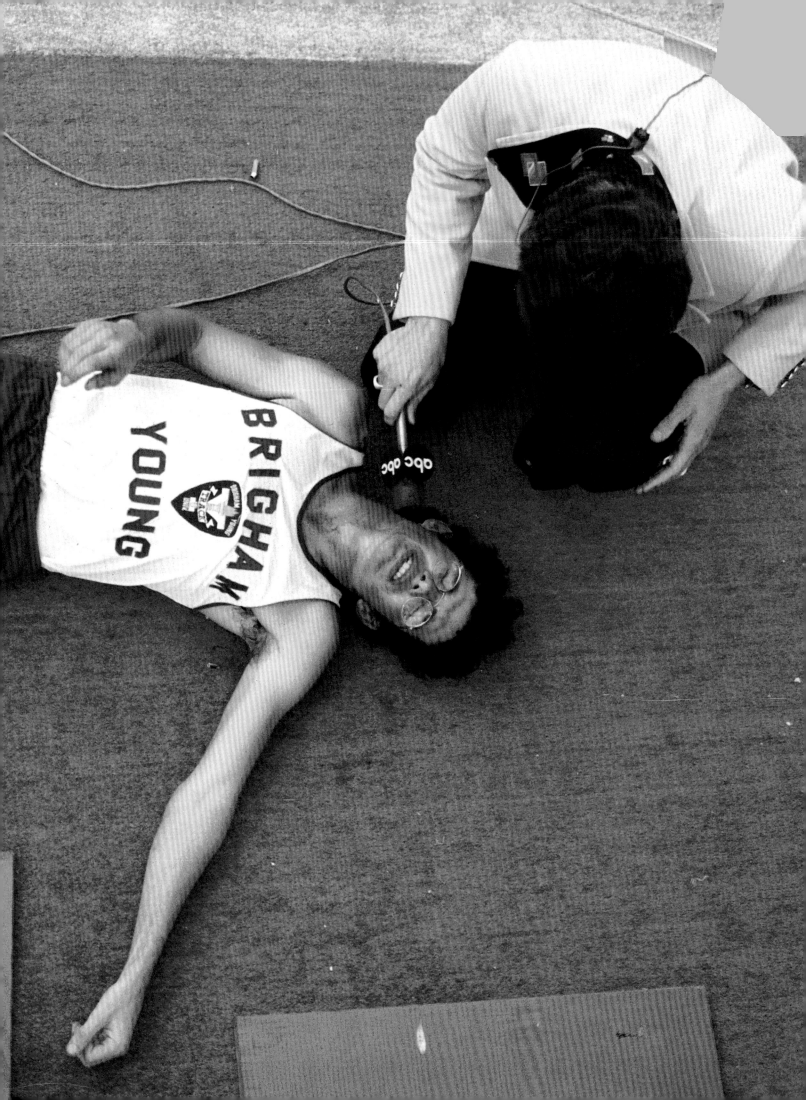

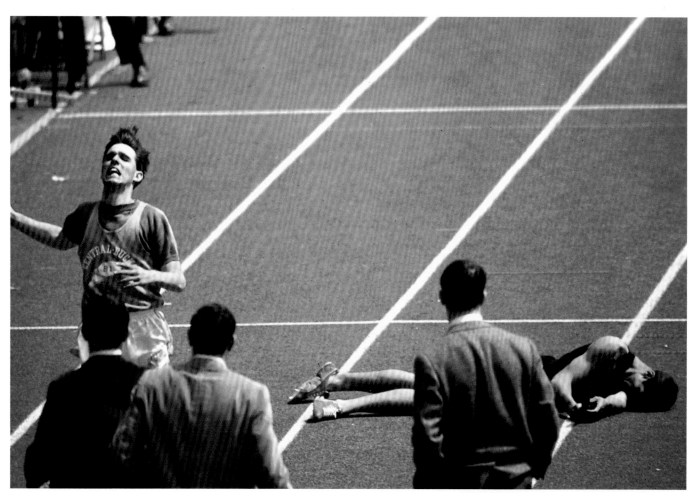

**Penn Relays.
Philadelphia, 1964**

**Swimmer. East
Germany, June
1976**

I think this is the
only truly unambig-
uous photograph in
this section. This
little girl flat out
likes to win.

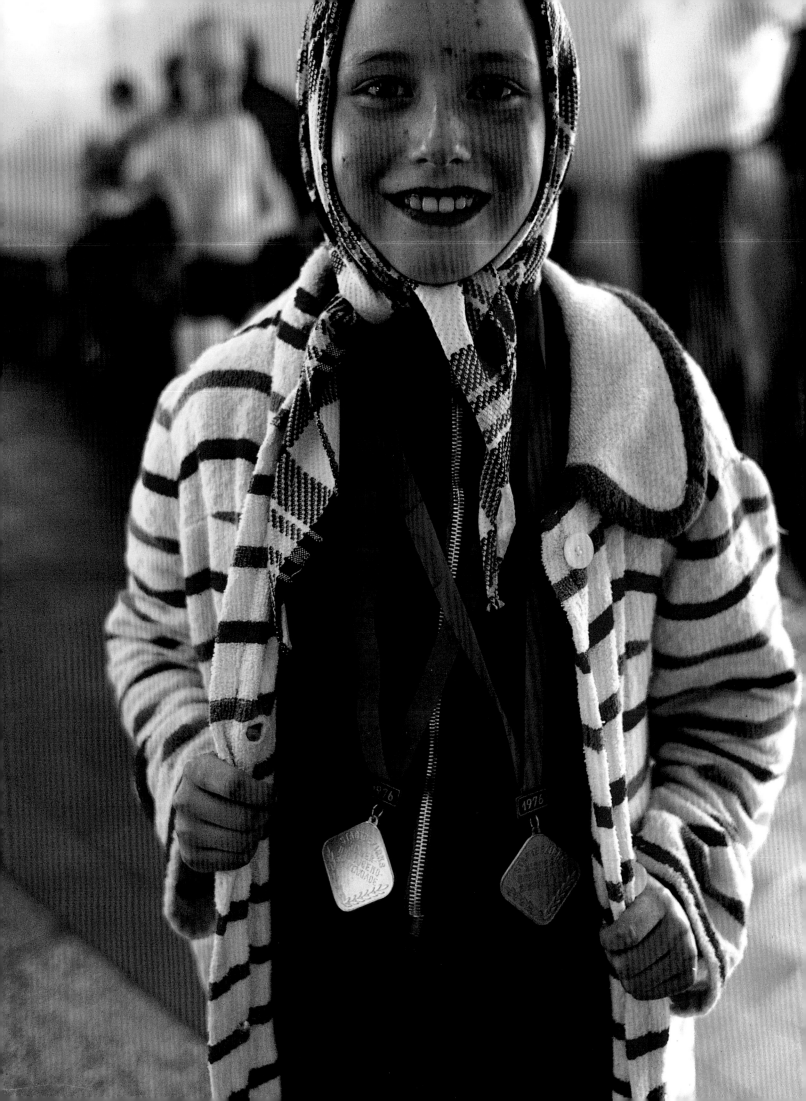

158
Jimmy Connors
after defeating Ivan
Lendl to win
the men's singles
final at the
U.S. Open. National
Tennis Center,
September 1982

159
**National Tennis
Center, September
1982**

Iooss has no idea
where these shad-
ows came from just
as he shot the board

at the conclusion of
the U.S. Open. He
believes that some
car lights must have
come on at that in-
stant, silhouetting
the other stragglers
against the tourna-
ment record.

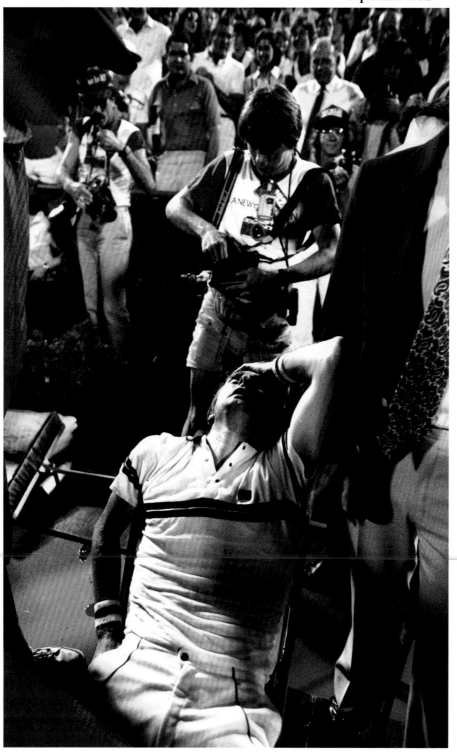

**Guillermo Vilas,
winner, men's
singles, U.S. Open.
West Side Tennis
Club, Forest Hills,
New York, 1977**

NATIONAL GEOGRAPHIC

You Can Be a
Paleontologist!

Scott D. Sampson, Ph.D.

NATIONAL GEOGRAPHIC
WASHINGTON, D.C.



What is paleontology?

**Hi!
My name
is Dr. Scott,
and I'm a
paleontologist.**

A paleontologist is a
scientist who studies
fossils—the remains of
plants and animals that
lived a long, long time ago.

DR. SCOTT
AND HIS TEAM
WORK TO DIG
UP FOSSILS.

PLANT FOSSIL

SEASHELL FOSSIL

MAMMAL FOSSIL

Some paleontologists search for ancient mammals. Others find fossils of plants, seashells, or fish. Some of these prehistoric plants and animals lived millions of years before that amazing group of reptiles known as dinosaurs.

Me, I love dinosaurs. I loved dinosaurs as a kid, and I still love them today. Some people say I never grew up! I love to find dinosaur fossils and think about what these animals and their world looked like millions of years ago.

Let's learn about the kinds of things paleontologists do! We'll start out hunting for dinosaur fossils. Then we'll dig them up, get them to a museum, glue the fossils back together, and study them in search of clues about prehistoric worlds.

At the end, I'll tell you a BIG secret . . .

Are you ready? Let's go!

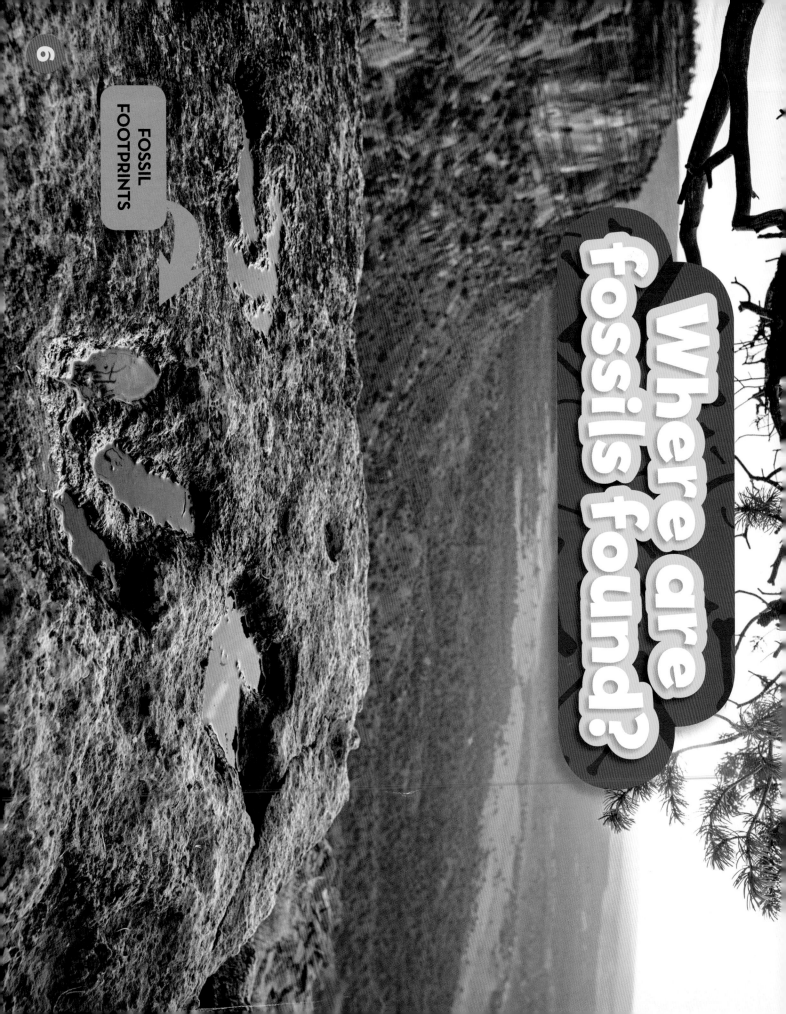

FOSSIL FOOTPRINTS

Where are fossils found?

The first step is to get out there and find some fossils! Believe it or not, dinosaur bones have been found on every continent. So if we want to discover dinosaurs, there are plenty of places to look.

Many fossils are found in "badlands," like Grand Staircase-Escalante National Monument in southern Utah, U.S.A. I've worked there for many years.

These places are called badlands because they're so dry and rugged. It's hard to grow food or raise animals there.

But for paleontologists, these are the good lands! Fossils are buried in rocks, so it's much easier to find fossils in places without a lot of plants covering the ground.

Because badlands are so hilly, they usually don't have many roads. So if we want to discover dinosaurs here, we'll have to do a lot of walking!

FOSSILS HAVE EVEN BEEN FOUND IN ANTARCTICA!

PALEONTOLOGISTS HIKE THROUGH THE BADLANDS IN UTAH.

ROCK HAMMER

BRUSHES

AWLS

BACKPACK WITH TOOLS

How do you find fossils?

If we want to go out finding fossils, the first thing to do is get a backpack with the right gear. We'll need fossil-digging tools, like brushes, awls, glue, and a rock hammer. Be sure to bring along pencils, pens, a notebook, and a camera. Oh, and don't forget your lunch, sunscreen, and plenty of drinking water!

Next, we'll head to a place where people have found dinosaur bones or other fossils before. It's always best to start where we know fossils can be found.

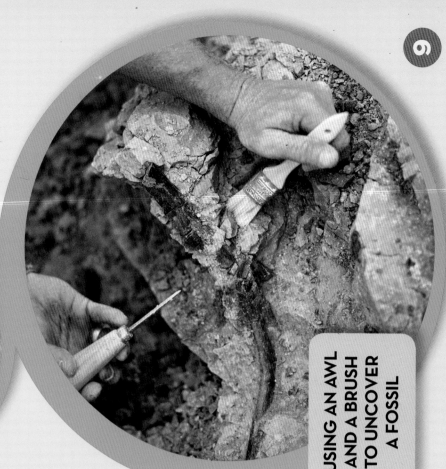

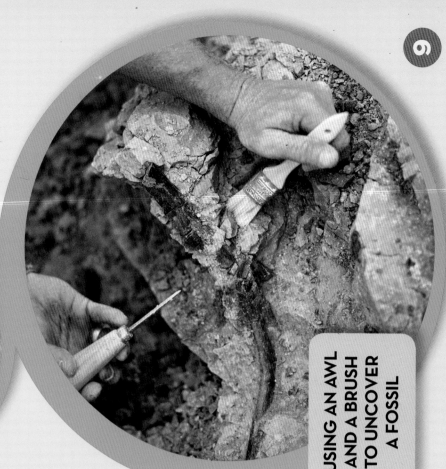

YOU CAN TELL ROCKS FROM FOSSILS WITH YOUR TONGUE! BUT ALWAYS ASK AN ADULT BEFORE PUTTING ANYTHING FROM THE GROUND INTO YOUR MOUTH.

USING AN AWL AND A BRUSH TO UNCOVER A FOSSIL

If we find something that looks like a piece of fossil but we're not sure, we can try touching it to our tongues. Fossils have tiny pores that make them stick to your tongue. Rocks don't!

Over time, fossils at Earth's surface tend to break into small fragments. Then they get washed down the hill when it rains. So once we've found some bits of fossil, follow the fragments up the hill. We'll keep going until we can't see any more of them.

Finally, we'll dig into the rock and try to find where the fossil fragments came from. If we're very lucky, we'll find more fossils. We may even discover the skull or skeleton of a new species that no one has ever seen before!

How do paleontologists dig up fossils?

Now that we've found part of a dinosaur, or some other prehistoric creature, it's time to dig it up!

The first step in an excavation is to remove the rock layers above the bones. That means digging with tools like big picks and shovels, sometimes working in the hot sun for many days, or even weeks. If the rock is extra hard, we may need large power tools like jackhammers or rock saws.

A THIN COAT OF GLUE IS CAREFULLY PUT ON THE FOSSIL AS IT IS EXPOSED.

IT'S ALWAYS EXCITING TO EXPOSE A FOSSIL TO THE LIGHT OF DAY FOR THE FIRST TIME IN MILLIONS OF YEARS!

Once enough rock is removed, we'll get down close to the fossils. Now it's time to switch back to smaller hand tools. We'll need rock hammers, awls, and brushes to carefully excavate the rock covering the bones.

Most fossil bones have cracks going through them. So as the rock is removed and the fossil is exposed, we put a thin coating of glue on the bone. That will hold the pieces together.

Be sure to uncover only a small part of the fossil. We'll want to leave most of it encased in rock for protection. Oh, and we'll need to remember to take photographs and carefully draw a map so that we know exactly where each bone was found!

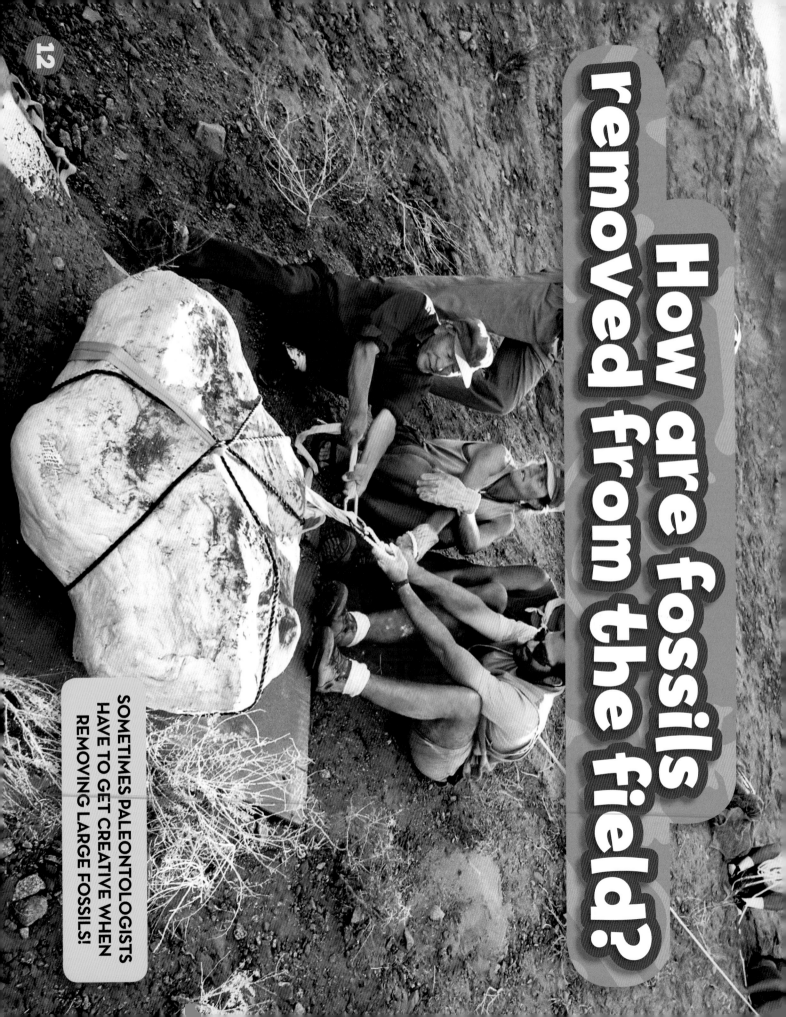

How are fossils removed from the field?

SOMETIMES PALEONTOLOGISTS HAVE TO GET CREATIVE WHEN REMOVING LARGE FOSSILS!

For more than a hundred years, paleontologists have been using a special three-step technique called plaster jackets to protect fossils.

Step 1 is to mix up a bucket of plaster and water.

Step 2 is to dip strips of a rough fabric called burlap into the wet plaster.

Step 3 is to cover the fossil with these plaster-coated strips.

After the plaster dries, the fossil can be flipped over so that more layers of plaster and burlap can be applied. Once the fossil is safely encased in its plaster jacket, it's ready to be moved!

If the fossil is small, we can carry it out in a backpack. Somewhat bigger fossils can be tied down to a stretcher and carried out by several people. Scientists need to get creative in the field! You never know what you'll need to do to move a fossil.

FOSSILS BEING WRAPPED IN BURLAP AND PLASTER

IF THE FOSSIL IS REALLY BIG, IT WILL NEED TO BE FLOWN OUT BY HELICOPTER!

How are fossils prepared in the lab?

A FOSSIL IN THE PREPARATION LAB

When I find a fossil, I bring it back to the museum. Some fossils go into a storage room to await preparation. But if it's a really important find, like a new kind of dinosaur, it goes straight to the preparation lab!

The preparators—the people who work in the lab—first remove the plaster jacket from one side of the fossil using a small power saw.

The next step is to begin taking away more rock so that the newly exposed pieces of the fossil can be glued back together. For this part, the preparator uses a variety of tools.

Power tools help to grind away big chunks of rock. Smaller tools, like dental picks (yes, the same kind your dentist uses), are great for carefully removing the rock that is touching the fossil.

This is hard work that requires a lot of patience. A fossil preparator may take more than a year to clean and glue back together a single fossil!

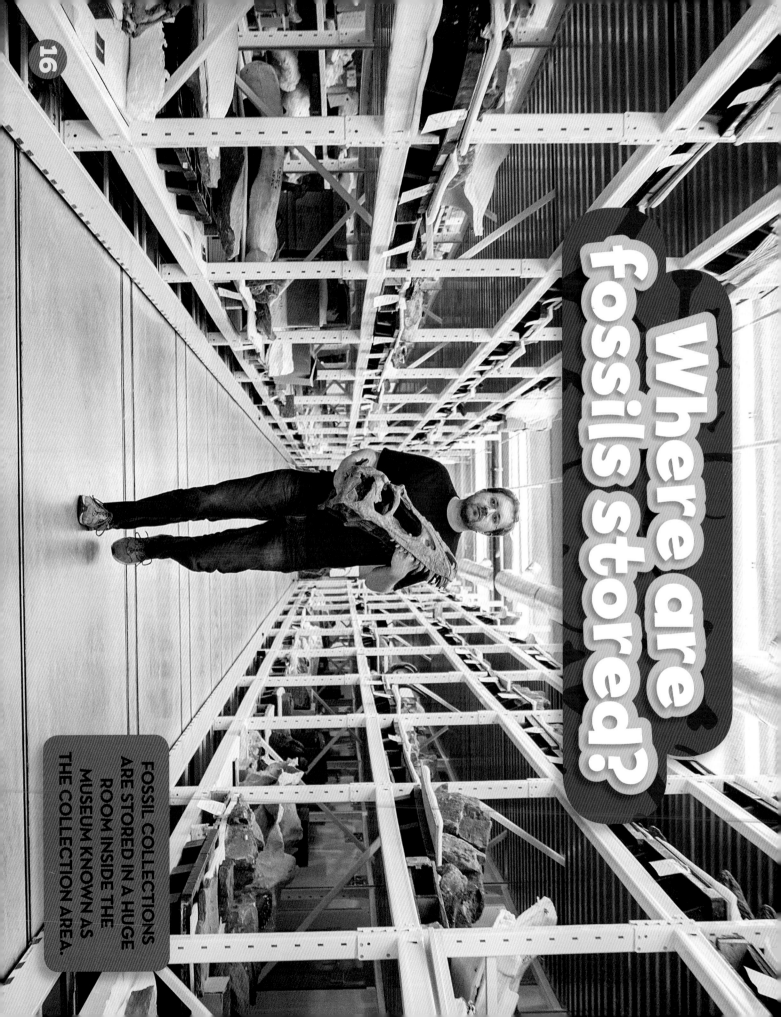

Where are fossils stored?

FOSSIL COLLECTIONS ARE STORED IN A HUGE ROOM INSIDE THE MUSEUM KNOWN AS THE COLLECTION AREA.

Imagine a huge room brimming with thousands of fossils. This is the museum's collection area. Most of these fossils will never make it out into the museum's exhibition halls. There are simply too many of them!

Every fossil has its own special number. And a label nearby lists things like the name of the animal, where and when it was discovered, and the name of the person who found it.

But these fossils don't just sit around collecting dust.

Believe it or not, this room is where paleontologists go to make discoveries! Sometimes they make these discoveries many years after the fossils are prepared and put away for storage.

How do paleontologists study fossils?

Paleontologists are like detectives, seeking clues to solve ancient mysteries. The first step is to ask questions. For example:

What did the animal eat?

How did the animal move?

To answer questions like these, we use many tools to look for clues. A microscope can be used to see tiny bumps on teeth. These can tell us a lot about what the animal ate. A CT scanner might peer into a skull, revealing secrets about the size of the dinosaur's brain or its sense of smell.

A CT SCANNER CAN BE USED TO LOOK INSIDE A FOSSIL WITHOUT HAVING TO BREAK INTO IT.

EINIOSAURUS

KOSMOCERATOPS

TRICERATOPS

Other clues can help us figure out what species of dinosaur we've found. For example, if our fossil is from a horned dinosaur—like my favorite, *Kosmoceratops*—we might compare its bones with those of other horned dinosaurs. That way we could figure out if the fossils were from a known species or from some creature never seen before.

Or maybe we want to know if our dinosaur could run fast. Then we might compare the leg bones of our new discovery with those of fast-running animals like horses or cheetahs.

The important thing is to keep asking questions and seeking clues. Then we can come up with possible answers, or hypotheses, to help us solve the mystery.

why did some dinosaurs look so strange?

KOSMOCERATOPS
SKULL

KOSMOCERATOPS
SKULL

Another great reason to study fossils is to figure out why dinosaurs look so strange! Some dinosaurs had horns and crests. Others had plates and spikes. Still others had bony clubs on their tails. How did dinosaurs use all these crazy features?

To find answers, paleontologists often look at the strange features of animals living today, like the antlers of deer and the horns of antelope.

Some weird-looking features of dinosaurs—like the tail spikes of Stegosaurus—may have been used to fight off predators. Other strange features—like the horns on the back of the Kosmoceratops skull—were likely used for showing off.

A STEGOSAURUS USES ITS TAIL
TO BATTLE AN ALLOSAURUS.

What did dinosaurs eat?

For most kinds of dinosaurs, we don't know the exact foods they preferred. But, by studying the teeth and jaws of dinosaurs and making comparisons with animals living today, paleontologists can learn a lot.

Dinosaur carnivores, like Tyrannosaurus, tend to have sharp, pointy teeth with tiny serrations, just like on a steak knife. These teeth were used for stabbing and tearing apart meat. That's just like the living great white shark!

GREAT WHITE SHARK

TYRANNOSAURUS (CARNIVORE)

DEER

TRICERATOPS
(HERBIVORE)

ORNITHOMIMUS
(OMNIVORE)

CASSOWARY

The teeth of dinosaur herbivores, like *Triceratops*, aren't as pointy as those of carnivores. The teeth of herbivores also tend to be packed closely together, just like we see in deer and other living plant-eaters.

We think that some dinosaurs, like the toothless *Ornithomimus*, were omnivores. That is, they ate both plants and meat. *Ornithomimus* and its close relatives were fast runners, and their toothless beaks would have been good for grabbing small animals, as well as for eating plants.

What was the Earth like when dinosaurs lived?

PLANT FOSSILS

When paleontologists head out to the badlands, we search for a lot more than just dinosaur bones. We want to know what the place was like when dinosaurs lived there. We want to know things like:

Was it wet or dry?
What other kinds of animals and plants were there?

So we search for lots more clues.

Today, the badlands in southern Utah—where Kosmoceratops lived—are part of a hot, dry desert. But we've found plenty of fossils of water-loving animals there, like fish, turtles, and crocodiles. They lived millions of years ago, at the same time as Kosmoceratops.

FOSSILS AND OTHER CLUES TELL US THAT THE LAND WAS WARM AND SWAMPY WHEN KOSMOCERATOPS ROAMED UTAH MILLIONS OF YEARS AGO DURING THE CRETACEOUS TIME PERIOD.

Are dinosaurs still alive today?

At the beginning of this book, I told you that I would share a big secret. Well, here it is . . .

Dinosaurs are still alive today!

The giant dinosaurs like T. rex are all gone, but thousands of different kinds of dinosaurs still live all over the world. Chances are that you see them every day.

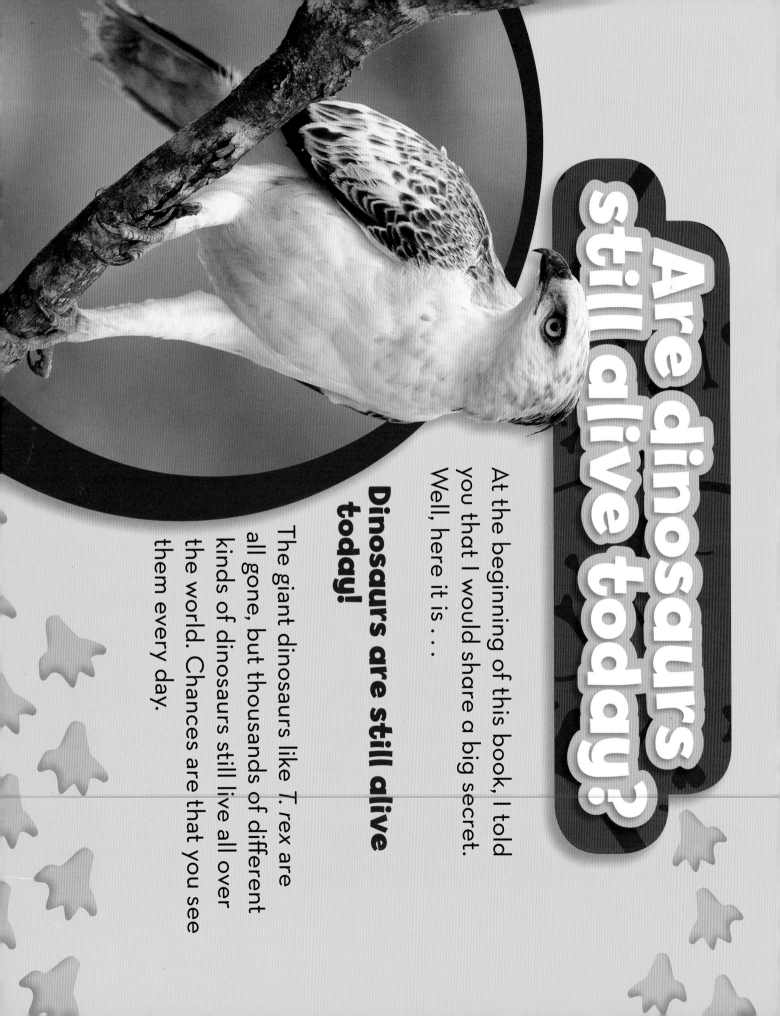

MICRORAPTOR

VELOCIRAPTOR

We call them birds!

All birds are closely related to small, meat-eating dinosaurs like Velociraptor that lived way back in the Mesozoic era, the "Age of Dinosaurs." Many features of birds, like feathers, appeared first in raptor dinosaurs like these.

We know this because paleontologists have discovered lots of dinosaurs with feathers. Some even had wings! Microraptor, for example, was a four-winged dinosaur (and not a bird) that probably climbed trees and used its wings to glide to the ground.

So eagles, owls, robins, and hummingbirds are not only birds. They're dinosaurs too! And if you like to eat chicken and turkey, guess what? You like to eat dinosaurs!

How do I become a paleontologist?

We've learned all about discovering, digging up, preparing, and studying fossils. But there are a few more things to keep in mind if you want to be a paleontologist. Here are some hints to help you along your path.

1 Learn as much as you can about all kinds of science. If you're going to study fossils, you'll need to know a lot about animals and plants living today, as well as those that lived a long time ago. You'll also need to understand how rocks formed and how Earth and life have changed over time.

2 Spend a lot of time out in nature. It's great to visit faraway places like national parks, but you can probably find plenty of nature close to where you live. You can even go looking for those dinosaurs known as birds! Most paleontologists I know spent lots of time playing in nature when they were kids.

3 Work on your fossil-finding skills by discovering things like rocks, insects, plants, bird feathers, and even fossils! You can make a "nature table" for your collection, kind of a mini-museum that will help you learn how to study all kinds of nature, including fossils.

**MOST OF ALL, REMEMBER:
GET OUTSIDE,
GET INTO NATURE, AND MAKE
YOUR OWN DISCOVERIES!**

GLOSSARY

Awl. A small, pointed hand tool used by paleontologists for removing rock from around fossils

Badlands. Hilly places with few plants, lots of exposed rocks, and sometimes many fossils

Burlap. A heavy fabric that can be cut into strips, dipped in plaster, and wrapped around fossils in the field so that they can be safely transported

Carnivore. An animal that eats only meat

CT scanner. A machine used by paleontologists to look inside fossils, especially skulls, without having to break into them

Excavation. A fossil dig site

Fossil. The remains of an ancient plant, animal, or other life-form that have been at least partially replaced by rock

Herbivore. An animal that eats only plants

Hypothesis. An idea you can test

Jackhammer. A large power tool used by paleontologists to break up rock around fossils

Microscope. A tool used by paleontologists to look at tiny features on fossils

Museum collection area. The place where fossils (and other kinds of objects) are stored and cared for

Omnivore. An animal that eats plants and meat

Paleontologist. A scientist who studies fossils

Plaster jacket. A coating of plaster and burlap used to protect fossils so that they can be safely transported

Preparation lab. The place where fossils are prepared, including removal of rock and gluing of broken fossil pieces

Preparator. The person who cleans fossils in the preparation lab

Rock hammer. A special hammer carried by paleontologists and geologists (scientists who study rocks), used for breaking into the rock

Rock saw. A power tool with a diamond-studded blade used by paleontologists to cut through rock around fossils

Serrations. Tiny bumps lining the teeth of meat-eating dinosaurs, used for tearing flesh

CREDITS

Many thanks to my mother, Catherine June Sampson, for igniting my lifelong passion for dinosaurs. Thanks also to my wife, Toni, and my daughters, Jade and Twangemeka, for their stalwart support. I am grateful to Mrs. Smith, my kindergarten teacher at Southlands Elementary School, for using dinosaurs to attract the attention of a distracted child. Warm thanks also to the paleontology staff and volunteers at the Denver Museum of Nature & Science, and to the many paleontology researchers and volunteers who have worked in Grand Staircase-Escalante National Monument. I dedicate this book to the millions of children around the world for whom, generation after generation, dinosaurs are an inspiring first foray into science.

The author and publisher also wish to sincerely thank the book team:

Shelby Alinsky, Kathryn Robbins, Jeff Heimsath, Joan Gossett, Kathryn Williams, and Anne LeongSon.

Title page: The skull of Kosmoceratops, a many-horned dinosaur discovered in Utah

National Geographic Partners
1145 17th Street N.W.
Washington, D.C. 20036-4688 U.S.A.

Visit us online at nationalgeographic.com/books

For librarians and teachers: ngchildrensbooks.org

More for kids from National Geographic:
kids.nationalgeographic.com

For information about special discounts for bulk purchases, please contact National Geographic Books Special Sales: specialsales@natgeo.com

For rights or permissions inquiries, please contact National Geographic Books Subsidiary Rights:
bookrights@natgeo.com

Designed by Kathryn Robbins
Illustrations by Franco Tempesta

Trade hardcover ISBN: 978-1-4263-2728-5
Reinforced library binding ISBN: 978-1-4263-2729-2

Printed in China
16/PPS/1

Photo Credits:
Cover (CTR), Franco Tempesta; Cover (LO RT), Stuart Ruckman/Natural History Museum of Utah; Back Cover (LE), Cory Richards/National Geographic Creative; Back Cover (RT), Courtesy of Scott Sampson; Dust Jacket (UP), Courtesy of Scott Sampson; Dust Jacket (LO), Franco Tempesta; 4 (UP), Cory Richards/National Geographic Creative; 2-3, Franco Tempesta; 4 (UP), Cory Richards/National Geographic Creative; 4 (LO), Courtesy of Scott Sampson; 5 (UP), Ira Block/National Geographic Creative; 5 (CTR), Kevin Schafer/Getty Images; 5 (LO), Roberto Machado Noa/Getty Images; 6 (CTR), Cory Richards/National Geographic Creative; 7 (UP), Dawn Nichols/iStockphoto/Getty Images; 7 (LO), Richard M. Wicker/Denver Museum of Nature & Science; 8 (UP), Cory Richards/National Geographic Creative; 8 (LO), Photo Researchers/Getty Images; 9 (UP), Courtesy of Brad Purdy/Bureau of Land Management-Montana/Dakotas; 9 (LO), Cory Richards/National Geographic Creative; 10-11, Cory Richards/National Geographic Creative; 12 (CTR), Louie Psihoyos/Corbis; 13 (UP), Lynn Johnson/National Geographic Creative; 13 (CTR), Scott Linnett/SDU-T/ZUMA Press; 13 (LO), Jon Austria/The Daily Times/AP Images; 14, Gabriel Bouys/AFP/Getty Images; 15 (UP), Richard M. Wicker/Denver Museum of Nature & Science; 15 (LO), Cory Richards/National Geographic Creative; 16, Cory Richards/National Geographic Creative; 17 (UP), Richard M. Wicker/Denver Museum of Nature & Science; 17 (LO), Cory Richards/National Geographic Creative; 18, Field Museum Library/Getty Images; 19, Franco Tempesta; 20, Cory Richards/National Geographic Creative; 21, Franco Tempesta; 22 (LE), Stephen Frink/Getty Images; 22 (RT), Franco Tempesta; 23 (UP RT), Franco Tempesta; 23 (LO RT), Franco Tempesta; 23 (CTR RT), Kevin M. McCarthy/Shutterstock; 23 (LO LE), Kevin Schafer/Minden Pictures; 24 (UP), Buddy Mayes/Getty Images; 24 (LO), Ira Block/National Geographic Creative; 25, Franco Tempesta; 26, Peter Waechtershaeuser/BIA/Minden Pictures; 27, Franco Tempesta; 28, Hero Images//Getty Images; 29 (UP), Paul Simcock/Getty Images; 29 (CTR), Nilky/iStockphoto/Getty Images; 29 (LO), gopause/Shutterstock; 31, Franco Tempesta; 32, Courtesy of Scott Sampson